FILM STARS

Stars are an integral part of the global film industry. This is as true today, in the age of celebrity culture, as in the studio era. Each book in this major new BFI series focuses on an international film star, tracing the development of their star persona, their career trajectory and their acting and performance style. Some also examine the cultural significance of a star's work, as well as their lasting influence and legacy. The series ranges across a wide historical and geographical spectrum, from silent to contemporary cinema and from Hollywood to Asian cinemas, and addresses both child and adult stardom.

SERIES EDITORS
Martin Shingler and Susan Smith

PUBLISHED TITLES
Elizabeth Taylor *Susan Smith*
Nicole Kidman *Pam Cook*

FORTHCOMING
Brigitte Bardot *Ginette Vincendeau*
Sabu *Michael Lawrence*

STAR STUDIES

A Critical Guide

MARTIN SHINGLER

A BFI book published by Palgrave Macmillan

Dedicated to Matthew George

© Martin Shingler 2012

All rights reserved. No reproduction, copy or transmission of this publication may be made without written permission. No portion of this publication may be reproduced, copied or transmitted save with written permission or in accordance with the provisions of the Copyright, Designs and Patents Act 1988, or under the terms of any licence permitting limited copying issued by the Copyright Licensing Agency, Saffron House, 6–10 Kirby Street, London EC1N 8TS. Any person who does any unauthorized act in relation to this publication may be liable to criminal prosecution and civil claims for damages.

The author has asserted his right to be identified as the author of this work in accordance with the Copyright, Designs and Patents Act 1988.

First published in 2012 by
PALGRAVE MACMILLAN

on behalf of the

BRITISH FILM INSTITUTE
21 Stephen Street, London W1T 1LN
www.bfi.org.uk

There's more to discover about film and television through the BFI. Our world-renowned archive, cinemas, festivals, films, publications and learning resources are here to inspire you.

Palgrave Macmillan in the UK is an imprint of Macmillan Publishers Limited, registered in England, company number 785998, of Houndmills, Basingstoke, Hampshire RG21 6XS. Palgrave Macmillan in the US is a division of St Martin's Press LLC, 175 Fifth Avenue, New York, NY 10010. Palgrave Macmillan is the global academic imprint of the above companies and has companies and representatives throughout the world. Palgrave® and Macmillan® are registered trademarks in the United States, the United Kingdom, Europe and other countries.

Designed by couch
Cover images: (front) *Devdas* (Sanjay Leela Bhansali, 2002), Mega Bollywood; (back) *Il gattopardo* (Luchino Visconti, 1963), Titanus/La Société Nouvelle Pathé-Cinéma/Société Générale Cinématographique

Set by Cambrian Typesetters, Camberley, Surrey
Printed in China

This book is printed on paper suitable for recycling and made from fully managed and sustained forest sources. Logging, pulping and manufacturing processes are expected to conform to the environmental regulations of the country of origin.

British Library Cataloguing-in-Publication Data
A catalogue record for this book is available from the British Library
A catalog record for this book is available from the Library of Congress
10 9 8 7 6 5 4 3 2 1
21 20 19 18 17 16 15 14 13 12

ISBN 978–1–84457–490–2

UNIVERSITY
OF
GLASGOW
LIBRARY

CONTENTS

ACKNOWLEDGMENTS

This book could not have been written without the inspirational work of Richard Dyer and Christine Gledhill and the generous support of colleagues at the University of Sunderland and its Centre for Research in Media and Cultural Studies: most notably, Julia Knight, Fred Marden, Shaun Moores and John Storey. A debt is also due to Ulrike Sieglohr, Cynthia Baron and Anna Raeburn for reading through and providing invaluable feedback upon draft chapters. Without Susan Smith's involvement, this book would never have evolved in the first place and our conversations about film stars and star studies have made a deep impression. Other conversations have also been instrumental in the formation of ideas and identification of sources and, therefore, thanks are also due to Melanie Bell, Janet Caldwell, Jim Cook, Colin Cruise, Richard Pearce and Simon Rushton.

INTRODUCTION

My introduction to star studies came in 1985 when I first read
Richard Dyer's *Stars* (1979). This reading was prompted by an
extraordinary reaction to my first viewing of Bette Davis in *Now,
Voyager* (dir. Irving Rapper, 1942). In an effort to understand why
this film star had made such a profound impact upon me, I turned
to what was then (and still is) the most illuminating academic study
of film stars and stardom. For me, it was the start of a long journey –
one that culminates in the writing of this book: my attempt to make
sense of stardom as a body of academic work, as an industrial
process and product, and as a cultural phenomenon. Repeated
viewings of Davis's performances in films of the 1930s and 40s have
continually reignited my fascination for this great Hollywood star
and compelled me to discover more about her, just as repeated
readings of Dyer's book have reanimated my investigations into
stardom, into the industrial and cultural uses of film stars. The
influence that Davis exerts upon me as a film viewer and the
inspiration of Dyer's work on stars have enabled me to comprehend
something of the power that film stars can have in society,
performing roles that go beyond those of acting in front of cameras
and microphones or appearing at premieres, on television chat
shows or at award ceremonies. How can something so seemingly
trivial and inconsequential as a film star be so important as to
warrant such consideration by academics, students of film and

My starting point: Bette Davis in her star
vehicle *Now, Voyager* (1942)

media, sociologists, historians, writers, critics and cultural commentators, even politicians?

The answer to this question surely lies in the fact that film stars are used in different ways by different kinds of people the world over. As objects of beauty and physical perfection or as imperfect human specimens, they provide pleasure, sometimes provoking humour, sometimes admiration and fascination. As icons, stars represent specific types of people, reflecting psychological, cultural, national, racial and sexual characteristics. As individuals with a proven track record of hit films and a substantial fan-base, stars secure funding and distribution deals for film-makers. They also undertake promotional work, generating public interest and media attention, ensuring the successful release of their films. As a source of gossip and speculation, they support a global media network of newspapers, magazines, broadcasting and the internet, while also raising questions about individuality, personhood, relationships, personal ambitions and desires. In short, they make a profound contribution not only to the film industry but also to the experience of life itself, attracting high levels of attention from the general public, journalists, media commentators, theorists and historians. Therefore, the questions 'What is a star?' and 'What do stars do?' become fundamental ones.

One of the most persistent questions asked about stardom is why some film actors become stars and not others. Is it simply the combination of photogenic looks, a phonogenic voice and an expressive face and body or is it the combination of talent with ambition, determination and charisma? Does stardom actually result less from personal qualities and more from a performer's business acumen, such as hiring a good agent, manager, publicist or lawyer to represent their interests and secure lucrative deals? Does an actor's stardom rely to a greater extent on the contribution of more creative personnel, such as a group of film directors, who contribute to the development of a number of hit movies that showcase a particular

performer to best advantage, or does a film star's status depend less on the films they make than his or her ability to generate intense media interest? Does a performer become a star the moment they receive star billing above the title of a film or when they become a recognisable brand, such as when a range of merchandise bearing their name or image is produced and sold in large quantities? Is it the almost universal recognition of such an image that makes a film performer a star? These questions have preoccupied many film scholars and are central to film scholarship on stars and stardom. Moreover, such questions have led to the development of an important branch of film studies known as star studies.

Star studies has developed over a significant period of time and taken numerous forms, so long and so various that it has become necessary for a book that maps the existing field of academic enquiry and considers what lies just beyond the known borders of this territory. This branch of film studies has also produced numerous star theorists and their work can be used as coordinates when mapping out the different areas of star studies. The work of these high-profile theorists deserves to be appreciated as significant scholarly achievement that has had a profound influence within the wider domains of media and cultural studies. Such theorists are not beyond criticism, of course, and nothing is to be gained by ignoring the valuable critiques that have been made in response to them: that is, such criticism enables us to refine, extend and diversify our enquiry into film stars and stardom. In delineating the terrain covered by star studies, this book offers a wide-ranging perspective and yet it is not without omissions and oversights. Where there is knowledge there is also ignorance and, therefore, while some areas are comprehensively covered here, others are under-represented or even neglected entirely (e.g., child stars). Readers are invited to fill such gaps with their own research, to actively respond to what is missing and further the debate. For, as well as looking back over the development of star studies, this book also looks forward, to the

promise of an even more comprehensive and diverse sub-disciplinary field, in which many more kinds of people (i.e., academics, researchers, archivists, students, writers, biographers, documentary-makers, etc.) contribute in unique ways to the ongoing development of this area. There is certainly considerable scope to extend the borders of knowledge and understanding here. The process of researching and writing this book has been hugely illuminating for me, augmenting my knowledge of the field, but it has also exposed some areas of ignorance, opening up the prospect of new avenues for further exploration beyond this book.

This book is aimed primarily at students and academics, particularly under-graduate and post-graduate film students, academic writers and teachers, and professional researchers in cinema history, although students of film, media, drama and cultural studies should also find some sections interesting and relevant depending on their specific areas of interest. The principal aim of the book is to organise the field of star studies (i.e., the scholarship on stars and stardom that has emerged within film studies since the 1970s) into a number of discrete areas to make it more manageable and comprehensible and, in the process, to put various scholars into a form of dialogue with each other. Rather than offer my own personal thoughts on stardom or on particular stars, I have restricted myself to the purpose of scholarly synthesis in order to provide readers with a map to make sense of the existing academic field. I have concentrated largely on Hollywood, which is the area of film history that I am most familiar with. However, in order to provide a more international and less western perspective, I have also made frequent references to Indian (Hindi/Bollywood) cinema. While a much greater range of national cinemas might have added significantly to this book (e.g., Japanese, African and South American), the Hollywood/Bollywood theme employed here has been adopted as a means of comparing two very different forms of stardom that have proven enormously successful for many decades,

constituting two very distinct versions that, finally, appear to be converging in the twenty-first century. The differences between these two systems and the ways in which they are increasingly occupying common ground have much to tell us about the history of film stardom. These have certainly provoked many academics to investigate and analyse them, constituting rich strands of scholarship within film studies; strands that future generations of students and scholars can either build upon or depart from.

Organised into six chapters, this book begins with an assessment of the published academic literature on stars (Chapter 1) and star acting (Chapter 2), moving from a consideration of the processes of acquiring stardom (Chapter 3) and the industrial mechanisms for developing stars (Chapter 4), to their meanings for audiences and fans (Chapter 5), as well as their cultural significance (Chapter 6). Beginning with an introduction to the work of leading star scholars, Chapter 1 explores how star studies became a major area of film scholarship, discussing in particular the seminal role played by Richard Dyer's *Stars*, but also noting the influence of earlier studies, including Edgar Morin's *Les Stars* (1957). The second half of this first chapter explores how, inspired by the likes of Morin and Dyer, many scholars have investigated the nature and function of film stars in Hollywood, Europe and Asia (namely, India and China), describing a range of theoretical approaches and methodologies that were subsequently adopted during the 1980s, 90s and 2000s, influenced by disciplinary debates about film history, industry, reception and audiences. Chapter 2, meanwhile, explores the various concepts and research methods star scholars use to analyse star acting, drawing mainly on *mise en scène* criticism and studies of performance and celebrity, acknowledging that acting plays a central role in distinguishing different kinds of film star from other types of entertainment celebrity, while also recognising the crucial contribution of other film industry professionals to a performer's attainment of stardom.

The remaining chapters of this book are designed to provide readers with a set of topics that might be considered when investigating film stars and stardom. While Chapter 3 focuses on star qualities, identifying the prerequisites for a performer's attainment of stardom, Chapter 4 delves into the industrial mechanisms for discovering and developing stars. Chapters 5 and 6, on the other hand, explore the meanings of stars in terms of, first, how star identities are described, formed and circulated and, second, how they come to represent, embody or stand in for wider social groups and historical moments. Throughout Chapters 3 to 6, case studies of individual stars are used to illustrate the main points. These also serve as an introduction to some of the most significant studies of stars, with numerous references to (and quotations from) a wide range of academic writing. It is hoped that readers will pursue further reading of the books and essays cited here but also that many will be inspired to conduct their own research projects, thus contributing in different ways to the expanding horizons of star studies.

1 STAR STUDIES: MAPPING OUT THE FIELD OF STAR SCHOLARSHIP WITHIN FILM STUDIES

Introduction

Film stars attract attention. They also play a seminal role in the production and marketing of movies, often accounting for a large proportion of a film's budget. Stars are used to secure funding for films due to the belief that they make a significant contribution to the potential profitability of movies in an otherwise unpredictable market. Many films are produced as 'star vehicles', showcasing the star's talent, capitalising on both their acting skills and their public persona. Stars are so vital to the overall operation and success of the film industry that their popularity is closely and systematically monitored. 'Bankable' stars are highly sought after and excessively well remunerated. Many of the world's top stars have a large international fan-base, while most of the major film-making countries have produced stars of international standing. Some stars have even been used to represent national characteristics within the global economy of the mass media, their fame extending well beyond the confines of the cinema via newspaper and magazine journalism, the internet, and television and radio appearances. Tabloid newspapers and lifestyle magazines are heavily dominated by images, stories and speculation about film stars, as are television chat shows and internet websites.

Susan and God (1940), starring Joan Crawford (on right) with Rose Hobart (on left) in gowns by Adrian

Given the importance of stardom within the film industry and popular culture generally, it is not surprising that the academic study of stars has become one of the most important branches of film studies. This area of film scholarship has proliferated since the publication of Richard Dyer's *Stars* in 1979, this book precipitating a 'seismic shift in the way in which star studies were perceived' (Hollinger 2006: 35). Dyer's combination of semiotics and sociology produced the 'star text' and stimulated considerable interest in star images across films, publicity and promotional materials. Meanwhile, Dyer's *Heavenly Bodies: Film Stars and Society* (1987) drew increasing attention to the interpretive activities of audiences, mainstream and marginal (e.g., the black and gay communities), with its illuminating case studies of Marilyn Monroe, Paul Robeson and Judy Garland. The first anthologies of star studies appeared in 1991 in Britain and the United States, Christine Gledhill's *Stardom* and Jeremy Butler's *Star Texts*, both containing extracts of Dyer's work as well as essays inspired by his approach. These collections promoted high-level scholarship on stars, demonstrating that star studies had become a legitimate area of academic enquiry.

This chapter provides an overview of the key works within star studies, highlighting the major trends within this branch of film studies, charting the way in which it became increasingly international, moving from theory to history and from the general (i.e., stardom as an industrial and cultural phenomenon) to the specific (i.e., case studies of particular stars). The focus here is less on stars and more on the academic literature about stars and stardom. While outlining the key themes and methodology of Richard Dyer's ground-breaking book, this chapter also considers the work of scholars that preceded and influenced *Stars*, as well as discussing the contribution of scholars that have subsequently advanced research on stardom.

Star studies

While the origins of star studies as a distinctive branch of film studies can be traced back to the late 1970s, the following decades represented a rich and volatile period of growth and development, one that finally settled into a period of consolidation at the end of the 90s. Prior to this consolidation, star studies was fragmented, its methods and terminology being contested, as numerous leading exponents sought to stake out their own territory.[1] Writing in 1998, Jeremy Butler stated that star studies was 'still in a rather embryonic state' (Butler 1998: 352). This was the year that a new edition of Dyer's *Stars* was published, while a section on stardom was included in *The Oxford Guide to Film Studies* (edited by John Hill and Pamela Church Gibson, 1998). Star studies really came of age, however, at the start of the twenty-first century. In 2000, a section on stars was included in *The Film Studies Reader* (edited by Joanne Hollows, Peter Hutchings and Mark Jancovich), while Paul McDonald's *The Star System*, Ginette Vincendeau's *Stars and Stardom in French Cinema* and Ulrike Sieglohr's edited collection *Heroines without Heroes* augmented an expanding body of literature on stars and stardom. The latter two publications, along with Bruce Babington's edited collection *British Stars and Stardom* (2001), were instrumental in broadening the international scope of star studies by raising the profile of European stars and identifying the distinguishing characteristics of stardom in specific national contexts. Indeed, Babington's book set its face squarely against the 'Hollywoodcentric film theorists' in an effort to undermine the orthodox accounts that had assumed that the characteristics of the Hollywood star system pertained equally in other national contexts (Babington 2001: 3).

In the twenty-first century the 'Hollywoodcentric' approach to star studies has slowly broken down, with some of the most original work being produced by European scholars on European stars, from Erica Carter's *Dietrich's Ghosts* (2004) to Tytti Soila's edited

collection *Stellar Encounters* (2009).[2] The latter, in particular, draws together a diverse selection of essays on European film stars, including those of Greece, Finland and Scandinavia, in a bid to redress the Anglo-American bias. In addition to challenging the notion of Hollywood as the originator of the star system, this book focuses largely on the relationship between stars and nationhood, the ways in which stars embody national characteristics and represent specific moments within a nation's history. Meanwhile, research on non-western stars has appeared in published collections,[3] culminating in the first major publications in English devoted exclusively to non-western stars: most notably, Neepa Majumdar's *Wanted Cultured Ladies Only! Female Stardom and Cinema in India, 1930s–1950s* (2009) and *Chinese Film Stars* (edited by Mary Farquhar and Yingjin Zhang, 2010). While the former extends the work of Richard Dyer with a detailed and authoritative examination of female stardom in Indian sound cinema prior to 1960, the latter provides an historical account of stars from various Chinese territories (including Taiwan and Hong Kong), from the silent era through to the end of the first decade of the twenty-first century, with many of its contributors subjecting the images of Chinese stars to a Dyerian analysis.

In order to be selective and focused, a number of star studies have used case studies as the basis for exploring various aspects of stardom, such as Karen Hollinger's *The Actress* (2006), Jeanine Basinger's *The Star Machine* (2007) and Mia Mask's *Divas on Screen* (2009). The increasing amount of material available on stars by the end of the 1990s gave star scholars greater scope to focus their research on more detailed investigation into the work, image and appeal of a single star. This is certainly part of the rationale behind the *Star Decades: American Culture/American Cinema* series edited by Adrienne L. McLean and Murray Pomerance for Rutgers University Press.[4] These books consist of between ten and twelve chapters written by different authors, each examining the work of a star or

combination of stars within a particular decade. The stars included here are taken to be representative of Hollywood cinema and American culture of the time, with each volume offering a wide-ranging look at various types of star for a specific era. Within a short space of time, this series of books has dramatically expanded the range of scholarship on Hollywood stars from the silent, classical, post-studio and contemporary periods.

Academic books devoted to the examination of the work, image and appeal of an individual star, however, still remain something of a rarity in film studies. Adrienne L. McLean's *Being Rita Hayworth: Labor, Identity, and Hollywood Stardom* (2005) is a notable exception, one that has been highly influential in various ways, paving the way for the gradual expansion of the single star study within academic publishing. This investigation into the discursive nature of the films, image, publicity, performances and business interests of the popular star of Hollywood musicals and crime melodramas of the 1940s and 50s, Rita Hayworth, expanded Richard Dyer's work on star images, publicity and promotion, making more extensive use of archival materials than previous studies of the star (i.e., using scrapbooks, press books, fan magazines and newspaper reviews from various archives and libraries). A significant part of the project was the re-evaluation of Hayworth's talents as a performer (i.e., as an actress, singer and dancer) through detailed scrutiny of her screen performances but also by investigating her working relationships with choreographers. This provided detailed examination of female stardom in classical Hollywood that challenged many of the established claims about Hayworth, establishing her professionalism and autonomy.

In 2007, Lisa Downing and Sue Harris stated that, 'very few single case studies existed in the field of academic publishing' (Downing and Harris 2007: 11).[5] They suggested that one of the main reasons for this was the widespread publication of non-academic books on film stars, noting that many film academics were concerned to distinguish their work from industry-based, fan-based

and biographical material. Nevertheless, they insisted that studies devoted to the work of a single star provide a useful way of reading star images. A single star case study, they point out, enables one to examine the work of a star both in and beyond their own national cinema, in relation to a variety of directors, and across a body of work that appeals to a range of audiences. It also enables a scholar to detect and explore 'the developments, breaks and lines of continuity that constitute her image over the course of a career' (Downing and Harris 2007: 8). Thus, in their own book, they note that a 'careful look at [Catherine] Deneuve as star image, both on-screen and off-screen, over a period of forty years, reveals previously undiscussed instances of prescience, lines of continuity and ignored fractures in her trajectory' (ibid.). Since the publication of their book, other single star studies have been published (e.g., Amy Lawrence's *The Passion of Montgomery Clift,* 2010a), while many more are anticipated as part of the British Film Institute's *Film Star* series.

Star studies before *Stars*

Richard Dyer's *Stars* brought together numerous studies of film stardom, along with work on gender and film, synthesising and advancing existing claims, while introducing his own ideas.[6] A number of the key studies upon which he drew had emerged in Europe (most notably, France) in the late 1950s and early 60s, including Roland Barthes's *Mythologies* and Edgar Morin's *Les Stars,* both published originally in French in 1957. Susan Werner has observed that Morin's study initially generated little interest from scholars in contrast to Roland Barthes's, although it received new attention and admiration in the 1990s (Werner 2007: 27). Morin borrowed freely from anthropology as well as Marxist theory in order to understand how film stars operated as myths within modern technological and urban societies, and his work on stars has been

seen as a response to massive and rapid cultural changes in postwar France, a situation in which French stars played a major social role in the popular negotiation of the various contradictions resulting from the clash and co-existence of modernity and tradition (Gaffney and Holmes 2007b: 8). The major theme resonating throughout *Les Stars* is the mythic nature of stardom. For Morin, stardom is a myth produced by the reality of twentieth-century human history but 'it is also because human reality nourishes itself on the imaginary to the point of being semi-imaginary itself', hence his claim that 'stars live on our substance and we on theirs' (Morin 2005: 148). 'Ectoplasmic secretions of our own being, they are immediately passed down the production lines of the great manufacturers who deploy them in galaxies stamped with the most distinguished trademarks' (ibid.).

Morin describes stars as *monstres sacrés* (sacred monsters), venerated public individuals above or beyond criticism by ordinary mortals. For him, the star is both real and imaginary, of life and dream, born from a conjunction of capitalism, modernity and the mythology of love, all three factors determining 'sacred monstrosity: the star' (ibid.: 135). Existing simultaneously in two worlds, the ordinary and extraordinary, 'the star straddles both sacred and profane, divine and real, aesthetic and magic' (ibid.: 84). To describe the combination of a star's extraordinary qualities and ordinariness, Morin employs the notion of the 'superpersonality', one that combines beauty and spirituality, one that 'must unceasingly prove itself by appearances: elegance, clothes, possessions, pets, travels, caprices, sublime loves, luxury, wealth, grandeur, refinement' (ibid.: 38). Morin also uses the term 'marvellous' to describe this state, arguing that 'the stars bluff, exaggerate, spontaneously divinize themselves' not just to attract publicity but also to be more like their ideal self, their double (ibid.: 55). The star's mythic identity is built from a mixture of belief and doubt, while their power for audiences lies in their search for coherent identity, adult personalities being formed out of playful mimesis (e.g., games and role-play). For the

public at large, stars offer 'patterns of culture' that 'give shape to the total human process that has produced them' (ibid.: 147). Whatever their precise role within the film industry, their importance, Morin insists, lies beyond that industry, in the wider culture in which stars are consumed and adopted as role models by all kinds of people: although chiefly, he claims, women and adolescents.

In many ways Morin's book sowed the seeds of some of the most important debates within star studies: the quasi-religious nature of star worship, the importance of publicity and merchandising, the prominence of the star's face and the importance of beauty and youth, the various levels of identification, the historical transformations in attitudes towards stars, and the distinctions between stars and characters, stars and lead actors, also between stars, pin-ups and starlets. While many of these points have subsequently been taken up by scholars (e.g., Jackie Stacey and Barry King), often little acknowledgment has been made regarding Morin's origination of these topics, in part perhaps due to the hyperbolic nature of his writings that, for some considerable time, may have appeared to invalidate the academic credibility of his research.

Charles Affron's writing on stars appears to have suffered a similar fate. When compared to academic writing on stars published after 1978, *Star Acting* (1977) seems allusive, hyperbolic and camp. This book contains many ideas that are worthy of academic consideration, particularly in terms of his interest in the dialectics of revelation and ambiguity, verisimilitude and abstraction, which provide a very useful starting point to a consideration of how stars act and how their performances are distinguished from those of other types of screen performer. Like Morin, he notes the celestial and religious vocabulary used to discuss film stars and also considers the role of fans in creating and sustaining stars.

The reverential and celestial vocabulary has been consecrated by decades of usage and press agency. The clichés' first connotations effectively separate

public from performer by an expanse of astral geography. The gods reign on high, the stars blink in the solar systems light-years away, and we mere mortals, worshipping at their shrines in blissful ignorance, celebrate the distance. (Affron 1977: 2)

Affron uses hyperbole here to convey the extraordinary emotions of being under a star's spell, while simultaneously mocking and caricaturing the extremes of this situation in recognition of the fact that much of this is stimulated by publicists on behalf of a huge and powerful industry. When he writes that we 'mortals are left clutching our wonder, and victims of that very wonder, overwhelmed by our enthusiasm and blinded by the light of the star's emanation', he evokes the various familiar, even hackneyed, tropes of melodrama (i.e., clutching, victims, overwhelmed, blinded), thereby creating some critical distance for himself as a scholar by using an obviously hyperbolic discourse (ibid.: 3). This is academic writing that is playful and daring but also, perhaps, rather fearful of attempting to make serious intellectual claims for film stars given that they could have been considered trivial within the context of academia in the late 1970s. Not surprisingly, therefore, Affron strays into camp, a discourse designed to take the trivial seriously, while rendering the serious trivial: for instance, when he writes that, films 'are breathtakingly perched between the unequivocal reality of the photographic process and a style that is by definition magnifying, hyperbolic, and utterly frivolous in its relationship to everyday modes of perception' (ibid.). It is camp that makes film's provisional occupation of a space between reality and style *breathtaking*, just as it is camp that makes film's relationship to everyday reality *utterly* frivolous.

The use of camp was both a radical and dangerous strategy in the 1970s, having the potential to invalidate scholarship, rob it of credibility, objectivity and authority. Imagine the reactions of scholars reading the following in 1977:

Coated with layers of makeup that obliterate blemish and dissymmetry, modelled by a miraculous array of lights, located and relocated by the giddy succession of frames, the stars capriciously play with life and subject it to a range of fictions from preposterous to profound. (Ibid.: 2)

How preposterous would scholars have found Affron's elegant description of the allure of such classic Hollywood stars as Garbo and Dietrich, with his '*giddy* succession of frames' and his 'capriciously' playful stars, particularly those most concerned with enhancing film's reputation as a serious, intellectually demanding academic discipline within the humanities? It is perhaps only since film studies established itself as an academic subject more solidly in the 1980s that the merits of such writing can be appreciated. It is perhaps only in the wake of the influence of queer theory in media and cultural studies that Affron's work can be taken seriously. It would seem to be much easier now to appreciate and acknowledge the value of his detailed analyses (even his ecstatic appreciations) of the film performances of such Hollywood stars as Lillian Gish, Greta Garbo and Bette Davis, which fill the pages of *Star Acting*.

Francesco Alberoni's essay 'The Powerless Elite: Theory and Sociological Research on the Phenomenon of Stars' has never needed any apology or justification on the grounds of academic integrity.[7] This was one of the first major sociological studies of stardom, written in a very different tone to the aforementioned works of Morin and Affron, and it had a profound influence on Richard Dyer's work on stars as well as on many other scholars of stardom and celebrity (e.g., P. David Marshall). Here Alberoni argued that stardom was a phenomenon directly linked to the development of large-scale industrial and urbanised societies, particularly in the early stages of nationhood, in order to fulfil various functions within the socio-political configuration of society: most notably, to distract public scrutiny away from the power elite (e.g., government ministers, aristocracy, monarchy, religious leaders and business

tycoons, etc.), as a focus for public debates about morality, as objects of identification and as symbols of social mobility. Within this configuration, stars represent an elite group in society that has no real power over the public but nevertheless enjoys unprecedented attention, wealth and freedom: in other words, exerting minimal social influence but generating maximum social interest.

Drawing upon Max Weber's work on charisma in his book *Economy and Society* (1968), Alberoni perceived of stars as those 'members of the community whom *all* can evaluate, love or criticize' (Alberoni 1972: 85, emphasis in original). As such, they are subjected to high levels of public scrutiny, operating as objects of gossip and scandal. In other words, they are continually evaluated. Evaluation takes a variety of forms but, most notably, in terms of the deviance or moral value of their character and behaviour in comparison to social norms. Alberoni notes that the conduct of stars is rarely judged in relation to general social norms but rather according to the perceived norms of the elite group or community. This necessarily entails the existence and maintenance of a gap between the society at large and the elite, divorcing their world (one of privilege) from that of the everyday, a world in which stars are placed by the will of the public. Their retention within the elite group requires careful management (just as the politician's does), so that the 'whole life of stars is thus astutely orchestrated and arranged', stars remaining under public scrutiny, being constantly evaluated and re-evaluated in order to ensure their place within the (powerless) elite, as representatives of a wider community (ibid.: 96). As part of this process, stars 'become an object of identification or a projection of the needs of the mass of the population' (ibid.: 92). Consequently, in his relatively short essay, Alberoni lay down many of the foundations of star theory, upon which Dyer and others would construct more detailed and elaborate theories of stardom and histories of the star system: namely, the nature of star power (and autonomy), media scrutiny of stars (i.e., the role of publicity), the exposure and control of scandal and gossip,

stars as symbols of morality (involving ideological contradictions being negotiated and resolved), the role of the audience in an individual's attainment and retention of star status, the relations between stars and fans (including the role of identification), and the significance of charisma. Each of these would resonate throughout Dyer's *Stars* and, subsequently, throughout star studies as it developed during the 1980s.

Dyer's *Stars*

While Richard Dyer's *Stars* was in part a survey of what had been done in the study of stars by 1978, it also broke new ground in providing a methodology for studying stars through a combination of semiotics and sociology, and by introducing three key concepts: (i) stars as 'images', (ii) star images having 'structured polysemy' that enable multiple interpretations (i.e., offering numerous meanings and pleasures) and (iii) stars as embodiments of ideological contradiction, through which social conflicts and crises are negotiated and resolved at a symbolic level. In terms of methodology, the book advocated the analysis of extra-filmic materials (e.g., press articles, previews, promotional materials and publicity) as a key part of film scholarship in addition to textual analysis of film sequences. The main task here was not to determine the correct meaning of stars but rather to expose the variety of meanings that a star has for different types of audience, different in terms of race, class, gender, etc. Understanding textual analysis to be grounded in ideology, Dyer first set out the social, institutional and economic conditions of stardom, while noting that the importance of stars goes beyond their industrial function. Dyer insisted that, since stars have wider cultural significance, film scholars need to explore the relationships between stars and audiences, including various aspects of identification (Dyer 1979: 17).

At the heart of this book is the way that stars represent models of human subjectivity and social types (i.e., operating as stereotypes), combining both ordinary (or typical) and extraordinary qualities. Dyer identifies this as one of the major contradictions of stardom, the paradox of stars being special but also like people in real life. The other major paradox lies in the way that stars are taken to be representative of social groups (racial, ethnic, national, regional, sexual, etc.), while being regarded as unique individuals (different from everyone else, more talented or beautiful, etc.). Consequently, the 'star both fulfils/incarnates the type and, by virtue of her/his idiosyncrasies, individuates it' (ibid.: 47). Much of Dyer's work involves exploring the nature, functions and ambiguities (i.e., the instabilities) of star images. The notion of the 'star image' is central to his study. He writes, for instance, that, a 'star image is made out of media texts that can be grouped together as promotion, publicity, films and criticisms and commentaries' (ibid.: 60). He also makes a clear distinction between publicity and promotion, noting the way in which publicity goes beyond studio-produced material to include press and broadcast interviews, gossip columns and magazine articles, their value being that they appear to grant audiences privileged access to information about stars and, consequently, lending these some degree of authenticity that promotional materials (e.g., posters, trailers and advertisements) otherwise lack (ibid.: 61). In so doing, Dyer promoted the analysis of publicity and promotional material as one of the principal means of understanding a star's image. This revealed that textual analysis of film sequences alone was insufficient to fully comprehend the meanings and values of stardom. After *Stars*, the analysis of critical commentaries and reviews became a significant feature of film studies, with many scholars exploring the newspaper and magazine holdings of libraries and archives around the world, making increasing use of these for understanding what films have meant for audiences, often different kinds of audience in different locations and historical periods (Staiger 1992).

During the 1970s, detailed and highly elaborated scrutiny of film sequences (often in combination with highly elaborated and sophisticated theorising) had become a distinguishing feature of the discipline. Dyer's advocacy of a more systematic examination of publicity and promotional matter in addition to film analysis represented one of several challenges to orthodox film studies at the time. Another challenge that Dyer posed was in regard to authorship (or auteur theory) by undermining the authority of the director as the main controlling force of a film, suggesting that (certainly in the case of star vehicles) actors were often the main determinants of narrative, iconography and style (Dyer 1979: 62). He also challenged some long-held assumptions regarding stars and actors as inert matter to be controlled by directors and editors. In a section on montage and *mise en scène*, for instance, he noted that, 'an important tradition in film theory has tended to deny that performance has any expressive value: what you read into the performer, you read in by virtue of signs other than performance signs' (ibid.).

Dyer's chief concern, however, is not how actors act but how audiences interpret an actor's performance, suggesting that elaborated notation systems for performance (e.g., Laban) may be useful for describing movements and gestures but have little value in terms of interpretation of a particular performance (i.e., for what it means for audiences) arguing that, 'any attempt to analyse performance runs up against the extreme complexity and ambiguity of performance signs' (ibid.: 133). Nevertheless, Dyer outlines these performance signs (including facial expression, voice, gesture, posture, movement, etc.) with some precision (ibid.: 134–6). Of particular significance for Dyer was the fundamental ambiguity performance plays in the relationship between star and audience, arguing that this 'ambiguity needs to be understood in terms of the relation between the performer and the audience in the film', noting that interpretation requires a general knowledge of such things as 'intonation, gesture, eye dilations', which invariably is culturally and

historically specific (ibid.: 134). Furthermore, the specific vocabularies of movement and gesture are also determined by generic conventions as well as the context in which they appear in individual films, being part of a larger system of meaning operating throughout the film's *mise en scène* (ibid.: 136). They are also part of long and established acting traditions, Hollywood acting being influenced by a conflicting set of performance methods drawn from vaudeville and music hall, stage melodrama, radio, repertory theatre and Broadway, in addition to the 'Method' (ibid.: 140). As part of his discussion of acting, Dyer noted that what often distinguishes stars from other actors is their idiosyncratic style of performance. He writes that, 'a star will have a particular performance style that through its familiarity will inform the performance s/he gives in any particular film' (ibid.: 142). Consequently, he insists that a major part of 'the business of studying stars is to establish what these recurrent features of performance are and what they signify in terms of the star's image' (ibid.: 143).

Star studies after *Stars*

Richard Dyer's contribution to star studies cannot be over-estimated. His works have inspired successive generations of film, media and cultural studies scholars. In 2010, in the introduction to *Chinese Film Stars*, the editors note that 'many of the contributors to this volume refer to Dyer's scholarship', the book's title having been chosen as a tribute to his 'seminal work in the field' (Farquhar and Zhang 2010: 3). However, while 'Dyerian' studies of stars have proliferated between 1979 and the time of writing, two alternative approaches have also emerged: the first involving a more in-depth investigation into the part played by audiences in terms of how they engage with stars and the second in terms of a more detailed examination of stardom as an industrial process. Both approaches are represented in

one of the first star studies anthologies, Christine Gledhill's *Stardom: Industry of Desire* (1991a), which both synthesised and put into a dynamic relationship different academic approaches to stardom. In so doing, this eclectic collection sought to promote the diversity of film scholarship on stars in an inclusive and open-minded framework.

Stardom was published after an impasse in film scholarship created largely by a rift between two major factions – what Gledhill refers to as the proponents of 'cine-psychoanalysis', on the one hand, and more cultural studies-based scholars, on the other. These factions had emerged partly as a response to Laura Mulvey's highly influential essay 'Visual Pleasure and Narrative Cinema' (1975), which had set out to reveal the extent to which patriarchal ideologies of sexual difference pervaded mainstream narrative cinema at the level of film style as well as content. In a compelling argument, she exposed the extent to which male characters typically assume more dominant narrative roles than females in Hollywood films, with male stars ordinarily positioned as subjects of a controlling gaze that simultaneously objectified their female co-stars. While female stars tend to be fragmented, frozen and fetishised as images, male stars are more often granted subjectivity and point of view, inviting the spectator's identification.

Utilising psychoanalytic concepts, Mulvey elaborated her thesis by distinguishing between two kinds of 'scopophilia' (visual pleasure): *fetishism*, involving the female body being transformed into a fetish, producing pleasure by denying the unconscious threat (i.e., castration) posed by her body with a display of excessive spectacle and costume; and *voyeurism*, providing a more sadistic form of pleasure by punishing the woman at the level of the narrative. In this account of the visual pleasures of mainstream narrative cinema, female spectators were forced to occupy masculine positions by identifying with male protagonists and sharing the male gaze (thereby denying a female gaze), while male stars were deemed

unable (or, at least, unlikely) to bear objectification by an erotic look. Hollywood, with its system of continuity editing (i.e., shot/reverse-shot, eye-line matches, etc.), was condemned as intrinsically sexist, with avant-garde (or non-narrative) cinema representing the only viable alternative. The very pleasures of Hollywood cinema that had drawn so many people to film studies as an alternative to studying literature or fine art were now rendered abject, provoking many counter-arguments designed to salvage mainstream movies and the pleasures of popular cinemagoing. Not surprisingly, a wealth of such counter-arguments emerged in film journals and books over the next decades, along with a series of counter-counter-arguments, both from within feminist film theory and elsewhere, culminating in the critical impasse noted by Christine Gledhill in her introduction to *Stardom*.

Partly in response to the impasse in film theory, from the mid-1980s film scholarship veered increasingly towards history, culminating in the early 90s with the publication of Janet Staiger's *Interpreting Films: Studies in the Historical Reception of American Cinema* (1992) and Jackie Stacey's *Star Gazing* (1994), which set out different ways for film scholars to investigate the historical and culturally rooted meanings of films, providing alternative methodologies for investigating film spectatorship than earlier theoretical (particularly, psychoanalytic) approaches. The call for a return to a more historical engagement with cinema led to the emergence of what became known as the 'New Film History', constituted in part by studies that qualified and challenged theoretical supposition with arguments supported by historical evidence, documentation and testimony. As the editors of *The New Film History: Sources, Methods, Approaches* have noted, what also distinguished this branch of film history was 'an understanding that films are cultural artefacts with their own formal properties and aesthetics, including visual style and aural qualities' (Chapman, Glancy and Harper 2007: 6). James Chapman, Mark Glancy and

Sue Harper have observed that contemporary film historians are required to understand the complex processes of filmic systems and the way that meaning is generated via editing, the various aspects of *mise en scène* (including performance), narrative and narration, sound and cinematography. In their introduction, they note that the conception of 'authorship' (one of four sections of the book) has been extended to account for the influential contributions of numerous personnel, including writers, art directors and stars as well as directors (ibid.). In fact, one of the defining features of this field, they claim, is the recognition of the role of stars as one of the main determinants of mainstream commercial narrative film, recognising also that star vehicles have been one of Hollywood's principal means of organising production.

During the late 1980s and early 90s, film studies was criss-crossed by numerous dividing lines. While film theorists took up either psychoanalytic or non-psychoanalytic positions, film historians were divided (among other things) between adopting the methods of reception studies or ethnography. Star studies was just one of many areas in which such divisions emerged and in which these positions were both negotiated and contested. Christine Gledhill's *Stardom* was published not only during this period but as a response to this situation, the editor drawing together theoretical and historical works that were variously informed by sociological, semiological and psychoanalytic approaches. Several of the essays had originally appeared in the journal *Wide Angle*, which was at the forefront of disseminating historical studies that both incorporated theory and revised existing historical accounts of various aspects of the film industry and film culture. Consequently, many of the essays included in *Stardom* question previous historical research in order to revisit and rethink some key areas of film history closely related to stardom.

The collection begins with historical accounts of the origins of the star system in American cinema, correcting some of the popular misconceptions that had arisen in orthodox film histories. Janet

Staiger's essay 'Seeing Stars' (previously published in the journal *The Velvet Light Trap* in 1983) refuted the established notion that the star system in American cinema was originated by Carl Laemmle, the head of the Independent Motion Picture Company (IMP), in 1910 when he poached actress Florence Lawrence (previously known as the 'Biograph Girl') from the Biograph Company. The story, which involves the announcement of the actress's tragic death in the press being refuted the following day and the declaration that she would soon be appearing in a series of IMP films, had been repeated in several major histories of Hollywood, with Florence Lawrence being identified the first film star (see Cook 1990: 41–2). Staiger, however, reveals that the Edison Company had begun promoting its stock company of players as early as 1909, borrowing various strategies of promotion from the American stage. She also claims that, in 1911, the Edison Company became one of the first American studios to credit its cast within its films and to provide exhibitors with slides advertising their players to be projected in between reels. This history was taken up by Richard deCordova in his essay 'The Emergence of the Star System in America' in the journal *Wide Angle* in 1985, which he developed into his book *Picture Personalities* in 1990. In an abridged version of this essay in *Stardom*, deCordova outlines key developments in the forms of information and knowledge circulating in the USA about film actors from 1907 to 1914, arguing that this was a critical period of transformation in which the star system came into fruition. DeCordova notes how the production and distribution of discourses about film performers involved three distinct types of knowledge, starting with discourses on acting from 1907, to the establishment of 'picture personalities'(actors known for their screen roles), culminating in the formation of star discourses (actors known for their personal lives as well as their screen roles) in 1914 (deCordova 1991: 17–24).

While discussion of acting features widely throughout *Stardom*, the book also makes it clear that there is far more to the work of stars

than the performances they give before the movie cameras. Promotional work, publicity and product endorsements and fashion modelling are all significant functions fulfilled by Hollywood's big names. This is clearly demonstrated in two influential essays included here: Charles Eckert's 'The Carole Lombard in Macy's Window' and Herzog and Gaines's '"Puffed Sleeves Before Tea-Time": Joan Crawford, Adrian and Women Audiences'. The combination of these two essays, moreover, is indicative of the book's revisionist approach to film history, with many of the claims made in the former (originally published in 1978) being challenged in the latter (originally published in 1985 with an 'afterword' added in 1991).

Charles Eckert's essay explored Hollywood's relationship with radio networks and with America's consumer culture of the 1930s, involving tie-ups with fashion and cosmetics manufacturers, as well as producers of drinks, electrical goods and automobiles. Eckert notes that during the mid- to late 1930s all of the major Hollywood studios adopted such practices to secure additional income streams, resulting in a large proportion of films aimed at women (as the principal consumers). While demonstrating the efficiency and entrepreneurialism of the Hollywood studios, Eckert also suggested that American women were more or less duped into buying consumer goods. It is this assumption that is interrogated and challenged by Charlotte Herzog and Jane Gaines in their essay. Assessing the impact of fashion promotion through films and film magazines, they found that claims that half a million copies of a fashionable dress worn by Joan Crawford in the film *Letty Lynton* (Clarence Brown, 1932) were sold were a myth, noting that 'Hollywood designers and fashion historians ... have continually cited the "Letty Lynton" dress as the most dramatic evidence of motion picture "influence" on fashion behaviour' (Herzog and Gaines 1991: 74).

In keeping with other developments within feminist film scholarship, Herzog and Gaines reconsider 'influence' in terms of

cultural production and women's subcultural response. Posing a series of questions about how female fans responded to 1930s female film stars, they ask whether star imitation was truly an indication that young women believed the message promoted by many Hollywood films that clothes could change their circumstances (ibid.). After a detailed consideration of the work of designer Gilbert Adrian (known simply as Adrian) for MGM, particularly his designs for Joan Crawford, the authors focus their attention on the fashion publicity produced to accompany such films as *Letty Lynton*, examining the way they address women. They conclude that while there is no evidence to prove that tens of millions of American women were seduced into buying ready-to-wear versions of Hollywood fashions during the 1930s, fashion 'worked to elicit women's participation in star and screen myth-making' and, while some women 'bought star products and tested star beauty recipes', many improvised with their own home-produced versions (ibid.: 87). This links directly to Jackie Stacey's project on British women's memories of Hollywood female stars of the 1940s and 50s, set out originally in her essay 'Feminine Fascinations: Forms of Identification in Star–Audience Relations' (1991) in *Stardom* and developed further in her book *Star Gazing* (1994). To both build on and depart from the work of Laura Mulvey on spectatorship and Richard Dyer on stars, Stacey examined the roles played by fashion and beauty products (i.e., those endorsed by stars) in the formation of the relationships between female fans and Hollywood stars, with the audience as the primary focus, their written testimony being analysed as much as the images of the stars.

Following the example of Richard Dyer, who had placed advertisements in the gay press requesting information about gay men's attachment to Judy Garland for his book *Heavenly Bodies*, Stacey advertised in two leading British women's weekly magazines, *Woman's Realm* and *Woman's Weekly*, to find readers willing to write about their favourite stars of the 1940s and 50s. This resulted in 350 letters and a further 238 completed questionnaires, enabling her

to examine the letters and questionnaires of white British women over the age of sixty, accepting that these are 'retrospective reconstructions of a past in the light of the present' and, as such, needing to be treated as narrative 'texts' rather than accurate and authentic accounts (Stacey 1994: 63). These revealed very different forms of cinematic identification from those associated with psychoanalytic feminist film theory, enabling Stacey to identify and distinguish between identificatory *fantasies* (e.g., worshipping) and *practices* (e.g., copying). Discussing extra-cinematic identificatory practices (i.e., pretending, resembling, imitating and copying), she identifies copying as the most common form, describing how female fans attempted to close the gap between themselves and the stars by transforming their appearance in order to look more like their favourite star (Stacey 1991: 155). She notes how her respondents' accounts revealed that stars were identified and remembered in relation to particular commodities: clothes, brands of soap and cosmetics.

Unlike earlier studies of Hollywood consumption and merchandising that had concentrated on production (most notably, Eckert's), Stacey's approach concentrated on consumption as consumer practice, on how and why women bought and used 'tie-in' products. Where previous accounts presented women as passive consumers of merchandise, they emerged in Stacey's work as more empowered and discerning. In this way, Stacey extended and revised the debate on consumerism and commodification, while simultaneously advancing the debate on identification and desire in audience–star relations, situating star studies at the crossroads of two important areas of film scholarship, consumerism and spectatorship. She also examined stardom within a specific national and historical context (wartime and postwar Britain), her study making an important contribution to studies of British Cinema, while establishing the importance of star studies for investigations into national cinema cultures. Stacey's work on stardom was one of the

first major attempts to use ethnographic methods as the basis of a star study and also one of the first to confine itself to a narrowly defined cultural, historical and theoretical framework. Out of this emerged some valuable work on memory and nostalgia, escapism, identification and desire, consumption and consumerism, knowledge and taste, as well the nature of fandom. [8]

While Stacey was instrumental in shifting the emphasis from star texts to the practices of audiences in stardom, others have steered star studies towards a more detailed understanding of the role of stars as workers within industrialised systems of film production, distribution and exhibition: most notably, Barry King, Danae Clark, Jane Gaines and Paul McDonald. Since the mid-1980s, Barry King has played a major role in terms of reconceptualising and providing a vocabulary for describing what stars do as actors and as workers within the changing economies of mainstream cinema. After receiving his PhD in 1984 from the University of London for his thesis on 'The Hollywood Star System: The Impact of an Occupational Ideology on Popular Hero-worship', King published his research in two articles: 'Articulating Stardom' in *Screen* in 1985 (later abridged and reprinted in *Stardom* in 1991) and 'Stardom as an Occupation' in Paul Kerr's *The Hollywood Film Industry* in 1986. Here, King made a distinction between two kinds of film acting, *impersonation* and *personification*, which result directly from three distinct economies: 'the cultural economy of the human body as a sign; the economy of signification in film; and the economy of the labour market for actors' (King 1991: 167). For King, the economics of acting lie principally with exclusivity: namely, actors with more exclusive attributes and skills (that their colleagues cannot replicate) are able to command higher salaries. The economies of film, moreover, are very different to those of the stage, where highly trained and gifted actors acquire the means – which King designates 'impersonation' – to subsume their own identities when performing characters, displaying versatility in the way they can convincingly

perform a wide range of character types. He notes that the tendency in cinema is to abandon impersonation in favour of 'personification' so that the actor's public identity is not subsumed within their character but rather remains on display, with the character overshadowed by their star persona.

Later, in his essay 'Embodying the Elastic Self: The Parametrics of Contemporary Stardom' (2003), King replaced the terms 'impersonation' and 'personification' with those of 'metaphorical' and 'metonymic' servitude, stating that, metaphorical servitude 'is the domain of the leading character actor who subordinates person as far as possible (technically and genetically) to the purposes of narrative, becoming a narrative function', while metonymic servitude involves greater similarity between the star's persona and the characters they play in their films (King 2003: 48). King notes that the metonymic servitude of stars results in them being narrative 'guests' within their films, their meaning (agency or character) lying outside the diegetic world of the film so that they can be read by audiences in terms of star persona rather than narrative character. He argues that while the stars of the studio era 'undertook metonymic servitude', appearing to be coherent and stable in their personae, contemporary stars 'are discursively challenged in their efforts to meld all the practices undertaken in their name into a coherent commercial identity' (ibid.: 49). Star's identities are now manufactured and maintained by a series of specialists who undertake responsibility for various and distinct aspects of their public profile. As a result, stars tend to work with what King calls a 'wardrobe of identities' (ibid).

Another critical shift in King's conception of stars (and a shift from studio-era stars to post-studio-era stars) occurs due to the fact that stars are now no longer employees of the studios but rather 'stakeholders in the enterprise that manages their career' (ibid.). He notes that the star as entrepreneur must be ready 'to switch roles as business opportunities arise', particularly in a global market that has

given rise to the constant rewriting of star personae as former identities are maintained in some roles and films (especially high-profile, very lucrative and long-running film franchises, serials or series) alongside newly invented ones (ibid.). King names this phase of stardom 'autographic' (i.e., self-writing). Thus, stars are no longer there to be read by audiences differently (i.e., as polysemic, as Dyer and others have described), but rather they produce themselves differently in order to be read in different ways, therefore playing a much more fundamental role in the process of interpretation than studio-era stars. Again this is linked to the basic economic fact that stars are no longer simply workers but entrepreneurs (that is, worker-managers). Operating in a fragmented, highly competitive, intensely scrutinised, highly commodified global market, the new generation of successful entrepreneurial stars are forced to manage their personae by 'stretching an apparent core of personal qualities to cover all contingencies' (ibid.: 60). King notes that, as a result, 'persona is elastic rather than plastic, closer to a procedure for surviving, a heuristic self, than an essence' (ibid.).

King's work breaks with Richard Dyer's notion of star texts, using Marxist economic theory combined with historical research, augmenting a branch of star studies that includes the work of Danae Clark and Paul McDonald. Of these three scholars, McDonald has retained the strongest connections to Dyer's work, particularly with his supplementary essay to the new edition of *Stars* published in 1998. In 'Reconceptualising Stardom', McDonald noted four main areas in which star studies had developed since 1979: namely, (i) stars and history; (ii) star bodies and performance; (iii) stars and audiences; and (iv) stardom as labour. Of these four areas, it is the latter that comes closest to McDonald's own interests and approach to stardom, enabling him to build on the work of Barry King, Danae Clark, Jane Gaines, Robert S. Sennett and Richard deCordova, among others. In so doing, McDonald has moved away from the interpretation of star images per se towards an investigation into the

institutional practices of stardom in terms of production, distribution and exhibition, of ownership and regulation, exploring what stars do and how they are used, not just by audiences but also by studios, agents, managers and publicists. 'To appreciate the social activity of stardom,' he writes, 'a pragmatics of star practices is needed to accompany a semiotics of star meanings' (McDonald 1998: 200).

McDonald, in his book *The Star System,* provides a coherent overview of developments in Hollywood stardom as an industry throughout the twentieth century. He argues here that understanding how stars operate in the context of production 'requires not only looking at the image ... but also the image as a source of economic value' (McDonald 2000: 118). This involves consideration of various factors: (i) the connections between the star systems of the American theatre (including vaudeville) and film; (ii) how in the studio era new stars were systematically developed or manufactured; (iii) how the break-up of the studio system from the 1950s impacted on the operations and effectiveness of the star system; (iv) how stars operate in the freelance labour market of post-studio Hollywood; (v) the role of agents; (vi) the nature of contractual arrangements between stars and production companies or studios; (vii) the function of stars not just as elite actors but also as producers and executive producers; (viii) the nature and function of licensing agreements concerning star images and merchandising; and, finally, (ix) the role of the internet in reshaping the nature and control of star images, as well as the relationships between stars and their audience (ibid.: 119). Observing that all the factors that were necessary for the development of the star system in America were in place by 1913, McDonald notes that during the 1930s and 40s the star system operated in virtually the same way at all five of the major studios: Paramount, Warner Bros., the Fox Film Corporation (20th Century-Fox after 1935), Radio Keith-Orpheum (RKO) and Metro Goldwyn Mayer (MGM), until a US Supreme Court ruling in 1948 forced these companies to divorce their theatre circuits from their

production and distribution operations. While covering the whole of this period, McDonald's book concentrates largely on the breakdown of the studio system, describing how the studios and the major stars adjusted when the American film industry adopted the 'package-unit' mode of production: the package ordinarily including a producer, a director, a writer and a star or group of stars, usually brought together by an agent.

McDonald has also explored the role of agents in his essay, 'The Star System: The Production of Hollywood Stardom in the Post-Studio Era' (2008). Here he examines the role talent agencies play in contemporary Hollywood alongside personal managers, publicists and legal representatives, noting that despite the shift of power from the studios to these mediating companies in the 1990s some things have remained unchanged: for instance, that a 'small cluster of companies … make, manage, and control the capital of stardom in Hollywood cinema' (McDonald 2008: 180). This begs the question of who does the choosing, selecting those relatively few leading film performers that become candidates for stardom. It also raises the issue of who gets chosen and why, questions that will continually resurface throughout the following chapters of this book.

Conclusion

Since the 1970s, star studies has become an important branch of film studies precisely because of its capacity to reinvent itself and embrace new areas of investigation and methodology. Over the years, scholars have utilised a wide range of methods to investigate numerous areas of stardom, national star systems and the work (i.e., films and images) of stars from different countries and different historical periods. In so doing, scholars have combined various methodologies in order to produce meaningful and comprehensive studies, involving analysis of films and extra-filmic materials (e.g., publicity and

promotion), fan discourse and audience surveys, interviewing film industry personnel from a wide range of fields of activity (e.g., production, marketing, merchandising and publicity), as well as filmgoers. Much more work remains to be done in terms of liaising with industry specialists, particularly in terms of agencies, management companies and legal firms, from many parts of the world, including Bollywood and China, in order to fill the gaps that still remain. This suggests that the future of star studies promises to be as rich as its history.

2 METHODS: WAYS OF ANALYSING SCREEN PERFORMANCE

Introduction

Many film actors become stars following a 'breakthrough' role in which their performance attracts the attention of film critics, receives rave reviews and is subsequently nominated for a major film award. On the back of this, they often gain a higher public profile, attain star status (with leading roles, top billing and star vehicles) and sometimes acquire a recognisable and distinctive (often imitable) signature style: that is, an idiosyncratic set of gestures movements, poses and expressions that become a major part of their trademark. Even though this is not the only route to film stardom, it is the classic one. Consequently, many stars, agents and managers take acting seriously. Stars go to considerable lengths to extend and improve their acting skills, while their publicists ensure that attention is drawn to their achievements. Critics and journalists pay close attention to star performances, charting their highs and lows, comparing one performance with another, either from an earlier film or by another actor in the same film. Film performances are scrutinised, interpreted and evaluated, repeatedly and in detail, by different kinds of people from all over the world: audiences, fans, buffs, newspapers critics, industry analysts and trade journalists, magazine feature writers, interviewers, gossip columnists, internet bloggers, celebrity reporters, film scholars and media students.

It is, therefore, not surprising that acting has been a major feature of star studies, being the central concern of books such as Charles Affron's *Star Acting* (1977) and Karen Hollinger's *The Actress* (2006) or occupying significant sections of Richard Dyer's *Stars* (1979) and Richard deCordova's *Picture Personalities* (1990). Peter Krämer's chapter 'Bibliographical Notes' in *Screen Acting* (1999) provides a useful introduction to a wide range of academic work on acting, identifying various categories of literature in addition to studies of stardom and celebrity: such as, histories of acting, general studies of the craft and profession of the actor, of women in theatre, of silent film acting, studies of Constantin Stanislavski, of 'method' acting and other acting manuals, biographies and autobiographies of actors, published interviews with actors, as well as some studies of the Hollywood studio system and its workforce (Krämer 1999: 170). Despite repeated claims of critical neglect, it is clear that plenty of research on acting exists and has existed for some time, constituting a rich seam of scholarship and a vital resource for film scholars studying stars and stardom.[1]

This chapter explores some of the most significant ways in which screen performance has been understood within film studies, considering various approaches to the analysis of film acting that have emerged within different branches of the discipline: most notably, *mise en scène* criticism, performance theory and celebrity studies. This includes the value and limitations of close textual readings, exploring the ways in which such things as script analysis can illuminate and enrich the analysis of film scenes and sequences. This chapter will also identify some of the prevalent terms and concepts used to distinguish between different modes, styles and degrees of performance. Recurrent questions arise here about the intervention and mediation of cinematic technology and technicians (e.g., coaches, choreographers, directors, editors, sound crew, etc.), which challenge to some extent notions of an actor's agency (i.e., as the author of their screen performance). On the other hand, a major

theme of this chapter is the distinctiveness of the star actor's performance style, their ability to develop a signature style made up of a repertoire of characteristic gestures, sounds, inflections, actions, expressions and movements, alongside the significance of an audience's recognition and appreciation of these (i.e., as a fundamental part of the pleasure of star acting). While the chapter seeks to demonstrate the rich diversity of ways in which screen performances are understood and analysed, it will also consider which of these methodologies offer the most effective and comprehensive means for exploring the nature and effects of star performance in film.

Analysing screen performance

Paul McDonald, in his essay 'Why Study Film Acting?' (2004), argues that analysis of film acting remains crucial to understanding the meaning and affective power of movies, stating that 'through attention to the micromeanings of the voice and body, it becomes possible to find in the very smallest of details the most significant of moments' (McDonald 2004: 40). For the purpose of this essay he adapts John O. Thompson's commutation test technique in order to compare the distinctive approaches and meanings of the actresses Janet Leigh and Anne Heche in the role of Marion Crane in *Psycho*, directed by Alfred Hitchcock in 1960 and Gus van Sant in 1998. In so doing, he is able to isolate the unique contribution of each actress to the same role, demonstrating the extent to which the poses, gestures and facial expressions of stars utilised by the directors as part of the film's *mise en scène* remain unique to each star. McDonald's use of the commutation test method here is different from that originally proposed by John O. Thompson in 1978. In his essay 'Screen Acting and the Commutation Test', Thompson used a semiotic technique to provide a more systematic analysis of screen

acting, a method that involves the hypothetical substitution of one actor (or an actor's trademark gesture) for another in order to consider how the meaning of a performance might change. So, for instance, this might involve the imaginary replacement of Bette Davis with Joan Crawford in the role of Margo Channing in Joseph L. Mankiewicz's *All About Eve* (1950) and a consideration of the consequences of this or, on the other hand, it might involve retaining Davis as Margo but swapping a feature, gesture or expression (e.g., her laugh) with that of Crawford. This technique not only enables scholars to isolate the distinctive methods and attributes of star actors, but also to expose the gap between actor and role (or character), enabling some judgment to be made about the extent to which a screen character or performance is indebted to the particular actor performing the role. As such, it is particularly appropriate for understanding star acting (see Baron and Carnicke 2008: 113–61).

Description forms the basis and starting point of much academic work on screen performance, many film scholars attending closely to the nuances of a star's acting. For instance, throughout *Film Performance* (2005), Andrew Klevan describes the intricate movements, expressions and gestures of film stars, scrutinising the performances of such stars as Charlie Chaplin, Laurel and Hardy, Cary Grant, Irene Dunne, Joan Bennett and Barbara Stanwyck. Emerging out of *mise en scène* criticism rather than star studies and influenced by the work Stanley Cavell and Victor Perkins, Klevan produced textual analysis of moments from films in painstaking detail. Setting great store by such analysis, he seeks to match with words the film-maker's precise and subtle use of images and sound, with a sharp eye and ear for detail as well as a sophisticated command of language in order to translate images and sounds into written prose. His goal here is to 'evoke the films and interpret them at the same time', revealing fresh aspects of well-known films by attending to gestures, postures, expressions that to most people might seem trivial, incidental or banal but here, through the use of

his prose, are reanimated and invested with meaning and pleasure (Klevan 2005: 104). His detailed descriptions of film moments illustrate the way in which actors are positioned in relation to each other and the camera to create an harmonious sense of coherence, Klevan remaining attentive to movement, gesture, framing and composition, lighting, costume and editing when describing how a sense of the organic unity is achieved by the various components of a film.

Klevan focuses at all times on the performance itself rather than on the performer, so that there is never any attempt to identify the uniqueness of an actor's approach to performance, what she or he brings to their role or how audiences might interpret their acting or characterisation according to previous roles or even the actor's persona (i.e., star image). For star scholars these are crucial questions and in a bid to address them many have turned for inspiration and guidance to James Naremore's *Acting in the Cinema* (1988), which has become one of the most influential studies of acting within film studies, providing many scholars with a framework and a vocabulary for analysing screen performance. Towards the end of this book, Naremore notes that the 'profoundly eclectic' nature of Hollywood acting has made the task of devising a typology of performance styles complicated (Naremore 1988: 273). Nevertheless, he does provide some useful terms and concepts that other scholars have subsequently adopted when undertaking analysis of film acting: most notably, ostensiveness and frames, representational and presentational performance. For instance, to distinguish between those performances that create a sense of the fictional character rather than the actual performer, Naremore used the term 'representational', while using 'presentational' to describe those in which the awareness of the performer's performance overshadows any sense of the character (ibid.: 28–30). Most of these terms and concepts are taken from Erving Goffman's *The Presentation of Self in Everyday Life* (1959), which explored the ways

in which people perform to greater or lesser extent in everyday situations, exploring the interrelations between theatre and life. Naremore observes, however, that theatrical performance invariably involves 'a degree of ostensiveness that marks it off from quotidian behavior', from how people act or behave in daily life (Naremore 1988: 17). This is a crucial point for Naremore, who maintains a distinction between performance for drama (stage or screen) and performing in real life, to which end he adopts Goffman's notion of 'frames' to designate the ways in which theatrical performers are demarcated in some way as being objects to be looked at (permitting observers to watch in an uninhibited fashion), their actions separated off as performances by drawing attention to their performative qualities.

Much of Naremore's study is devoted to 'tracing out varieties of ostentatious, actorly expertise', including the most minimal through slight and subtle gestures or looks, which nevertheless have a pronounced affect in determining the frame of the performance and inviting the audience's attention (ibid.: 27). Consequently, analysis of actors' stillness, restraint and posture (e.g., how they stand) takes on especial importance, Naremore observing that even the most natural-looking actors 'have learned to master both the performing space and every aspect of their physical presence' (ibid.: 49). In this, he notes, Hollywood cinema has gained from a variety of developments within nineteenth- and early twentieth-century European theatre, combining naturalism, psychological depth and interiority (e.g., Stanislavski's teaching) with older and more expressive styles of gestural performance (e.g., François Delsarte, Steele MacKaye and David Belasco) (ibid.: 53). Naremore cites several notable Hollywood actors of the studio era (e.g., Cary Grant and James Stewart) who might be 'described as a consummate modern practitioner of vaguely Delsartian technique' even when they tend to use personalised rather than standardised gestures, expressions and poses (ibid.: 63).

Cary Grant (centre) being Roger Thornhill in
North by Northwest (1959)

It is in the second part of his book ('Star Performances') that
Naremore provides some valuable insights into the nature of *star
acting*, raising questions about the relationship between stars, actors
and the characters they play and how all of these are understood by
audiences. For instance, he states that the 'performer, the character,
and the star are joined in a single, apparently intact, image, so that
many viewers regard people in movies as little more than spectacular
human beings' (ibid.: 157). In order to help conceptualise these
relationships more clearly, he distinguishes between three aspects of
characterisation: *role*, the fictional character; *actor*, the being
performing the character; and *star image*, an intertextual
phenomenon born out of the actor's previous roles, various filmic
properties and publicity (ibid.: 158). Naremore's account of Cary

Grant demonstrates how star image has tended to dominate over both actor and role in Hollywood, claiming that viewers tend to 'lose sight of Grant's craft because his image, like that of most of the major stars, overshadows the technique that helped to create it' (ibid.: 234). However, his analysis of Grant's performance in Alfred Hitchcock's *North by Northwest* (1959) reveals that, 'a vivid star personality is itself a theatrical construction', noting that 'it takes as much acting to play "Cary Grant," adjusting him slightly to meet the requirements of "Roger Thornhill," as it does to perform any other movie role' (ibid.). Naremore establishes Grant as a consummate artist with great technical control, noting how his background as an acrobat and vaudeville player influenced his acting method, particularly his timing and his ability to create small but effective actions with 'absolute clarity' (ibid.: 225). He also observes that even though his emotional range was limited, Grant proved to be an 'expert at crisp expressiveness and movement' (ibid.). Naremore's analysis of Grant's performance in *North by Northwest* therefore concentrates on the actor's technical expertise, as well as the interaction of his performance abilities and his star image in order to bring his character Roger Thornhill to life on the screen. Consequently, Cary Grant emerges from this book as one of the most accomplished star performers working in classical Hollywood cinema.

Philip Drake, in his essay 'Jim Carrey: The Cultural Politics of Dumbing Down', describes Naremore's *Acting in the Cinema* as a 'good starting point in any discussion of screen performance' and provides a succinct overview of Naremore's approach and terminology, clarifying his framework, noting how Naremore arrived at his conclusion that Hollywood films are, by and large, representational through a combination of indirect address and low degrees of ostensiveness, lending performances an everyday (quotidian) quality (Drake 2004: 74). However, while welcoming the precision of Naremore's terminology and the usefulness of his schema for comparing screen performances, Drake suggests that

greater emphasis might be placed on the work of audiences, noting that recognition of a favourite performer 'clearly increases the ostensiveness of their performance signs' (ibid.). Thus, it is not so much what the performer is doing that renders the performance highly ostensive (hence *presentational*) as much as the audience's recognition that what they are doing is what they always do. In a later essay, 'Reconceptualizing Screen Performance', Drake offers a more focused and theoretically elaborated approach to analysing star performances on film, describing the crucial role played by audiences in terms of how they 'bring their particular cultural capital, expectations, and memories of previous performances to the cinema, and ... are involved in a complex process of evaluation and ascribing cultural value to a particular performance' (Drake 2006: 85). Here Drake qualifies Naremore's claim that acting in narrative film is ordinarily representational (i.e., in character) and achieved through low levels of ostensiveness (showing or showing off) to create a quotidian (i.e., life-like) effect by observing that '*all* star performances must to an extent ... be already encoded ostensive signs' on the grounds that 'individual stars become associated with a repertoire of performance signs' (ibid.: 87, emphasis in original), what Drake refers to as an 'idiolect'. [2]

Star performances must always be recognizable as the products of stars, of individuals whose signifying function exceeds the diegesis (this is an economic imperative of stardom). It is by varying the ostensiveness of their performance, as well as external reframing signifiers (such as publicity and reviews) that they can manage this without disrupting the representational mode of the performance as a whole. (Ibid.: 93)

Consequently, many Hollywood stars manage to stay in character (hence, their performance remaining *representational*) despite being recognised as stars with their own idiosyncratic acting style by deploying an additional set of gestures and expressions that appear to

emanate from the character (their *role*). In order to explore this aspect of *star acting*, Drake uses Goffman's notion of 'involuntary expressive behaviour', which designates an act that suggests an automatic or spontaneous action or reaction. However premeditated, such actions convey spontaneity, along with the sense of some deeper (i.e., unconscious) impulse, conferring a sense of naturalistic authenticity, hence truth and sincerity. Drake notes that such behaviour is particularly associated with method actors, who use involuntary expressive behaviour as a means of disclosing information about their characters indirectly: for instance, through a telling but apparently secondary gesture, a gesture that seems both minor (almost incidental or accidental) and unmotivated in any obvious way. He describes the indirectness associated with such unmotivated gestures as 'expressive coherence', noting that their low-level ostensiveness suggests to an audience that their significance is psychological. In an analysis of Marlon Brando's performance in *The Godfather* (Francis Ford Coppola, 1972), Drake uses Goffman's concept of 'disclosive compensation' to account for the use of (apparently) unmotivated gestures by method actors in order to maintain the audience's interest in (and sense of) their character, demonstrating how this actor manages to be both Brando, the star, and Don Vito Corleone, the Mafia boss (Drake 2006: 92).

Philip Drake's work on screen performance has been taken up and extended by Lisa Bode in her essay 'No Longer Themselves? Framing Digitally Enabled Posthumous "Performance"' (2010), which investigates the digital 'repurposing' of star performances: that is, recycling film footage of deceased stars to create posthumous performances in films, such as Marlon Brando's in *Superman Returns* (Bryan Singer, 2006). Here Bode raises some pertinent questions about the status of acting when it is received by audiences in the full knowledge that it has been taken out of context (thereby removing any trace of intentionality) and heavily manipulated by film technicians. Bode's essay represents an intervention in the debate on acting in the

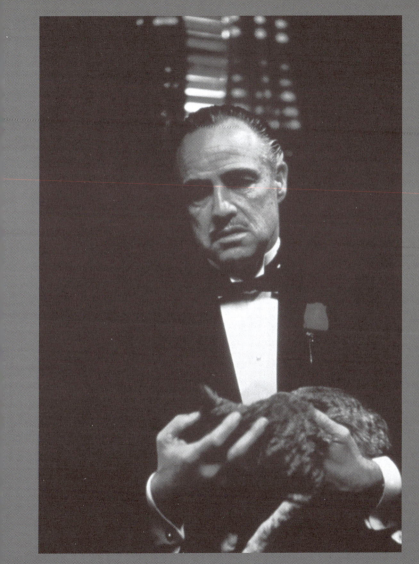

Being Brando, the star, and Don Vito Corleone,
the Mafia boss, in *The Godfather* (1972)

digital age, in which the widespread use of motion capture techniques, digital compositing and computer animation in mainstream commercial film-making has undermined the agency of actors, focusing attention on 'a mode of representing performers that appears to exemplify [this] kind of disintegrated technologized performance', what she calls 'digitally enabled posthumous "performance"', the inverted commas around the word 'performance' here signalling 'the level of generalized epistemological uncertainty' that they provoke (Bode 2010: 48).

Lisa Bode describes the various techniques involved in the production of digitally enabled posthumous 'performances' designed to generate new performances and meanings out of old material (e.g., digital compositing being used to paste a dead person's face onto a living body double), but also the way information about these processes is revealed to audiences via the internet and DVD extras, so that audiences are made aware of the level of construction involved. Noting Philip Drake's arguments about the importance of audience evaluation of screen performances (and the deployment of cultural capital as part of this), she suggests that the way films are received, read and evaluated needs to be recognised as part of an ever-changing process. In other words, the reception frameworks for evaluating screen performances change in response to technological innovations, among other things. She argues that a slow transformation has been taking place in terms of 'the ways we think about the gap between stars and their images, about what screen performance can be, and the extent to which performance can be read as collaborative and technology reliant' (ibid.: 69). As a result, she suggests that film scholars need to adjust their understanding of how audiences read film performances, imagining 'a screen performance continuum encompassing all the modes of technological mediation and augmentation of performance', ranging from more 'acting-centered performances' to 'more overtly technologically bound performances' (ibid.). Consequently, the

challenge for film scholars is to keep up with the audience's changing perceptions of film acting, as well as to develop a more systematic approach to analysing such different types of screen performance.

Bode's essay is one of a number of studies that have sought to more fully understand and take account of the diverse processes of producing film performances. For instance, Gianluca Sergi, in 'Actors and the Sound Gang', has considered not only how film actors use their voices but also how those voices are mediated by technology and contextualised by the soundtrack as a whole by sound personnel. Benefitting from interviews with leading Hollywood sound designers (e.g., Gary Rydstrom, Larry Blake and Randy Thom), Sergi reveals how a highly proficient team of sound specialists record and edit actors' voices, organising them into the soundtrack alongside music and sound effects. With deceptive simplicity, he writes that, film actors 'do not just speak, they are recorded', thereby acknowledging the extent to which the production of a voice on film necessarily involves a group of people with expertise in recording as well as the technology that makes recording possible (Sergi 1999: 126).

In order to explain the various processes involved in creating a cinematic voice, Sergi distinguishes between the factors under the control of actors and those beyond their control. In exploring the former, he notes the actor's desire to 'interpret' their lines of dialogue according to their unique skills and attributes (ibid.: 127). While the script presents actors with some clear constraints, they are still required to work out what kind of voice their character should use when speaking. This can involve actors making a choice between any number of possible variables, such as accent, pitch, rhythm, pace, volume, modulation, timbre, intonation, grain, resonance, of dry or moist mouth, of the positioning of teeth, tongue and lips, of the muscles around the lips and cheeks, of how much breath is used to energise the words, of what sighs, murmurs and other inarticulate or paralinguistic noises to punctuate the words of the script. Often this

will include some negotiation with what a co-actor is doing with their voice, an actor being required to either match or differentiate their voice from that of their colleague. None of this is straightforward, nor is it clearly set out in a script. This constitutes part of the work and the autonomy of an actor, although it ordinarily involves collaboration with fellow members of the cast and crew.

When it comes to the factors beyond an actor's control, these are many and various. As the film voice is in essence a recorded voice, it is necessarily a mediated one, chiefly by the microphone. Different microphones not only record different vocal properties but also their position while recording can produce many notable variations. A bad choice (either in terms of the type of mic or its position) on the part of a sound recordist at the time of the recording can lead to the actor having to dub the scene during post-production using Automatic Dialogue Replacement (ADR), recorded in a sound studio, an actor being required to recreate an earlier performance at a different time and in a different space so that it produces a perfect (i.e., undetectable) match to their image. It is after this process is complete that an actor's voice actually takes shape, this being the point when it is integrated into the final mix. Stressing the extent to which film acting is essentially a matter of relations (i.e., between actors and scripts, actors and other actors, actors and technology, actors and crew), Sergi concludes with the recognition of the complex set of mediations involved between actors and the medium in which they work (ibid.: 136).

Subsequently, Pamela Robertson Wojcik has taken issue with some of these arguments, stating that 'while Sergi's work is important for its emphasis on the way technology shapes performance, he still views acting as somehow distinct from technology, and the work of sound design as "mediation" that can influence how we perceive acting but distinct from the act of performance' (Wojcik 2006: 75). In her essay 'The Sound of Film Acting', Wojcik insists that 'film acting as such does not exist prior to

mediation' and that 'much of what Sergi considers to be factors within the actor's control – including pauses, volume, even pitch – can be and are modified through various aspects of recording and sound design' (ibid.: 75). Wojcik contends that while the voice may appear to be rooted in the body, the voice heard at the same time that the actor's body is seen on film is most often recorded separately from those images, either using ADR or MOS (i.e., recording without sound) or the sound comes from another take and is grafted onto the image during post-production (ibid.). One of the principal aims of this essay is to alert film scholars to the extent to which the voices on a film's soundtrack are recorded separately from the corresponding images. Wojcik suggests that 'the voice must never be considered as emanating in any simple way from its visual source' (ibid.). She argues that, 'rather than assume an integrated performance by the actor that is then manipulated, fragmented, or otherwise mediated, we need to consider actor labor as existing within, for, and through mediation', recasting 'film acting as a complex and layered process that often depends upon the separation and reintegration of sound and image' (ibid.).

Wojcik reminds us that, 'film performance occurs in multiple time segments – multiple and repeated moments of actors' performances in production, postproduction, and exhibition' (ibid.). While it is understandable that film-makers, actors and publicists should collude in the effacement of the highly fragmented and manipulated approach to the creation of an aesthetic experience, for Wojcik, the danger is that film scholars collude with this notion by suggesting a level of coherence between sound and image, voice and body that does not reflect the conditions of film-making (ibid.: 80). Without being privy to the editing logs for a film, however, it is virtually impossible to say with any degree of certainty whether the shots in the final version of a particular film sequence are accompanied by the actual dialogue that was recorded along with the images. Nevertheless, Wojcik cautions film scholars that when

discussing film acting they 'must find a way to account for the role of technology in performance', insisting that 'an analysis of film acting would have to account for the representation through careful description, without resorting to guesswork or assumptions about origin' (ibid.). This is much easier said than done, of course, particularly since, as Starr A. Marcello notes in her essay 'Performance Design: An Analysis of Film Acting and Sound Design', 'it is nearly impossible for the spectator to discern whether or not the dialogue track was recreated in ADR' (Marcello 2006: 66).[3] This is also true for film scholars who, unless able to interview members of the production team (e.g., the editor) or examine their editing logs, will inevitably struggle to work out which sounds were recorded with which images. Consequently, guesswork (or hypothesis) will necessarily remain a vital tool for film scholars in their bid to explore the meanings and production of screen performance.[4]

The studies of screen acting by Starr A. Marcello, Lisa Bode, Pamela Robertson Wojcik and Gianluca Sergi acknowledge the extent to which a star's performance in a film is heavily dependent upon both collaborators and technology, being highly mediated. Elsewhere, performance scholars insist upon actors' agency and authority (i.e., their ability to determine their performance). For example, the collection of essays compiled under the title *More Than a Method* (2004) by editors Cynthia Baron, Diane Carson and Frank Tomasulo reveal such an insistence. Baron, Carson and Tomasulo state in the introduction to this anthology that they are diametrically opposed to 'the long-standing perception that film technology and cinematic technique produce screen performances' (Baron, Carson and Tomasulo 2004: 11). The editors and their authors take the view that 'while film audiences encounter performances that have been modified by the work of directors, editors, cinematographers, makeup artists, music composers, and others, films nonetheless create meaning and emotional effects at least in part by the way they present performances' (ibid.). Also insisting that there is more than

one method to film performance, this anthology illustrates that there is more than one way of analysing film acting. The authors included here use a variety of methods and terms, although textual analysis remains a key feature of every chapter. This book, as the editors point out, 'offers no overriding argument that there is a single continuum that separates "artificial, codified, self-reflexive" acting from "natural, realistic, lifelike" performance', seeking instead to collapse these categories into each other by locating 'lifelike elements in the most self-reflexive performances', while teasing out the formalistic qualities of what passes for naturalism (ibid.: 6).

Much of the existing scholarship on acting in film studies acknowledges that mainstream commercial cinema is suffused with a tremendous variety of acting styles and traditions, a situation intensified in the twenty-first century, when film stars work across a wide range of media and compete for attention (and employment) alongside a host of other types of performer within the field of celebrity. Marcia Landy, in her essay 'Yesterday, Today, and Tomorrow: Tracking Italian Stardom', writes that the 'phenomenon of stardom today would seem to be in crisis, its future tentative' (Landy 2009: 243). Having examined stardom in the Italian film industry from the silent era to the early 2000s, she notes that modern film stars not only have to compete with the stars of television and other media but also computer animation, including dead stars that have been 'revivified through re-animation and manipulating images culled from their cinematic oeuvre', all of which provokes questions about the role of film stars in the age of digital reproduction (ibid.). In this age, she claims, stars such as Roberto Benigni operate largely as celebrities, working across a variety of media and undertaking various roles, including television presenter, writer and commentator, in addition to being the Academy award-winning actor of *La Vita é bella* (*Life is Beautiful*, 1997), in which he starred as well as directed and co-wrote the script (ibid.: 242). She concludes that his stardom can best be identified as a form of hyperactivity,

Hyperactive stardom: Roberto
Benigni with his Oscars for *La
Vita é bella* (*Life is Beautiful*)
(1997), which he co-wrote and
directed, as well as playing the
leading role

stating that 'his star image threatens to be destroyed through over-
exposure and over-stimulation' (ibid.: 243). Contemporary Italian
stars, however, are not alone in this, given that, as Paul McDonald
has observed, 'the production of Hollywood film stardom has
become part of the more general production of celebrity, and, rather
than a product of the film business, Hollywood stardom today is
created across a broad-based entertainment industry' (McDonald
2008: 180). Similarly, Mary Farquhar and Yingjin Zhang write that
the 'institution of stardom, in China as in the West, is now part of a
celebrity culture' (Farquhar and Zhang 2010: 13). Consequently,
virtually all studies of contemporary stardom need to reckon with the
wider context of celebrity and with the operations and uses of the
media in general (see Holmes 2005).

Performing as actors, stars and celebrities

Much of the scholarship on stars and stardom that has been developed within film studies has had a major influence on the development of celebrity studies as a distinct branch of cultural studies: most notably, Joshua Gamson's *Claims to Fame* (1994) and P. David Marshall's *Celebrity and Power* (1997). While the former combines the work of Francesco Alberoni, Richard Dyer and Barry King with ethnographic research on fan cultures and practices, the latter brings together film studies' research on stars with cultural studies and literary theory in order to more fully understand how film stars form part of an integrated system of celebrity in which entertainers (e.g., film, television and pop stars) operate in relation to politicians.[5] Within this account, film stars play a major role, representing the 'pinnacle of the celebrity hierarchy', appearing to be the most powerful, successful and independent individuals within the field of entertainment (Marshall 1997: 226). Furthermore, the 'distinctive quality of the film star is built on the control of knowledge about the star beyond the filmic text and, within the audience, a desire to know more' (ibid.: 228). While audiences have greater access to information about, and contact with, television celebrities and pop stars (i.e., through live chat shows and concerts), film stars remain notoriously distant, detached from the everyday world inhabited by their fans. Information about them is rigorously controlled (contained *and* orchestrated) despite every attempt to obtain it by fans, gossip columnists, journalists and paparazzi, etc. More than any other type of celebrity, the film star is associated with distance and aura, both of which set them apart and intensify their power and attraction.

Despite being at the very pinnacle of the celebrity hierarchy, however, film stars must continually compete with sporting heroes, television personalities and pop singers for their place in the public arena. As a result of increasing numbers of entertainers and non-entertainers becoming celebrities, 'there has been quite a

pronounced shift towards performance as a mark of stardom and the concept of star-as-performer has become a way of re-establishing film-star status through a route which makes its claim through the film text rather than appearances in newspapers' (Geraghty 2000: 192). Since the 1990s, with a mass media environment increasingly dominated by celebrity, the acting skills of film stars have acquired greater levels of cultural capital. Consequently, while many film stars have taken their place alongside television, radio and sporting personalities (and their spouses and partners), others have played down such associations in favour of their work. Responding to this situation, Christine Geraghty has offered a number of ways of rethinking stardom and acting in her essay 'Re-examining Stardom: Questions of Texts, Bodies and Performance' (2000). This essay suggests that traditional models of stardom (particularly those based on Dyer's work) need to be unpacked and reformulated.[6] To better understand what various film stars have in common and how they differ from other types of celebrity, Geraghty identifies three types of film star – stars as celebrities, professionals and performers – which are determined by the relative exposure they receive in terms of their off-screen or non-professional life and also the degree to which their acting skills are showcased in publicity (ibid.: 187). Of these, *celebrity* film stars are those whose personal life circulates most widely and in greatest detail, while *professionals* and *performers* are both defined largely in terms of their work rather than their private lives, the former maintaining fairly consistent screen personae (e.g., Harrison Ford and Whoopi Goldberg), while the latter are known for their acting skills, playing a wide selection of character types (e.g., Meryl Streep and Dustin Hoffman).

Geraghty notes that celebrity film stars proliferated in the 1990s due in part to the relative slowness of film production and the inevitable long gaps between the release of one star vehicle and another, prompting many actors to take work in other media (e.g., television, theatre, advertising, etc.) in order to maintain a more

continuous public profile. Other stars, however, have worked exclusively in film, taking roles in a wide variety of genres. Geraghty observes that for those stars who appear in a greater range of genres, higher levels of consistency are required in terms of performance (i.e., a recognisable idiolect) in order to maintain the promise of a reliably specific set of pleasures, particularly when viewers choose films from the comprehensive selection available in video stores. Meanwhile, at the other end of the acting scale, the film *star-as-performer* is more or less reinvented from one film to the next, eschewing consistency in favour of versatility. In the 1990s, Geraghty points out, some film stars used displays of (visible) acting to distinguish themselves from other types of celebrity and also from other types of film star (i.e., *stars-as-professionals*). In such cases, experience, training and intelligence possess cultural capital in a market otherwise dominated by youth and good looks, although age counts differently for male and female stars in Hollywood. Thus, while the categories of *star-as-professional* and *star-as-performer* work well for most male film stars, the category of *star-as-celebrity* tends to work more effectively for female stars. As Geraghty has noted, the media's use of women as spectacle has meant that the press and television have provided profitable outlets for female film stars, citing Julia Roberts, Demi Moore and Nicole Kidman as examples of celebrity stars (ibid.: 196).

Geraghty's three categories of stars provide scholars with useful ways of distinguishing between different kinds of contemporary film actor, providing an appropriate starting point to a consideration of how they operate within the wider sphere of popular culture and the extent to which their reputation is based upon both their work and the stability of their picture personality (to use Richard deCordova's phrase). However, in many cases, such clear-cut distinctions are hard to make. Take, for instance, the case of Gwyneth Paltrow. Karen Hollinger's case study of Paltrow in *The Actress* (2006) reveals the extent to which she has functioned as a celebrity since her highly

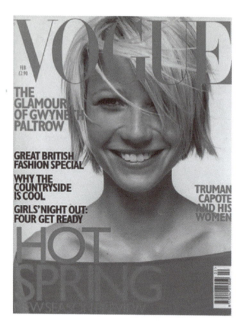

Hollywood celebrity Gwyneth Paltrow on the cover of British *Vogue* (February 1998)

publicised romance with Brad Pitt in the mid- to late 1990s. She writes that the 'barrage of publicity surrounding their relationship suddenly made Paltrow a major celebrity and shaped her star image even before she had a starring film role', while also setting the pattern for much of her career, with a heavy concentration by the media on her affair with co-star Ben Affleck and her subsequent marriage to pop star Chris Martin (Hollinger 2006: 195). Consequently, since the start of her film career, Paltrow has rarely been out of the media spotlight, her celebrity credentials established through her relationships with other stars (including her much publicised friendship with Madonna) and her image consistently adorning the cover of celebrity and fashion magazines, such as *Vogue*, *Elle*, *Cosmopolitan* and *Marie Claire*.

While these facts suggest that Paltrow conforms to Geraghty's category of *star-as-celebrity*, Hollinger's chapter on the actress reveals

that she is dedicated to her work as a screen performer (i.e., a professional) and that more actorly credentials are also part and parcel of her image (i.e., a performer). For instance, as the daughter of acclaimed stage actress Blythe Danner, Paltrow is widely considered to have grown up with acting in her blood, surrounded by actors and being introduced to the theatre at a young age. In addition, her breakthrough roles in the classic literary adaptation of Jane Austen's *Emma* (Douglas McGrath, 1996) and the theatrical costume biopic *Shakespeare in Love* (John Madden, 1998) established her star status within genres known for showcasing acting skills, particularly when an American actress is required to perform with an English accent. Close working relationships with auteur directors such as David Fincher (*Se7en*, 1995) and Anthony Minghella (*The Talented Mr. Ripley*, 1999), in addition to a reputed tendency to turn down Hollywood blockbusters (e.g., *Titanic*, 1997) in favour of low-budget films such as *Sliding Doors* (Peter Howitt, 1998), *Shallow Hal* (Farrelly Bros., 2002) and *The Royal Tenenbaums* (Wes Anderson, 2002), have lent credence to the idea that Paltrow is more concerned with interesting work that stretches her as an actor than in consolidating her box-office appeal or superstar status. Her roles in prestige literary films, such as *Possession* (Neil LaBute, 2002), based on A. S. Byatt's acclaimed novel, and *Sylvia* (Christine Jeffs, 2003), a biopic of the poet Sylvia Plath, suggest a commitment to quality films with their literate scripts and complex roles. When these are considered alongside Paltrow's work in theatre, most notably her appearance at London's Donmar Warehouse in David Auburn's Pullitzer Prize-winning play *Proof* in May 2002, Paltrow would appear to be a strong contender for the category of *star-as-performer*.

For Karen Hollinger, Paltrow epitomises the difficulties facing young female stars in Hollywood who are celebrated for their looks, charm and fashion sense at the expense of their acting abilities. While Hollinger concludes that there is also 'a would-be actress concealed

under this conventional movie star exterior', it might also be argued that beneath the surface of this *star-as-celebrity* is a *star-as-performer* (Hollinger 2006: 219). One of Paltrow's achievements has been to establish her claim to stardom on the basis of celebrity *and* performance, so that attention has shifted increasingly (although not exclusively) towards the latter as her career has developed. Having ascertained that an actor such as Paltrow had initially achieved notoriety as a celebrity, it would be all too easy to overlook the contribution of her acting to her star status, producing a study that largely examines her publicity rather than analysing her screen performance with detailed close textual analysis of her acting in a representative sample of her films. However, as Hollinger and Geraghty have both demonstrated, Gwyneth Paltrow makes for an illuminating case study for star acting in contemporary Hollywood cinema.

Christine Geraghty examines Paltrow's performance style in more detail in 'Performing as a Lady and a Dame: Reflections on Acting and Genre' (2003), comparing her screen work to that of the British actresses Emma Thompson and Kate Winslet in such films as *Sense and Sensibility* (Ang Lee, 1995) and *Titanic* (James Cameron, 1997). Here, Geraghty's analysis of Paltrow's performance in *Emma* reveals certain correspondences with Thompson's in *Sense and Sensibility*, such as the elaborate and complex phrases spoken in light, almost whispered tones, often rather flat and invariably rapid, frequently ironic and often uttered through a narrow or closed mouth. Attention to these performance details demonstrates Geraghty's interest in star acting as much as her earlier essay had demonstrated her recognition of importance of celebrity for film stardom. This also suggests that film scholars in the twenty-first century are using close textual analysis of film acting as a means of distinguishing their work from scholars of media and cultural studies more generally. Further evidence of this can be found in Bruce Babington's introduction to *British Stars and Stardom*, where he

Gwyneth Paltrow in her Academy award-winning role in *Shakespeare in Love* (1998)

argues that textual analysis is an important critical tool due to the fact that 'the basic activity of the film star, on which all associated charisma, discourses and practices ultimately depend, is performance' and that, therefore, the analysis of star performances in films is 'central to star study' (Babington 2001: 23). Moreover, since 'the most fundamental difference between the film star and other kinds of stars – pop stars, sports stars, supermodels, television celebrities etc. – is the elision of the star persona with fictive characters within screen narratives', Babington insists that it remains vitally important that the details of film star performances are closely scrutinised and considered as part of any investigation into their work (ibid.). While this is certainly the case, it should also be noted, however, that textual analysis of the final print of a film can only offer so much insight into its meaning and production, and that such analysis can be significantly augmented by analysis of extra-cinematic matter: most notably, scripts.

Alan Lovell and Peter Krämer have argued that the 'neglect of the script has impoverished film scholarship generally and has had a particularly important effect on explorations of acting' (Lovell and Krämer 1999: 2). 'To understand acting properly,' they insist, 'you need to know not only about the way actors work but also about the nature of the materials they are working with', the most crucial material usually being a script (certainly in terms of studio-era Hollywood) from which actors, coaches, dialogue directors and directors craft performances and characterisation (ibid.: 3). Yet, as they point out in the introduction to *Screen Acting*, script analysis has seldom been used as a tool by film scholars when talking about stars or even when performances have been scrutinised. In more recent times, though, some film scholars have compared the final version of the film print with drafts of the script, noting the actor's changes to dialogue and direction in an attempt to determine their contribution to the performance on screen (see Lawrence 2010a and Barton Palmer 2010b). This method can prove particularly instructive, providing a clearer sense of a star's method, contribution and control, enabling scholars to discern what was proscribed by the scriptwriter(s) in terms of performance and what was introduced by the actor.

Cynthia Baron and Sharon Marie Carnicke, in *Reframing Screen Performance*, suggest that film scholars should study scripts the way film actors do, as blueprints for building characters (Baron and Carnicke 2008: 208–19). This forms a central component of a systematic approach to the analysis of film acting, such analysis arising out of an ambition to '*reframe* screen performance by replacing, for a moment, the familiar focus on stardom with concentration on actors' observable performance choices' (ibid.: 5–6, emphasis in original). Detailed analysis in this book is motivated by the aim to reveal the extent to which film acting is finely crafted but also in recognition of the fact that audiences attend closely to 'the slightest shifts in performers' facial expressions, the smallest changes in their vocal intonations' in order to derive meaning from films,

including subtle changes in camera framing or minute variations in an actor's energy (ibid.: 6). By drawing attention to actors' performances (and performance methods and choices), the authors seek to work against a long tradition of denying and disguising the work that actors do on film and the craft involved in their work, a tradition extending throughout the history of Hollywood publicity and film studies.

In order to analyse a range of film performances, including the most apparently naturalistic, Baron and Carnicke propose an eclectic methodology that draws on Prague School semiotic theory, the influential taxonomies of gesture and movement developed by François Delsarte and Rudolf Laban, as well as Stanislavski's method of script analysis. By combining the socio-semiological work of the Prague Linguistic Circle (c. 1926–48) with Delsarte's system of poses and gestures and Laban's system of movement, Baron and Carnicke propose a wide-ranging and flexible methodology for describing and understanding the effects of film actors' breathing, gestures, poses and facial expressions. Meanwhile, in order to better understand the way actors prepare for and execute their performances, they use Stanislavski's technique of 'active analysis', which involves locating the actions and counter-actions of a scene, recognising the fundamental importance of the script and script analysis at the heart of most film performances. For Stanislavski, 'discrete units of action serve as building blocks for story and scenes', what he called 'bits' and American actors and acting coaches call 'beats', these being coherent segments of a scene that constitute the 'structural dynamics' of their performance (ibid.: 210). Baron and Carnicke's method involves identifying, first, the *given circumstances* of a scene for each character; second, each character's main *objective* (e.g., their *problem* to be overcome); third, the series of actions each character takes to achieve their objective (i.e., targeted *actions* or *counter-actions*); fourth, the *units of actions* (or *beats*) involved in this process, marked by changes of tactic (e.g., shifts in

register) (ibid.: 214–31). Using this method as the basis for a series of detailed analyses of moments from a varied selection of films, Baron and Carnicke offer a persuasive case for adopting a more programmatic approach to the detailed analysis of screen performances. Their carefully worked out system, moreover, offers original insights into how professional actors (including stars) work and prepare their roles for film, with a script as their inevitable starting point.

Conclusion

While the continuing evolution of star studies as a significant and exciting area of film studies rests largely upon the expansion of its field of enquiry (e.g., with increasing numbers of studies of stars from different countries, historical periods and genres), it also lies with the methods used to investigate how performances are produced and who is involved in their production, as well as how these have been received by audiences. Such work is challenging, requiring a combination of skills and knowledge. In addition to gaining valuable insights from the extensive range of publications that come under the umbrella of 'star studies', film scholars studying stars have much to gain from *mise en scène* criticism, specifically in terms of developing an eye and ear for detail, as well as an ability to translate complex combinations of sounds and images into words. Once these skills are utilised in addition to the methods, taxonomies and terminology of performance theory and in combination with script analysis, scholars are in a position to more fully comprehend and evaluate the work and achievements of star actors. With insights gleaned from interviews with industry professionals, practitioners (i.e., cast and crew), audiences and fans, star scholars can be confident that their research is not only comprehensive but also ambitious and authoritative.

3 STAR QUALITY: IN SEARCH OF THE PREREQUISITES FOR STARDOM

Introduction

A star has exceptional looks. Outstanding talent. A distinctive voice that can easily be recognized and imitated. A set of mannerisms. Palpable sexual appeal. Energy that comes down off the screen. Glamour. Androgyny. Glowing health and radiance. Panache. A single tiny flaw that mars their perfection, endearing them to ordinary people. Charm. The good luck to be in the right place at the right time … An emblematic quality that audiences believe is who they really are. The ability to make viewers 'know' what they are thinking whenever the camera comes up close. (Basinger 2007: 3)

What makes a star a star *can* be determined, as Jeanine Basinger's statement indicates. However, Basinger also adds that a star has something else, 'the bottom line of which is "it's something you can't define"', acknowledging that there is invariably something elusive and indefinable about star quality (ibid.: 4). Perhaps this is why stars fascinate us and also what makes them a fascinating subject to study. The nature of star quality has long been a feature of much writing about stardom: in other words, those qualities that are most commonly associated with stardom or even considered prerequisites. While these qualities are necessarily subject to change over time and may vary in different national or cultural contexts, some qualities are commonly considered necessary for a star to achieve success: most notably,

charisma, expressivity, photogenic looks, mellifluous voices, attractive bodies, fashion sense and style. Of course, there are inevitably exceptions to the rule: that is, stars that rise to the very pinnacle of stardom without possessing one or even a number of these.[1]

One of the biggest stars on the planet by the dawn of the new millennium was Shah Rukh Khan (often referred to as SRK), with millions of fans scattered across the globe: Australia and New Zealand, Canada, North and South America, the UK and many parts of Europe, in addition to the Indian subcontinent from which he originated. Dubbed the 'Tom Cruise of Hindi Cinema' and the 'King of Bollywood', Shah Rukh Khan has risen to global super-stardom despite frequent accusations of being undistinguished as an actor and despite his lacking the fair skin and good looks of the classic Hindi screen idol. His biographer, Anupama Chopra, notes that in Bollywood, 'leading-man roles were played by a select group of actors, who were usually conventionally handsome men with light skin', whereas villains were usually ugly, leaving little room for confusion (Chopra 2007: 113). Consequently, as 'soon as an actor walked into frame, the audience could identify him as heroic or villainous' (ibid.). However, although Khan initially made his name playing villainous and anti-heroic roles in Abbas Alibhai and Mastan Alibhai Burmawalla's *Baazigar* (*Gambler*, 1993) and Yash Chopra's *Darr* (*Fear*, 1993), his breakthrough role was the romantic hero of Aditya Chopra's *Dilwale Dulhania Le Jayenge* (*The Brave-hearted Will Take the Bride*, 1995), which made SRK the hottest heart-throb in Bollywood. Capitalising on his exuberant performances, his boundless energy and his charismatic star persona, a team of writers, choreographers, costume designers and film directors have transformed this actor into 'the ultimate brand ambassador for Bollywood and India' (ibid.: 221) and the 'face of a glittering new India' (ibid.: 11), however dark and imperfect that face may be. Neither his lack of beauty nor his lack of acting skills has prevented him from attaining super-stardom in Bollywood cinema.

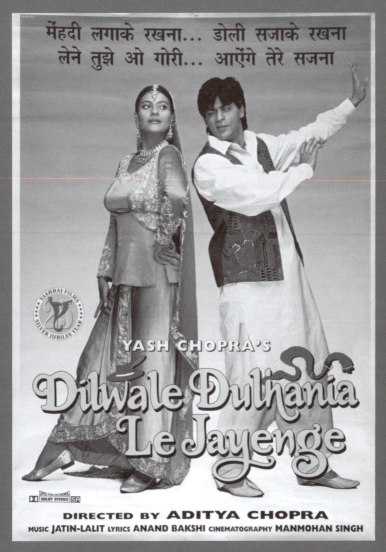

King of Bollywood: Shah Rukh Khan, with Kajol, in *Dilwale Dulhania Le Jayenge* (*The Brave-hearted Will Take the Bride*) (1995)

This chapter considers the importance for stardom of various qualities widely considered necessary for the attainment of star status within mainstream commercial cinema in various parts of the world, incorporating a series of case studies from the USA, India, Britain and Europe. This includes glamour, physical attractiveness (of face and body), vocal attractiveness and distinctiveness. The running theme throughout this chapter is one that has persisted in film studies for many years: that is, the question of whether acting talent is or is not necessary for stardom in commercial cinema. While there have been many successful and popular stars who have been deemed lacking in acting skills, this chapter insists that versatility is required of cinema's star actors, given the need for them to perform with a range of different actors and co-stars, and work with numerous directors and technicians, across a wide range of genres in order to sustain a successful career in the film business. The starting point, however, is a consideration of what raises an elite group of film actors above all the rest.

Glamour

Stars stand out. They have a certain lustre, a special sheen and a sparkle, that makes them glitter, that makes them glamorous. For Jane Gaines, the word 'glamour' represents the 'perfect amalgam of money and love' in its combination of 'glitter and *amour*' (Gaines 1986: 43). For Stephen Gundle, on the other hand, 'glamour is notoriously difficult to define' (Gundle 2008: 2). In his book *Glamour: A History*, he writes that, in his view, 'glamour is best seen as an alluring image that is closely related to consumption', describing it as an 'enticing and seductive vision that is designed to draw the eye of an audience' (ibid.: 5). He adds that it 'consists of a retouched or perfected representation of someone or something whose purpose it is to dazzle and seduce whoever gazes at it' (ibid.).

While acknowledging that the subjects of glamour are very varied, Gundle insists that these are invariably associated with a number of specific qualities, 'beauty, sexuality, theatricality, wealth, dynamism, notoriety, movement, and leisure', noting that the 'more of these that are present, the more glamorous the result and the more successful the image is likely to be in arousing wonder and envy among those who see it' (ibid.: 6). In discussing the historical development of glamour, Gundle notes that its origins lie not in the highest echelons of society (e.g., the monarchy or aristocracy), but rather with the aspirational bourgeoisie, citing late eighteenth-century courtesans as being 'among the first fully glamorous personalities', ladylike (but not ladies), flamboyant and 'luxurious sex objects' (ibid.: 11). Mixing high-class values with sleaze, courtesans established a tradition that many would adopt in pursuit of glamour throughout the nineteenth and twentieth centuries, most notably Hollywood film stars. Gundle identifies Greta Garbo as the greatest and most glamorous Hollywood star and her studio MGM as the one most closely associated with the production of glamour, particularly during the Depression of the late 1920s and 30s (ibid.: 173 and 176).[2] Throughout this period and for many decades thereafter, Gundle notes that stars were 'wrapped in a romantic aura' that obscured their humble origins, transforming the image of hard-working industry professionals into the ultimate icons of luxury, consumerism and excess (ibid.: 179).[3]

Jackie Stacey, in *Star Gazing*, her study of British women's memories of Hollywood stars of the 1940s and 50s, reveals the extent to which the appeal of stars like Joan Crawford, Bette Davis and Ava Gardner lay in a sense of unobtainable glamour for women living in wartime and postwar austerity. 'The appeal of Hollywood stars was typically remembered in terms of their "glamour". A frequent feeling expressed was that glamour belonged to American femininity, and thus Hollywood stars were preferable to British ones' (Stacey 1994: 113). Stacey also notes that, 'star glamour was understood not only

in terms of appearance, but also as signifying confidence, sophistication and self-assurance, which were perceived by female spectators as desirable and inspirational' (ibid.: 154). Consequently, in Hollywood's female stars of the 1940s and 50s (e.g., Rita Hayworth and Marilyn Monroe), British women found glamorous identities generally lacking in British cinema, with one or two exceptions (most notably, Diana Dors). In contrast, French films have long had a reputation for being glamorous, stylish and fashionable. Ginette Vincendeau, in *Stars and Stardom in French Cinema* (2000), describes the close links between late1940s and 50s French cinema and the country's fashion industry, noting the way in which, for instance, Christian Dior's 'New Look' of 1947 was popularised through cinema. Consequently, the tight-waisted, tailored jackets, bosom-emphasising tops, full skirts and stiletto heels of the 'New Look' can be seen in many French films of the 1950s, especially those about the fashion world, such as *Mademoiselle de Paris* (Walter Kapps, 1955), *Le Couturier de ces dames* (Jean Boyer, 1956) and *Mannequins de Paris* (André Hunnebelle, 1956). She also notes that the thriller *Bonnes à tuer* (Henri Decoin, 1954) features a 'fabulous display of Balmain evening gowns' (Vincendeau 2000: 87).

By the mid-1950s a new fashion icon burst onto the international scene, presenting a more youthful, rebellious and sexually charged image of French femininity. This was Brigitte Bardot, whose performance in Roger Vadim's *Et Dieu … créa la femme* (*And God Created Woman*, 1956) caused a sensation in France and the USA. Vincendeau notes that Bardot became famous for her cheap and skimpy clothes, which (combined with her lack of underwear) emphasised her figure while connoting freedom, replacing the rigid tweeds, satins and silks of couture with soft cotton and gingham. She writes that, 'her clothes are casual, often crumpled, the buttons undone, and she eschews accessories: little jewellery, often no shoes, usually no handbag, hat or gloves' (ibid.: 88). Similarly, her hair is invariably long, wild and abundant, in

contrast to the short, neat style associated with the 'New Look'. Diana Holmes, has also noted that Bardot's outfits 'implied a more radical revision of the feminine by connoting ease of movement, refusal of constraint, and identification with the rebelliously casual style of male teen idols such as James Dean and Marlon Brando' (Holmes 2007: 53). In France during the 1960s a more youthful and stylish masculine look was promoted by Jean-Paul Belmondo in films such as Jean-Luc Godard's *Pierrot le fou* (1965), where he flaunts his trim and toned physique in 'light suits and slip-on shoes, jeans and clinging white T-shirts, the classic sexy male outfit of the post-war period' (Vincendeau 2000: 167). Meanwhile, in the film *Cent mille dollars au soleil* (Henri Verneuil, 1964), 'his jeans and Lacoste shirt mark him as modern by comparison to the older actors (Lino Ventura and Bernard Blier), who wear ordinary trousers and shirts' (ibid.). However, if there is one French star that has come to personify glamour more than any other it is Catherine Deneuve. Vincendeau claims that her glamour 'was a throwback to great Hollywood icons like Greta Garbo and Grace Kelly, to both of whom she was often compared' (ibid.: 198). By the 1990s, Deneuve was the official face of Yves Saint Laurent cosmetics but long before then she had been associated closely with leading French fashion. Indeed, in 1967, *Belle de jour* (Luis Buñuel) inaugurated her longstanding partnership with Saint Laurent designs, after which she became the 'semi-official ambassador for French fashion on and off screen' (ibid.: 204). 'Deneuve's clothes, whether by Saint-Laurent or Saint-Laurent inspired, have foregrounded the feminine bourgeois image of a woman in a tailored suit, with short skirt and high heels' (ibid.).

By contrast, Norwegian actress Liv Ullman has evolved a persona in opposition to the glamour of French and Hollywood stardom. Gunnar Iversen claims that the stars produced by the film industry in postwar Norway typically lacked 'some of the essential qualities that usually are ... attributed to stardom, most obviously, glamour' (Iversen 2009: 74). He asserts that glamour 'was perceived

as something not belonging to or inappropriate in Norwegian culture at the time' (ibid.: 79). 'Norwegian screen stars therefore never were rooted in the ideology of consumerism in the same way as American stars, and were not characterized by keywords like "glamour", "extravagance" and "luxury", but rather with associations to "naturalness" and "ordinariness"' (ibid.). Thus, he argues that Liv Ullmann's star persona is best understood in terms of a 'charismatic ordinariness' that conveys both purity and naturalness, even though she began her film career as a Bardot-style sulky sex-kitten (ibid.: 78). As her image on the cover of Tytti Soila's book *Stellar Encounters* testifies, when Liv Ullmann became a star in Norway in the late 1950s she possessed a natural beauty rarely seen in Hollywood films, one that neither her unstylish hair and clothes nor the lack of make-up and glamour lighting can disguise.

Photogeny

Despite some exceptions, a general belief persists that film stars, particularly Hollywood stars, must be good looking, and the majority are: from Greta Garbo to Julia Roberts, from Rudolph Valentino to Brad Pitt. Jeanine Basinger suggests that much of Brad Pitt's appeal comes 'from his angelic looks', describing him as 'the ultimate in contemporary male beauty' (Basinger 2007: 541). She also notes that from the moment he caught the public's attention with his supporting role in Ridley Scott's *Thelma and Louise* in 1991, he seemed 'cut out to be a sex symbol' (ibid.). His good looks have enabled him to be cast opposite beautiful women, such as Julia Roberts in Steven Soderbergh's *Ocean's Eleven* (2001) and Angelina Jolie in *Mr. and Mrs. Smith* (Doug Liman, 2005). They have prevented him from being over-shadowed by male co-stars such as George Clooney in *Ocean's Eleven* and Orlando Bloom in Wolfgang Petersen's *Troy* (2004), while making him stand out opposite Morgan

Freeman and Kevin Spacey in David Fincher's *Se7en* (1995) and Edward Norton in *Fight Club* (Fincher, 1999). To date, his looks have not prevented him from being cast in films that have broadened his star persona and acting range: from Neil Jordan's homoerotic horror *Interview with a Vampire* (1994) to Terry Gilliam's science fiction fantasy *Twelve Monkeys* (1995), David Fincher's melodrama *The Curious Case of Benjamin Button* (2008) and Quentin Tarantino's World War II violent comedy *Inglourious Basterds* (2009).

Brad Pitt is one of a number of exceptionally attractive men working in Hollywood in the twenty-first century (e.g., Johnny Depp, Keanu Reeves and Colin Farrell) and may even be considered one of the best-looking male stars the cinema has ever produced, along with Rudolph Valentino, James Dean, Jean Marais, Alain Delon and Robert Redford. Ginette Vincendeau writes that, in the 1960s, 'Delon's stunning looks, his classically beautiful face and tall, slim yet muscular body were the defining aspect of his star persona' (Vincendeau 2000: 173). However, she notes that he was also described in the press in terms of his devilish, androgynous and ambivalent beauty, indicating that he was considered too beautiful and that his beauty became associated with cruelty. She writes that the 'association of Delon's beauty with sadism is so recurrent that the conclusion is inescapable: it is his beauty itself, in its excess, which is cruel' (ibid.: 176).

While Delon's beauty made him stand out among his contemporaries and attracted admiring audiences around the world, his eroticisation also proved problematic. Vincendeau notes that his early films 'are structured around the narcissistic display of his face and body', particularly in the two films he made with Luchino Visconti, *Rocco and His Brothers* (1960) and *The Leopard* (1963). She writes that 'the popular success of Delon's early films shows that this erotic male display was widely pleasurable and acceptable to a mainstream audience' (ibid.: 175). However, she also notes that once his face began to reveal the signs of ageing, his career declined,

stating that all 'ageing stars carry the memory of their younger glory, but with very beautiful stars the process is particularly poignant', noting the shock caused by his appearance in 1983 in Volker Schlöndorff's *Swann in Love*, with his 'excessive make-up, visibly dyed hair and nasal voice', along with a set of camp gestures that marked a significant departure from his usual minimalist performance' (ibid.: 181). Alain Delon thus provides a case study for understanding the ambivalences and insecurities of beauty, raising questions about the way in which excessive beauty can be limiting for a film actor in terms of restricting the types of roles they are allowed to play and shortening their careers by restricting it to their youth. While Alain Delon is one of a minority of men who have built their film careers upon their good looks, most male stars (e.g., Jean Gabin and Gérard Depardieu) have succeeded in French cinema without the aid of beauty. Vincendeau notes that Delon's contemporary and occasional co-star Jean-Paul Belmondo has what 'the French call a *gueule* (a word used for the face of an animal, a "mug")', noting his irregular and elongated face with thick lips, flattened nose and deep lines (ibid.: 166). She points out that the word '*gueule*' may imply coarseness but, in a man, it also suggests character and authenticity. Consequently, both Belmondo (in the 1960s) and Jean Gabin (in the 30s) reputedly possessed a rugged virility that made them sexually attractive.

Edgar Morin, in his 1957 study *Les Stars*, pointed out that ugly men have often become great stars of the cinema, citing as examples the German actor of the 1920s Emil Jannings and the British actor of the 30s Charles Laughton. In contrast, he claimed that it is invariably beautiful women who become cinema's greatest stars, stating that beauty 'is an effective equivalent of all the other virtues' (Morin 2005: 132). He also noted that while theatre actresses are not necessarily required to be beautiful, female film stars are.

Beauty is one of the sources of 'star quality,' and the star system does not content itself with prospecting for it in merely its natural state: it has created or

revived the arts of cosmetics, costume, carriage, manners, photography, and, if necessary, surgery, which perfect, prolong, or even produce beauty. (Ibid.: 31)

As this statement indicates, youth is as important as beauty for film stardom. So, as Morin noted, the 'requirement of beauty is also the requirement of youth' (ibid.: 36). Again, in theatre and opera, youth matters little, while 'in the American cinema before 1940, the average age of female stars was twenty to twenty-five; their career was shorter than that of male stars, who ripen, if not age, in order to attain an ideal seductive status' (ibid.).

Many of France's most successful film actresses have been celebrated for their beauty: most notably, Brigitte Bardot and Catherine Deneuve. Deneuve, for instance, came to movies on the strength of her looks rather than any training in acting or theatre experience. Beginning in small parts in comedies alongside her sister Françoise Dorléac in the late 1950s, Deneuve shot to fame with Roger Vadim's *Les Parapluies de Cherbourg* in 1964. Ginette Vincendeau describes her face in this film as being 'characterized by translucent skin and smooth, yet well-defined, lines: a short and straight nose, perfectly arched eyebrows, a full yet delicate mouth and high cheek-bones' (Vincendeau 2000: 199). However, one of the more unique and perhaps remarkable aspects of Deneuve's career has been its longevity. While Brigitte Bardot's film career faded during the late 1960s as she entered middle age, Deneuve's stature continued to grow well into her fifties with films such as *Indochine* (Régis Wargnier, 1992), Lars von Trier's *Dancer in the Dark* (2000) and François Ozon's *8 Women* (2002) and *Potiche* (2010). Nevertheless, despite her continuing high profile in the twenty-first century, other French actresses have replaced Deneuve as the face of French beauty, being used to sell French films and French cosmetics abroad, most notably Juliette Binoche, whose beauty was vividly captured in Léos Carax's *Mauvais sang* in 1986, as well as in advertisements for Lancôme's Poême perfume (see ibid.: 245–8).

Beauty queen: Aishwarya Rai, former Miss
World and Bollywood superstar, advertising
Lux soap

French movie actresses, of course, do not have a monopoly on
beauty. In 2000, Aishwarya Rai was voted the most beautiful 'Miss
World' of all time, having originally won the Miss India competition
in 1994 and then gone on to win the Miss World title that year. On
the back of this she became one of India's most successful and
famous models and, eventually, one of the country's most successful
and internationally famous film stars, carving out an impressive
career in Bombay cinema (e.g., *Devdas*, 2002), British cinema (*Bride
and Prejudice*, 2004) and Hollywood (*The Pink Panther 2*, 2009),
becoming the face of L'Oreal in 2003, as well as the face and body of
a well-known brand of soap. However, while Rai's international
stardom may have resulted largely from her beauty, it would be
wrong to assume that it is only her appearance that has ensured her
success. For beauty is no guarantee of stardom. Many beautiful
women have tried their luck in the film industry over the years and
failed.[4] While many beautiful women have succeeded in Hollywood

(e.g., Hedy Lamarr and Ava Gardner), many less beautiful women have achieved either the same or even greater levels of success (e.g., Bette Davis and Barbra Streisand). Stardom clearly requires something more than beauty, whether it is the ability to reflect and absorb light in order to photograph well or the ability to register a psychological depth that suggests a set of emotions and thoughts.

Speaking of Greta Garbo, Charles Affron described her face as being 'like a fabric – so rich that its texture is interesting in itself, so flexible that it retains its design in all degrees of tension', noting her special relationship with the camera (Affron 1977: 152). Clearly, Garbo's beauty was enhanced by the camera but, even then, she possessed other qualities that made audiences want to see her films: a charismatic foreignness and an enigmatic sadness and loneliness; a certain style and manner that was uniquely her own (yet imitable); a complex, ambiguous and even contradictory persona that proved fascinating, bringing her fans back to see her time and again. In addition to beauty, stars clearly require a distinctive and appealing personality, some singular feature (a talent or a style) that makes them stand out, one that might be almost impossible to identify. After 1927, Hollywood stars were also required to possess an interesting, distinctive and attractive voice as much as a beautiful or handsome face.

Danae Clark, in *Negotiating Hollywood*, points out that during the transition to sound in the late 1920s, many stars were dropped by the studios not because they lacked talent or had inadequate voices but because new faces were sought to represent the new technology of 'talking pictures'. She writes that,

the aesthetic and technological revolution brought on by the talking picture demanded a new standard of beauty. The old style, epitomized by the 'cold immobility' of silent stars, was replaced by a modern standard of beauty based on inner warmth, grace of motion, and, above all, personality. (Clark 1995: 112)

Clark's point reminds us that standards of beauty are subject to change from one historical period to another but also, in cinema, correlate closely with technology and technological innovation. While beauty offers audiences visual pleasure (the delights of gazing upon attractive faces and bodies), it also suggests perfection (i.e., physical perfection) and therefore represents a guarantee of quality that can sell a film to a prospective audience. 'In their contests and "talent" searches', Clark notes, 'the Hollywood studios tended to privilege beauty as a marketable commodity' for the simple reason that beauty sells, not just films but a host of products associated with the film industry: most notably cosmetics, toiletries, fashion and accessories (ibid.). Attaching a beautiful face and body to the marketing of a brand of soap transforms that product into both a luxury item and a superior brand. In this instance, the model's physical perfection is taken to be emblematic of the product's high quality, for which consumers are required to pay a premium. From an industry point of view, Hollywood needed beautiful stars to sell their films but also to endorse a range of related merchandise. From an audience point of view, Hollywood's beautiful stars could be consumed by fans not only by viewing them in close-up on the big screen but also through the purchasing of associated consumer products.

Jackie Stacey, in *Star Gazing*, has noted that the letters she received from British women about their attachment to Hollywood stars of the 1940s and 50s indicated that they consumed the bodies of stars as though they were commodities: that is, separated out into bits and pieces. She notes that many of the women in her research project 'remember stars in terms of body parts they admired and, through the consumption of products, attempted to replicate their ideal through the transformation of particular body parts' (Stacey 1994: 207). Bette Davis's eyes, Joan Crawford's shoulders, Betty Grable's legs and Jane Russell's breasts are just a few of the iconic body parts of Hollywood in the 1940s and 50s. By the 50s,

Hollywood and European cinema were dominated not just by idealised and commodified bodies but pneumatic ones, the exaggerated proportions (and curves) of Hollywood stars such as Marilyn Monroe and Jayne Mansfield matched by British star Diana Dors, French star Brigitte Bardot, Italian stars Sophia Loren and Gina Lollobrigida, Swedish star Anita Ekberg and Swiss star Ursula Andress. These stars proved to be a match also for the imposing and statuesque physiques of male stars such as Charlton Heston, Kirk Douglas and Burt Lancaster, who were later surpassed by the pumped-up bodies of Sylvester Stallone, Arnold Schwarzenegger and Dolph Lundgren in the 1980s and 90s, setting new standards in male movie musculature (see Yvonne Tasker 1993). In twenty-first-century Hollywood and Bollywood, toned and buff male bodies have become the norm, setting the standard in masculine beauty and producing spectacular and highly commodified bodies that can sell movies as well as an associated range of products to men as well as women. A rare commodity, beauty makes the possessor stand out from the crowd. It can captivate and beguile but it can also be scrutinised and deconstructed, quantified, historicised and contextualised. Film scholars need to both analyse the beauty of stars and look beyond it, identifying other skills and attributes that make a star successful, effective, appealing and enduring (e.g., performance skills and expressivity). In some cases, it may even be useful for a film scholar to close their eyes when analysing a beautiful star.

Phonogeny

Garbo's voice is rich and deep, as is that of her contemporary Marlene Dietrich, two European actresses who became legendary figures in Hollywood during the 1930s, celebrated for the beauty of their faces *and* voices, inspiring not just adulation but emulation. Thus, when the German film industry of the Third Reich sought a

star commensurate with the international stature of Garbo and Dietrich they hired Swedish actress and singer Zarah Leander on the strength of her likeness (in face and voice) to these women. Leander subsequently became the most successful and highest-paid film star in Germany from 1937 to 1939. Erica Carter attributes much of that success to the star's rich contralto voice, which had an androgynous and sublime quality, transcendent and liquid, that could travel through the auditorium of a movie theatre and resonate through the bodies of her audience (Carter 2004: 179–204). While Zarah Leander was not the only European female star whose fame and fortune lay in her deep and resonant voice,[5] such qualities are more often associated with male stars and, indeed, many great male film stars have become well known and celebrated for their rich vocal tones: Paul Robeson, Orson Welles, Richard Burton and Amitabh Bachchan among them. On the other hand, many others have turned their lighter voices to advantage, particularly in comedy, including male stars such as Roger Livesey and James Stewart, as well as female stars such as Judy Holliday and Marilyn Monroe. In all these cases, and many more, the voice is a distinctive and defining feature of the star's persona ('persona' being, literally, 'through sound') and, as such, deserves detailed attention. It is perhaps no surprise then that Tytti Soila, in the introduction to her book *Stellar Encounters*, notes that many of the twenty-two contributors to her collection of essays on popular European stars have identified the voice (along with eyes) as 'the most noteworthy idioms of individual performance' (Soila 2009: 17).

Annette Kuhn, in her essay 'Film Stars in 1930s Britain: A Case Study in Modernity and Femininity' (2009), notes the disparity between the contemporary reactions and memories of two popular British stars of the 1930s, Robert Donat and Jessie Matthews, stating that, while Donat's voice 'figures as the true marker of his quality and genuineness', Jessie Matthews' voice denotes anything but authenticity (Kuhn 2009: 183–4). In interviews with a range of

people as part of her *Cinema Culture in 1930s Britain* project, Kuhn came across considerable antagonism towards the musical comedy star Jessie Matthews, with numerous respondents reporting antipathy towards her 'phoney' voice with its 'elocuted pseudo-Mayfair accent' (ibid.: 186). What Matthews' voice evokes above anything, Kuhn notes, is middle-class aspiration. The knowledge that Matthews originated from a poor, working-class Cockney background but consistently adopted a 'plummy' middle-class accent when performing renders her an impostor for those who remember her, reminding them of the class-consciousness of interwar British cinema. By comparison, Manchester-born Robert Donat is remembered much more fondly and with respect, despite the fact that he also had elocution lessons to remove his regional accent. Kuhn's respondents speak of his 'beautiful voice,' appreciating the fact that while it enabled him to sound like an English gentlemen it never made him seem too posh.

Susan Smith's analysis of Robert Donat's voice at the end of MGM's *Goodbye, Mr Chips* (Victor Saville, 1939) reveals the beauty and artistry of this voice but also its distinctive emotional qualities that not only rendered it less posh but also less masculine than many other male English voices of the period. Smith notes that 'it is here that Donat … is able to combine the rich, warm tones and cello-like timbre of his voice with a much higher, more musically ascending key' (Smith 2007: 228). Analysing a scene in which the elderly schoolmaster comforts one of his young pupils, Smith notes that Donat inflects 'the lilting rhythm and higher, upward end of his notes here with wistful pauses and cadences' to capture and convey a sense of optimism and poignancy (ibid.: 229). Further noting the actor's use of depth and a 'shifting variety of emotional shading to his voice', Smith observes how Donat captures the beauty of a scene he is describing while reaching out to the boy in a protective and parental way (ibid.). She describes how the actor 'manages to invest the schoolmaster's words with a wonderfully composite gender-nurturing

quality and using a voice itself suggestive, through its complex tone and texture, of this embracing of male and female parental roles' (ibid.). Thus, the appeal and complexity of Donat's voice is that it provides a rare instance of a nurturing male voice in cinema, otherwise associated with power and authority but here combining authority with something more caring, sentimental and emotional. Smith argues that 'it is precisely its readiness to invest in this emotionalisation of the male and his ability to discover a nurturing side to himself that enables the film to make such a significant departure from traditional depictions of masculinity' (ibid.: 230). Testifying to the appeal and respect for such a performance, Smith notes that in 1940 Donat won the Best Actor Academy Award for his role in *Goodbye, Mr Chips*, beating Clark Gable, who had been nominated for his performance as Rhett Butler in *Gone with the Wind* (Victor Fleming, 1939). Donat's voice was clearly one that audiences on both sides of the Atlantic could relate to as gentlemanly without being supercilious. This was a quality that most English actors would need to cultivate if they were to enjoy international success, particularly in Hollywood.

Sarah Street has noted that many of the accents in British films were incomprehensible to American audiences, reviewers frequently complaining that they were too difficult to understand as a result of words being 'drawled out', so that when British actors arrived in Hollywood to appear in films they were invariably given instruction on voice production (Street 2006: 62). Many British actors in the 1930s–50s saw a move to Hollywood 'as a logical step forward from a successful career in British films' and many managed to make a successful transition: most notably, Clive Brook, Laurence Olivier, Charles Laughton, Leslie Howard, Ronald Colman, Herbert Marshall, Greer Garson, Merle Oberon, Vivian Leigh, Robert Donat, Deborah Kerr and James Mason (ibid.).[6] Many European actors, however, have failed in their bid for Hollywood stardom on account of their voice and, particularly, their accent. Alastair Phillips

and Ginette Vincendeau note that 'major European stars like [Jean] Gabin, Annabella, Marcello Mastroianni, Isa Miranda and Alain Delon floundered in Hollywood partly on account of accents that were discordant, faintly ridiculous or simply difficult to understand' (Phillips and Vincendeau 2006: 11).[7] Given the persistent demand in Hollywood for foreigner roles, especially in European-themed movies, having a foreign accent has proved to be an advantage, so that for many European actors based in Hollywood (e.g., Paul Henreid, Paul Lukas, Peter Lorre, Ingrid Bergman, Marlene Dietrich and Lilli Palmer) their accent 'was their major job asset and cultural capital ... as well as their greatest handicap' (ibid.).

Alastair Phillips has noted the significance of Charles Boyer's 'mellow and romantic' voice in his attainment of Hollywood stardom and success in the 1930s, describing him as France's most successful émigré star after Maurice Chevalier (Phillips 2006: 86). Between 1929 and 1934, Boyer moved back and forth between Europe (mainly France and Germany) and Hollywood, returning successfully to appear in multi-language and English-language Hollywood productions, steadily enhancing his international profile as an actor. However, it was his appearance as a romantic French doctor in *Private Worlds* (Gregory La Cava) in 1935 that won him a mass following with American and international audiences, determining his star persona as the quintessential 'French lover'. Phillips notes that the key to Boyer's success in Hollywood lay in his French speaking voice, pointing out that although he was given English-language tuition as part of his training at MGM, this and other studios were 'careful that the star never lost the significant "Frenchness" of his accent' (ibid.: 87). According to Phillips, what made Boyer so appealing to audiences was his combined use of eyes and voice. He writes that in one of the actor's most successful Hollywood films of the late 1930s, *History is Made at Night* (Frank Borzage, 1937), 'we can see again how adept the actor was at using both his voice and eyes to captivate the moviegoing audience' (ibid.:

90). He adds that, it 'is as if a constant ironic register is being maintained by the interplay between Boyer's hinting eyes and the suave appeal of this accented voice' (ibid.: 91).

In contrast, Jean Gabin's voice scuppered his success in Hollywood in the early 1940s, as Ginette Vincendeau has explained. In her essay ' "Not for Export": Jean Gabin in Hollywood' (2006), she writes that in his two Hollywood films, *Moontide* (Archie Mayo, 1942) and *The Imposter* (Jean Duvivier, 1944), Gabin appears handicapped by having to speak in English, slowing down his pace and producing some histrionic gestures by way of compensation (Vincendeau 2006: 120). Whereas part of his distinction as an actor in French films of the 1930s was his use of a 'radio-style' voice that was relatively fast and yet understated, in his American films he seems slow and deliberate, speaking emphatically and apparently lacking confidence 'in his ability to be understood' (ibid.: 120). Indeed, Vincendeau notes that there are several moments near the beginning of *The Imposter* when his speech is incomprehensible and where he appears to be speaking 'through clenched teeth' (ibid.). As this example indicates, an actor's ability to produce effective performances is dependent on a range of factors that includes language, but also the collaborative and technological context in which their work is produced.

Expressivity and acting talent

Danae Clark claims that, in Hollywood in the 1930s and 40s, acting talent was not essential for a star to become successful (Clark 1995: 111). Nevertheless, she also notes that, by the early 1930s, 'slightly more than two-thirds of the actors under contract with the major studios had begun their careers on the stage' and that, 'although the studios may have looked initially to beauty for star material, the addition of talent legitimated and gave depth to the spectacle of

beauty' (ibid.: 112). Of course, the majority of actors working in Hollywood in the 1930s and 40s were not stars (who constituted an elite group), a greater proportion being character actors and supporting players. These were generally considered to be the most talented and, as Clark states, 'were thought to carry the real burden of acting and were often relied upon to conceal a star's lack of ability' (ibid.: 25).

In 1957, Edgar Morin argued that the film star and the non-actor were born of the same need, 'a need not for an actor but for a type, for a living model, a presence' (Morin 2005: 132). He suggested that film's requirement for a 'minimum degree of expressive cinematic performance' allows for the actor to be dispensed with in favour of a 'star who is automaton and mask, object and divinity' (ibid.). Furthermore, this is made possible because film technicians are able to transform actors into objects, endowing 'a face-mask, one that is often already charged with all the adorable glamour of beauty, with all the subjective riches as well' (ibid.: 134). For Morin, the movie actor's performance operates as two poles: the mask and 'naturalness', which can be alternated according to the requirements of the shot or be brought together in what he calls the 'the quiet face', which attempts to reconcile 'the permanent expression of the mask with the thousand tiny lifelike expressions', constituting 'naturalness' through the interiorisation of the performance before a camera (ibid.: 128).

The repression of gestures and body movements tends to draw all attention toward 'the soul of the face.' The movie actor's performance is not necessarily abolished, but tends to metamorphose itself into the art of the subjective presence within the framework established by the living model (the mask or expressive type). (Ibid.: 129)

Garbo might be considered the exemplar of this process.[8] However, in *Star Acting*, Charles Affron dismisses the 'rather widespread

opinion that she is not acting at all', arguing that her 'acting is of a complexity that makes it difficult to assess in the context of standard technique', requiring intense concentration to understand and appreciate it (Affron 1977: 8). Similarly, he insists that, 'Garbo's gift is not naturalness, but rather the power to make a whole range of events, from the utterly common to the utterly preposterous, extensions of her self' (ibid.: 148). In a detailed analysis of a scene from *Grand Hotel* (Edmund Goulding, 1932), where Garbo's character, the Russian prima-ballerina Grusinskaya, discovers a stranger in her room (John Barrymore), Affron notes how the actress portrays her confused, lethargic and resigned state when the intruder refuses to leave. He describes how Garbo's face registers 'varying degrees of self-consciousness through the alteration of the relationships between her features' in such a way that she not only avoids a more conventional 'set of grimaces, cliché masks that pass for expressions in acting' but produces the 'clearest graphics for ambiguity and change' (ibid.). Attending to the subtlest facial movements (such as how her eyes widen and her mouth becomes fuller), he notes how these 'seem enormous, but they are actually very slight – shifts of chin, mouth, and eyes that, because of our familiarity with her face, cannot fail to be noticed' (ibid.: 150). He also notes how the 'rapidity of the transformation heightens our awareness', declaring at one point that,

Each time I see this shot I experience the same nervousness as when I hear a great singer about to negotiate a very difficult passage – will she get all the notes in on time? Will she do it beautifully? Will the fixed shape of the phrase contain the vitality of the performer? With Garbo, we see the notes, and their articulation in no way destroys the pattern and the integrity of the sequence. (Ibid.: 150)

Affron uses the analysis of this scene to dispute the myth of the inscrutable Garbo, arguing that the intimacy of the frame fully

registers the changing contours of her mouth and her eyelids in close-up to expose her progress from incomprehension to understanding. 'An actress can scarcely let us see more', Affron proclaims, adding that '[s]he registers this plenitude in successive spatial patterns', drawing the viewer in 'by discovering herself' (ibid.: 158).

Affron considers the claim that Garbo's acting is pure instinct rather than technique, concluding that there may be some truth in this. He notes that her 'greatest moments are those nonverbal and non-verbalizable ones, when she somehow seizes the most transitory states and is able to pass them on to us in their purity, avoiding the words, gestures, and expressions of explicit translation' (ibid.: 168). However, when he describes her handling of objects, he draws attention to a feature of her acting that might be thought of as a technique.

Garbo bestows her unaffected commitment upon things, forming the connections in the viewer's perception through the stillness of her presence and glance. Her technique, if that is indeed the word to describe it, often lies in her patience and trust that our powers of concentration are equal to her own. The harmony of her face with the grace of her body and the quite unnatural slowness of her pace focus our gaze, drawing us within the actress's persona and the world that animates it. (Ibid.: 183)

For Affron, this 'drawing in' is the key to Garbo's power and uniqueness as a star, hence the title of his sixth chapter, which contains his analysis of her performance of *Grand Hotel*, is 'Grusinskaya's Room: Drawing In'. What Affron celebrates in his reading of Garbo is the actress's sensitivity and her unconventionality, her repeated refusal to produce the expected in her performances and to focus attention on the less dramatic moments, such as moments of solitude when waiting for the arrival of a lover and instances that occur between the delivery of her lines of

Glamour and acting talent: Greta Garbo and
John Barrymore in *Grand Hotel* (1932)

dialogue. Affron writes that she 'acted against the grain', reorganising
the 'worn-out grammar of melodramatic types' and using her clichéd
roles as 'pretexts for pushing the self', often by giving 'more
attention to the *ands* and *buts* than the *I-love-you-truly*s' (ibid.: 186,
emphases in original). From this account, Garbo emerges as a subtle,
skilful, intelligent and innovative actor rather than just a natural and
instinctive one or as a beautiful and inexpressive mask that the
camera could transform into something meaningful, pleasurable or
divine.

Many film directors have built their reputation upon the idea
that they and not the actors create meaning: most notably, Alfred
Hitchcock and Robert Bresson. Ginette Vincendeau writes that, for
the French New Wave cinema of the late 1950s and 60s, it 'was

important that actors and actresses were seen not to act, especially in contrast to the Tradition of Quality cinema, which foregrounded polished performances, careful lighting and framing, experienced mastery of space ... well-modulated delivery of dialogue' (Vincendeau 2000: 117). Foregrounding improvisation by filming on location, directors such as François Truffaut and Jean-Luc Godard promoted casual speech and underplaying, retaining mistakes and fluffed lines in some cases. This was a mode of cinema that not only sought to counter older traditions of French and American film-making but also to make the directors rather than the actors the new stars of the cinema. Nevertheless, New Wave stars did emerge (e.g., Jean-Paul Belmondo and Jeanne Moreau) and many of these proved to be highly versatile performers capable of building and sustaining prominent film careers in art-house *and* mainstream commercial cinema, and across a range of genres.

Versatility is a feature of star acting, particularly in the post-studio era. Although stars are often considered to play themselves in each and every role, being associated with a particular type, a specific genre and a recognisable set of mannerisms, the reality is that most stars since the 1960s have been required to work for different production companies, with a variety of directors and crew, often in different countries and across a range of genres and media in order to maintain their star profile. Even stars that work in one national context, regularly collaborating with a specific group of film-makers, need to be versatile in their approach to performance, as is revealed in Rayna Denison's essay on Shah Rukh Khan's post-millennial films (Denison 2010).

While acknowledging that Bollywood's biggest star of the 1990s and 2000s is not generally celebrated for his acting skills, Denison insists upon his versatility as an actor by noting the extent to which he works across a range of genres and plays a range of character types, maintaining a relatively consistent star persona despite this high level of diversity. She notes that, since 2000, Khan's acting

choices have shown a high degree of variation, including parodies of his own previous work (e.g., *Om Shanti Om*, Farah Khan, 2007), as well as a significant degree of genre mixing. Denison observes, for instance, that in *Main Hoon Na* (*I Am Here for You*, Farah Khan, 2004) Khan is required to make sudden shifts between action sequences and melodrama, describing his acting here as 'generically aware', which also involves mixing various Hollywood and Bollywood styles in a complex blend. From this perspective, a star widely regarded as 'average' and 'unexceptional' as an actor seems considerably more accomplished. The importance of this essay, moreover, is that it forces us to think about the complexities of film acting and how we as scholars understand and appreciate the challenges facing star actors. Denison has noted that as the actors at the centre of film narratives with the most screen time, stars often have 'the most generically complex parts to play' (ibid.: 187). As a result, she adds, 'the central actor is typically required to produce a more generically nuanced performance than those around him or her, while at the same time producing a performance that often becomes the bench-mark for expressive coherence across the film' (ibid.). Viewed in this light, the challenges facing star actors would seem to be considerable, requiring them to develop a critical awareness and facility for a range of acting styles and genres, as well as a distinctive idiolect that links each of their performances from scene to scene and film to film. This requirement suggests that while physical and vocal attractiveness might enable them to stand out from their fellow performers, ultimately their longevity as film stars demands much more.

Conclusion

Among the numerous issues and topics worth considering when conducting research on an individual star is the quality or qualities

that singled them out for stardom and distinguished them from other film performers. In some cases, this will be their physical attractiveness, their good looks or physique. In other cases, this will be their attractive or expressive voice, face, eyes and/or body. Some stars may be distinguished by their remarkable acting talent and distinctive idiolect, their poise or energy. Many stars may combine such qualities, some of these compensating for others that may be lacking (e.g., looks rather than acting talent or vice versa). Detailed analysis of a star's films, publicity and reviews can provide a useful means of understanding what made a star a star, as well as what made them different from other stars. Such questions can provide a useful starting point to an investigation into their stardom but it may also reveal the degree to which such qualities remained consistent throughout their career as a defining characteristic or how these changed over time as the star aged or gained experienced. The loss of such qualities as looks, voice and glamour, for instance, may account for a decline in popularity. Identifying a star's particular qualities and mapping these over time, therefore, constitutes a major component of many star studies.

4 STAR SYSTEMS: THE MECHANICS OF STAR PRODUCTION

Introduction

Jeanine Basinger writes that 'the entire studio system depended on movie stars and was built on top of them', describing stars as the 'most precious commodity in the economic system' (Basinger 2007: 16). She adds that film 'factories took charge of the star-making process, speeded it up, and ultimately reduced the phenomenon to its essence: even dogs and kids could be stars, if handled correctly' (ibid.: 18). Basinger claims that the Hollywood stars that came to prominence after the coming of sound in the late 1920s were machine-made: discovered, developed, modified, branded and rebranded in a highly formalised system, the 'studio system', whether they were Lassie or Shirley Temple, Mickey Rooney or Rin Tin Tin.[1] Robert S. Sennett, in *Hollywood Hoopla: Creating Stars and Selling Movies in the Golden Age of Hollywood*, similarly argues that, from the 1930s to the 50s 'making stars, becoming a star, and connecting with the stars was a national obsession and the mantra of the industry' (Sennett 1998: 36). Consequently, stars 'were built, bought, and sold' (ibid.).

Stardom has been a dominant feature not just of Hollywood but of film industries around the world and, as such, can be considered in terms of the mechanics of the star system, including the way stars are discovered, developed, deployed, presented and

evaluated within the film industry. The system is characterised by star and studio associations (e.g., Garbo and MGM, James Cagney and Warner Bros., Shah Rukh Khan and Yash Raj Films), the production of star vehicles (e.g., the Charlie Chaplin film, the Gracie Fields film, the Arnold Schwarzenegger film), often associating certain stars with specific genres (John Wayne and Westerns, Gene Kelly and musicals, Boris Karloff and horror movies) or developing actor pairings (Ginger Rogers and Fred Astaire, Nargis and Raj Kapoor, Rock Hudson and Doris Day). The system also entails actor–director pairings (Rock Hudson and Douglas Sirk, Amitabh Bachchan and Hrishikesh Mukherjee, Robert De Niro and Martin Scorsese, Johnny Depp and Tim Burton). The role of agencies, such as ICM (International Creative Management), in packaging talent (most notably, stars, writers and directors) is crucial here, with these associations and collaborations operating within economic and legal frameworks. Contracts determine a star's conditions of service with a studio, their levels of autonomy and control. Within this system, some stars have prospered, even becoming the directors and producers of their own films (e.g., Woody Allen, Jodie Foster and Amitabh Bachchan). While some aspects of the system have changed over time, others have remained consistent.

This chapter is chiefly concerned with the economics and business practices of stardom and the ways in which stars operate within the industrial context of film production, distribution and exhibition: that is, as workers, commodities and capital. It sets out some of the main characteristics of the star systems of Hollywood, Bollywood and (to a more limited extent) Europe, noting changes over time, such as from the studio to post-studio era, raising questions about the economic value of stars and considering some of the principal mechanisms for managing stars and transforming them into commodities that can be bought and sold. In part, this is concerned with the terms and conditions of the contracts between stars and studios, but it is also about casting practices (particularly

typecasting) and the use of star vehicles as a means of stabilising demand for film among moviegoers. This chapter also notes the way in which a number of major stars have gained greater levels of control over their work by becoming directors and producers, often of their own star vehicles, a process that entails substantial amounts of training and experience in addition to investment and collaboration.

Industries

Although cinema originally had little need of stars, by 1919 the content, production and publicity of the movies were focused on stars and the star system became central to the commercial film industry during the 1920s (Morin 2005: 4). Edgar Morin describes this period as a 'glorious era' when stars were truly stars (eccentric, excessive and larger than life) in comparison to the 1930s, when stars were brought down off their pedestals, no longer regarded as gods so much as commodities, 'a total item of merchandise' (ibid.: 113). Richard Dyer, on the other hand, argues that stars 'are involved in making themselves into commodities', with the star being fashioned out of 'the raw material of the person', through a variety of processes (e.g., make-up, hairstyle, clothing, dieting, body building, plastic surgery, etc.), their personality being as malleable as their body (Dyer 1987: 5). While much of this process is undertaken by specialists and professionals (e.g., make-up artistes, hairdressers, dress designers, dieticians, body-building coaches and trainers, acting coaches, dance tutors, etc.), Dyer insists that the star also plays an active role. Similarly, Paul McDonald asserts that both stars and the star system are products of collective work, involving a number of professionals: including producers, talent agents, publicists and managers (McDonald 2000: 117). Within the detailed division of labour that was a defining characteristic of the studio system (c. 1920–60) stars were 'categorized as performance specialists', who assumed a range

of tasks, including reading scripts and learning lines, rehearsal, shooting scenes (repeating takes when required), dubbing or post-synchronisation and promotional activities (ibid.: 9). As the elite group within a hierarchy of film actors, stars function like any other actor but with additional responsibilities in terms of promotion and generating publicity (ibid.: 10).

Stars are differentiated from other film actors by the level of attention given to them in terms of marketing, promotion and critical reception, but also in the level of remuneration they receive. Stars are not only a category of labour but also a form of capital, constituting a significant investment. An actor's star status ultimately rests upon their proven popularity with large numbers of moviegoers and the extent to which that sizable audience can be predicted to attend a movie in which the star appears. On that basis, a star can command a high salary, which is justified by the probability that audiences will pay to see their films.

As in Hollywood, the power of the Indian star developed gradually but the position stars command today – both economically and in the popular imagination – is the result of an idiosyncratic economic system that has accorded them more absolute power than even their Hollywood contemporaries. (Gandhy and Thomas 1991: 107)

According to Behroze Gandhy and Rosie Thomas, the star system in India 'developed in parallel – and with awareness of – the Hollywood star system', although with large numbers of film companies operating like extended families, many being family businesses (ibid.: 108).[2] While the stars of the 1930s usually received monthly salaries 'that were far from excessive', this changed during the 1940s when, often on the back of war profiteering and illicit arms deals, wealthy independent producers entered the film industry as a means of money laundering (ibid.: 113). These producers lured the major stars away from their studios by paying them enormous fees, star

Raj Kapoor with Nargis (Fatima Rashid) in
Andaz (*Style*) (1949)

salaries rising rapidly from around 3,000 rupees per month in most
of the big studios in the 1930s, to around 20,000 rupees per film by
the early 1940s, to as much as 200,000 rupees by 1950. By 1955,
these figures had doubled (ibid.: 119).

The biggest male stars to emerge during the 1950s were Dilip
Kumar (star of Bimal Roy's celebrated *Devdas*, 1956), Raj Kapoor
(star of Shombhu Mitra's *Jagta Raho*/*Stay Awake*, 1956) and Sunil
Dutt, who co-starred with Nargis in Mehboob Khan's classic *Mother
India* (1957). Nargis (originally Fatima Rashid) was the biggest
female star of the 1950s, having appeared in many of Raj Kapoor's
films during the early to mid-1950s (Majumdar 2009: 150–5). None
of these, however, were able to match the star power and success of
Amitabh Bachchan, after his breakthrough role in Prakash Mehra's

Zanjeer (*Shackles*, 1973) and his starring role in Ramesh Sippy's spectacularly successful *Sholay* (*Flames/Embers*, 1975). Bachchan's popularity and star profile remained unprecedented until the 1980s, when he was eventually superseded by a younger generation of stars: most notably, Aamir Khan and Shah Rukh Khan.

During the 1990s, Bollywood was transformed into a high-tech global entertainment industry. Once run by an older generation of largely uneducated men with little respect for orthodox business practices (e.g., contracts, lawyers and agents), it became dominated by a new generation of technological, university-educated urbanites determined to compete more directly with Hollywood. On 10 May 1998, Bollywood was granted 'industry status' by the Minister of Information and Broadcasting, opening up opportunities for investment by banks and other financial institutions, which required more formalised operating and accounting systems, leading to many of the industry's most notorious irregularities being tightened up. This led to marked improvements in the production standards of Bollywood films, so when Shah Rukh Khan remade Amitabh Bachchan's *Don* (Chandra Barot, 1978) in 2006, it became a big-budget glossy spectacular, having more in common with Tom Cruise's *Mission: Impossible* (Brian de Palma, 1996) than Bachchan's tough, gritty underworld thriller.

By the twenty-first century, the structures of the Indian and American film industries had much more in common than during the 1940s and 50s. Since the 60s, the Hollywood studio system has crumbled as a result of anti-monopolistic legislation, competition from television and declining audience figures. Nevertheless, stars have remained central to the new production systems implemented to ensure the industry's survival. Paul McDonald, in *The Star System*, has explained the key changes that took place in the industry from the 1950s, with the rise of the 'unit-package system' in which independent production companies negotiated distribution deals with the major Hollywood studios with a star (or a number of stars)

as an integral component (McDonald 2000: 71–8, 81–8 and 111–13). Throughout the remaining decades of the twentieth century, Hollywood film stars gained increasing levels of freedom and control over their work, including setting up their own production companies, forming partnerships, acquiring a percentage of the box-office takings for their films and commanding ever-increasing salaries. Stars as diverse as Robert De Niro, Whoopi Goldberg, Tom Hanks, Goldie Hawn, Steve Martin, Eddie Murphy, Julia Roberts, Sylvester Stallone and Robin Williams prospered in this new commercial environment. [3] However, McDonald notes that in the wake of a series of failed star-driven blockbusters questions were raised at the end of the 1990s about the financial viability of expensive stars (ibid.: 101).

Economic studies of the film industry have frequently challenged the view that stars reduce the uncertainty of a film's success, guaranteeing greater profitability in terms of box-office returns. De Vany and Walls's 1996 study 'Uncertainty and the Movie Industry: Does Star Power Reduce the Terror of the Box Office?' suggested that the strategy of using high-profile stars has negligible financial benefits (De Vany and Walls 1996). While John Sedgwick and Michael Pokorny, the editors of *An Economic History of Film*, dispute this, they (and several of the authors included in this anthology) can only claim a limited influence for the ability of big-name and expensive stars to impact positively on a film's profitability. They suggest that many stars do have a positive financial impact but only across a portfolio of films rather than on each and every film (Sedgwick and Pokorny 2005: 157). In order to establish the economic benefits of using stars in films, Larry Stimpart, Judith Laux, Coyote Marino and George Gleason conducted an extensive review of the available studies and literature in 2008 for their essay 'Factors Influencing Motion Picture Success: Empirical Review and Update'. Here they concluded that 'a successful motion picture is the result of many factors that are combined in a unique way to produce

a winning product' (Stimpart et al. 2008: 48). The most important factor they discovered was the quality of the film, as represented by awards and positive reviews. Other notable factors likely to affect the performance of a film at the box office are marketing and advertising, along with distribution and release dates (e.g., holiday periods). While sequels of successful films are likely to improve a film's chances of commercial success, the presence of major stars appears limited and inconsistent in terms of guaranteeing box-office returns. Indeed, what much of the economic research on the film industry indicates is that the value of stars comes from generating publicity as part of the marketing strategy rather than stabilising the financial returns of a particular movie (Bakker 2001).

Paul McDonald has suggested that the package-unit mode of production has resulted in a 'shortening of the average life-span of star popularity' and increasing the variability of their track record at the box office (McDonald 2000: 101). However, he accounts for this high degree of fluctuation in stars' revenue by noting that in the post-studio era many stars have adopted a strategy of accepting work in low-budget, independent and art-house or cult movies in addition to big-budget studio blockbusters in order to satisfy creative as well as commercial ambitions. A star's involvement with more creative, innovative low-budget 'indies' is likely to reduce their overall box-office record, creating higher levels of unevenness.

Today, actors and actresses *float* across and around stardom. They take jobs as they choose, accept whatever billing is appropriate to the role, keeping careers moving from film to film, country to country, big-budget flick to small independent movie, from film to television to stage – whatever and wherever. (Basinger 2007: 525, emphasis in original)

According to Jeanine Basinger, there is no longer one system for developing stars, with no 'star machine' operating in Hollywood since the 1960s (ibid.: 525-6). She describes the stars that belong to

this era as 'neo-stars', defining a neo-star as an 'actor who floats between typecasting and character acting' (ibid.: 537). Nevertheless, she insists that audiences 'refused to abandon type, stubbornly settling for modern movie actors to be defined by a specific "type" of *role*, which is not the same thing as the typecasting of the past' (ibid., emphasis in original). In the past, stars were not only real stars (i.e., larger than life and more glamorous) but types, having recognisable and fairly consistent screen personalities, often forced to sacrifice variety by their studio, having forfeited their right to choose their roles or to determine their image when signing their contract.

Contracts

As one sign of the star, the studio term contract has some advantages over other signs (personal appearances, newspaper interviews, photographs), which promise indexicality but deliver only myth. The contract has a truth status because it bears the notarized signature of the actor, divulges his or her legal name, and contains confidential information about the real conditions under which the star works. (Gaines 1992: 146)

The above statement from Jane Gaines's *Contested Culture: The Image, the Voice and the Law* indicates the value of contracts for star scholarship, noting the contract's distinction from virtually all other forms of star text in terms of its status as not only a legal document but also one that is essentially truthful. Thus, contracts can be revealing in all kinds of ways, providing a sense of the person behind the star image as well as detailing their relationship to their studio, their specific requirements (e.g., perks) and duties, reflecting the distinctive nature of their stardom and their status within the wider context of the acting fraternity. Just as these have all been carefully thought out, negotiated and very precisely articulated, they reward careful scrutiny and consideration.

Ever since Hollywood instituted mechanisms to produce and manage stars, contracts have played a vital role in the film industry. In order to retain control and ownership of their talent, studios employed stars on contracts that could last for seven years, with an annual or biannual option to release the star if they were no longer viable. The star, on the other hand, did not have the option of leaving the studio until the full term of the contract had expired unless the studio decided to release them. As long as they were under contract, the vast majority of Hollywood stars from the late 1920s to the early 60s were legally required to work exclusively for the studio that had contracted them, having no say in the roles in which they were cast nor how their image, voice or performances were used, either in films or promotion and publicity. The major studios (MGM, Paramount, Warner Bros., RKO and 20th Century-Fox) had large 'stables' of stars from which they could repeatedly cast their films in numerous combinations to ensure both consistency and novelty. Danae Clark has observed that the Screen Actors Guild reported that 'between 1937 and 1946, the number of players under long-term contracts to Hollywood studios varied between six hundred and eight hundred' (Clark 1995: 23). She also notes that as the option contracts that bound stars exclusively to the major studios for up to seven years provided no legal entitlement for actors to break this arrangement, producers were able to 'regulate the division of labor under the star system and enforce the use of typecasting', forcing actors to continually play the same kind of role (ibid.). Paul McDonald notes that for 'performers new to the industry, a term contract with a studio offered an attractive and secure prospect' (McDonald 2000: 62). However, he also notes that, as a performer's career developed, 'the initial conditions laid out in the studio's contracts frequently proved restrictive' (ibid.). For as long as the contract ran, the studio was able to manage the actor's image and workload in return for a salary that was determined (with a series of annual increases) at the time of

signing, thereby preventing large pay increases following a dramatic leap in popularity.

Major stars are notoriously (and many claim, excessively) well paid, particularly male stars, who have consistently earned more than their female counterparts.[4] Moreover, there is a huge differential between the salaries received by stars (those actors at the apex of their profession) and their colleagues lower down the scale (e.g., character actors, supporting players, extras and stunt people). Danae Clark, in *Negotiating Hollywood*, writes that during the 1930s the Screen Actors Guild discovered that the vast majority of professional actors working in Hollywood were on low incomes. She writes that, an 'estimated 71 percent of the actors who worked in 1933 earned less than $5,000; only 21 percent earned between $5,000 and $10,000; and the high-priced category of stars (those earning more than $50,000 per year) constituted only 4 percent of the total acting profession' (Clark 1995: 60). Since then stars have gone on to command huge fees, with the likes of Tom Cruise and Will Smith earning over $20 million for some of their films during the late 1990s and early 2000s. Jeanine Basinger writes that, when 'assessing the astronomical salaries top stars make (the big ones are called "the $20-million club"), people forget that today's actors have to assemble a mini-studio roster of personnel in order to operate' (Basinger 2007: 526). She notes that in addition to agents, business managers, lawyers and publicists, many stars also have to hire security staff, script developers, writers and fashion advisors: in other words, the kinds of specialist employees previously hired by the studios to assist their stars during the studio era.

During the studio era there was no standard contract, with individual actors being able to negotiate their own terms and conditions of service. Nevertheless, many contracts contained more or less the same set of features, such as the provision for studios to be able to loan stars out (for a fee) to other studios without the consent of the actor, the fee going to the studio rather than the star. Any star that

refused to be loaned out or to play a role determined by their studio would invariably be threatened with suspension without pay. Indeed, Gaines suggests that one of the major ways in which studio executives exploited the contract system involved using a technique that she calls 'cost-effective miscasting' (Gaines 1992: 152). This strategy involved assigning high-salaried actors to play unsuitable roles, so that when the actor refused, the producer could suspend them, saving the studio the expense of their weekly salary and thus reducing the studio's overhead costs. Gaines notes that suspension 'effectively stopped the seven-year contract clock, thus adding more time to the actor's required employment for every day he or she was laid off' (ibid.). In this way, with repeated periods of suspension, a seven-year contract could run for eight or nine years. However, Gaines also notes that no actor under contract could actually be legally forced to work, 'since to force an employee to work is a violation of the involuntary servitude clause of the Thirteenth Amendment to the US Constitution' (ibid.: 153). Nevertheless, in practice what studio bosses could do was 'enforce the contract's *negative services covenant*, which stipulates that the employee must not work for anyone else during the term of the contract' (ibid., emphasis in original). Any employee who took another acting job (in film, radio or theatre) would find themselves sued for breach of contract, ending up in court.

Barry King, in his essay 'Stardom as an Occupation', notes that stars were one of the few highly paid staff in Hollywood during the studio era to be hired on fixed-term full-time contracts and paid a fixed salary, irrespective of how many films they made or how much money their films earned (King 1986: 165). In contrast, directors and writers tended to operate on a freelance basis, which enabled them to make films for numerous different studios, negotiating their salaries on a case-by-case basis, enabling them to capitalise on previously successful films by demanding higher fees. Star contracts were also unusual in other ways, especially in terms of the ownership of a star's image. One of King's most important contributions to the

debate on star contracts is his recognition of the split between the studio's legal right to the actor's body, face, voice, etc., and the actor's natural or physical possession of these.

Whilst the contract for the employment of the star closely stipulates the limits on the utilization of the image and the necessity for the preservation of its physical/psychological bearer as a matter of legal ownership, nevertheless it remains factually the case that the star is ultimately the possessor of the image. (Ibid.: 168)

Since the star is physically attached to their image, however much that image has been developed by a studio, they appear to have some grounds for claiming legal ownership of it. King observes that this results in the confrontation of a legal monopoly with a physical one, rendering the contractual arrangements between stars and studios ambiguous and contentious. Jane Gaines, meanwhile, has stated that the 'basic film and television talent contract is markedly different from the employment contract in other industries (in which one agrees to be separated from one's labor power for the duration of the employment) because of what it is that the actor leaves with the employer' (Gaines 1992: 155). While most workers leave the products of their labour with their employer, the screen actor can do so only by being 'permanently separated from tangible aspects of personhood – his or her voice and photographic likeness' (ibid.).

And since photographic and electronic technologies do, in fact, preserve the actor in time, the legal question becomes, Can the actor regain control of his or her image after the expiration of the term contract? Can these aspects of personhood, once they are embalmed in celluloid or stored on magnetic tape, ever be reclaimed by the actor? (Ibid.)

Gaines notes that, in most cases, studio-era contracts granted a studio 'sole and exclusive right' to an actor's name, performance,

image and voice, allowing it to use these for the purposes of advertising and publicity, as well as all other types of entertainment: film, theatre, radio and television (ibid.: 156). Gaines states that these contracts frequently granted studios the rights for all uses of an actor's 'acts, poses, plays and appearances', this expression being widely understood to transfer these unquestionably to the copyright holder (i.e., the studio). However, the rights to the 'name, voice, and likeness' remained less clear and more contestable, given that these elements are uncontrovertibly aspects of personhood (ibid.: 157). Consequently, as Danae Clark has demonstrated in *Negotiating Hollywood*, this area became characterised by 'struggle, resistance and negotiation between star and studio, the studio's rights being repeatedly contested' throughout the 1930s and 40s (Clark 1995: 24).

British actor Robert Donat was involved in a series of contractual disputes with Hollywood studios during the 1930s, having previously enjoyed more flexible working arrangements in Britain that enabled him to make films with a number of studios and combine film and theatre work (Street 2006). However, while Donat had to fight the Hollywood studios during the 1930s and 40s in order to preserve his autonomy, French actor Charles Boyer skilfully managed to turn the studio contract system to his advantage when he worked in Hollywood from 1929, as Alastair Phillips has noted (Phillips 2006). Boyer was initially hired on short-term contracts with MGM, Paramount and Fox that enabled him to continue working in Europe in between engagements in Hollywood. In 1934, he hired the agent Charles Feldman to negotiate a series of one-picture contracts for him. Although typical of French working practices, this was unusual in Hollywood at the time. By 1936, Phillips observes that, 'Boyer had assembled an individualised administrative team that comprised of an accountant and financial adviser as well as personal secretary' (ibid.: 87). He notes that another of Boyer's important associates was the independent

Tovarich (1937), starring Charles Boyer and
Claudette Colbert

producer Walter Wanger, who, in 1937, 'leased the star to Warner
Bros. for eight weeks for the sum of $100,000' in order to appear
opposite Claudette Colbert in Anatole Litvak's romantic costume
drama *Tovarich* and to MGM to star as Napoleon opposite Greta
Garbo in Clarence Brown's *Conquest* (ibid.: 88). Boyer would appear
to be one of a minority of stars who operated successfully in
Hollywood during the studio era outside of the typical fixed-term
option contract system. [5]

Discoveries

By 1930, the Hollywood studio system had been developed in the
USA to manufacture a large number of stars in a highly systematic

and cost-effective way (McDonald 2000: 44). Recruiting performers from vaudeville, burlesque, theatre and radio, studio talent scouts scoured the theatres and nightclubs of major cities in search of new stars. Following a successful screen test, many performers were placed under exclusive long-term contracts with the studio. Once signed, a 'contract player' would receive a weekly wage while undergoing an intensive apprenticeship, receiving tuition from the studio's speech and diction coaches, along with acting classes with the drama coach. By the late 1930s, virtually all of the major studios operated a drama school, so that acting training and coaching formed an important part of the Hollywood studio system in the 1940s and many of the big stars of this era were required to gain and perfect their acting methods.[6] Cynthia Baron and Sharon Marie Carnicke note that the studio-era acting teachers taught actors to use the script as a blueprint for building characterisation, while preparation was required to 'integrate directorial suggestions and interact effectively with other actors' (Baron and Carnicke 2008: 27). Many of these techniques (subsequently associated with the 'method' and Lee Strasberg's teaching) were taught in Hollywood during the 1930s and 40s under the guise of 'modern acting', being based largely on the teachings of Constantin Stanislavski. Stanislavskian principles of script analysis, character development and research, along with the identification and use of identifiable 'beats' (or units of action), formed a vital part of actor training in studio-era Hollywood (ibid.: 211–12). Moreover, the peculiar method of mainstream commercial film-making made actor 'training, experience, and more independent preparation' essential (ibid.: 236). With limited time for rehearsal and scenes shot out of sequence, actors needed to arrive on set prepared and understanding how each scene fitted into both the story and their character's development.

While many Hollywood actors joined the film industry having acquired a drama school education and theatrical experience, some arrived with little or no background in theatre (e.g., from radio,

vaudeville or some other area of entertainment, such as sport) and therefore needed to be given a crash course in drama. Besides acting, other lessons included singing and dancing, etiquette, movement, fencing, horse riding, swimming, boxing and languages (McDonald 2000: 44). While undergoing such training, stylists would be consulted about hair, make-up and fashion. Hair was frequently restyled, dyed (occasionally electrolysis being used to change the hairline), eyebrows were reshaped, false eyelashes fitted and teeth capped and enamelled.[7] Teeth might even be removed to lend greater definition to cheekbones and, in some cases surgery might realign noses or remove blemishes to the skin. New names would often be found for these made-over actors in a bid to augment their glamorous new image. While some stars were able to retain their names because they suited their persona, had an attractive rhythm and were easy to pronounce and spell (e.g., James Cagney), others needed some minor refinement (e.g., Elizabeth Grable became Betty Grable) or major adjustment (e.g., Doris von Kappelhoff became Doris Day), while others were changed altogether (e.g., Lucille LeSueur became Joan Crawford). The Hollywood star treatment was, according to Robert S. Sennett, 'ruthless, impersonal, and universal' so that, as soon as a name had been agreed upon, a biography was invented for the newcomer, who would then be escorted to parties, premieres and nightclubs by a studio publicist to generate media interest (Sennett 1998: 37). Only then would the task of finding suitable film roles begin, from which would emerge the newcomer's 'type'.

In *The Star Machine*, Jeanine Basinger describes the way in which the major Hollywood studios of the 1930–50s, used a three-step process for developing new stars, known in the industry as the 'build-up' (Basinger 2007: 45). During the first stage, contract players appeared in 'bit parts' and 'walk-ons', small roles with minimal dialogue. Success at this stage could lead to speaking parts. However, a newcomer's continued casting would depend on them

being singled out for praise by reviewers or by generating fan mail, all newcomers being subjected to intense scrutiny: for instance, by research companies hired by the studios to study and assess their performers' popularity, using a variety methods. This included fan mail and box-office takings, but also 'star ratings' based on interviews with moviegoers of different ages, sex, income and geography (McDonald 2000). Many of the major Hollywood studios commissioned such research from Audience Research Inc., a company set up in 1938 by George Gallup to provide the film industry with 'Continuing Audit of Marquee Values' (Stacey 1994: 107). A star's 'Marquee Value' provided an index of how an actor's name associated with a film could impact on that film's box office. An increasing marquee value could result in the actor being given top billing in their films, while also ensuring that the options on their contract were taken up when their contract came up for renewal.

If a contract player received positive feedback in terms of fan mail, box-office receipts, star ratings and marquee value then, as Basinger writes, 'the system *really* went to work' (Basinger 2007: 45, emphasis in original). During the second stage of the 'build-up', the studio's publicity department would be set in motion, with the newcomer's fake biography and studio portraits (including female 'cheesecake' or male 'beefcake' shots) being 'planted' by publicists in a range of publications. In between personal introductions to magazine editors (e.g., of *Photoplay*, *Modern Screen*, *Screenland*, *Movie Stories* and *Screen Album*), reporters and gossip columnists (most notably, Louella Parsons and Hedda Hopper), the newcomer would be able to test out their newly acquired performance skills in leading roles opposite other newcomers or in supporting roles for established stars. If they received good reviews and found favour with audiences (e.g., at previews) they would graduate to the third and final stage, being cast in leading roles in their own vehicles in an attempt to find the most appropriate (i.e., lucrative) 'type'. Jeanine Basinger notes that this final stage of the 'build-up' usually involved

three types of film: (i) the actor is noticed by audiences; (ii) their perfect type is discovered; (iii) the favoured role is repeated (ibid.: 79). Basinger insists that '[e]very top-of-the-line movie star had to find a type that he or she could play over and over' (ibid.: 71).

Typecasting was the dominant practice in Hollywood from the silent to the sound era, and from the studio to post-studio era, having been adopted from the American stage, where a 'lines of business' system was established in the 1860s to supply stock companies with actors for particular types of character (Wojcik 2004b: 169–89). The Hollywood stars that came to prominence during the 1910s, started out as types: Mary Pickford as an adorable, playful tom-boy; Douglas Fairbanks as an athletic adventurous hero; Lillian Gish as a suffering angel of virtue; Charlie Chaplin as the pathetic but wily and funny little tramp and Gloria Swanson as a glamorous seductress.[8] By the 1920s these stars were all famous for their off-screen personalities and personal lives, their wealth and ambitions, their high-profile relationships and friendships, developing public images that went beyond (and even contradicted) their type and yet their repeated attempts to abandon their on-screen types usually resulted in disappointed audiences and disappointing returns at the box office.[9] Consequently, typecasting became a common feature of the film industry and, by the 1930s and 40s, it was firmly established as a major component of the Hollywood studio system, enforced by the fixed-term option contract, and enshrined within the star machinery that discovered and developed stars. Even once the studio system had been broken up, successive generations of audiences revealed a distinct preference for stars being used consistently to play a particular type or, at least, set of types, ensuring that many actors, even when they took charge of their own casting choices by directing and producing their own star vehicles, often appeared in roles that, on the whole, remained consistent with their previous work.[10] Nevertheless, generations of actors have resisted typecasting, often denouncing the practice or citing it as a reason for either quitting the

film business or, at least, avoiding Hollywood productions in favour of independent or foreign ones. [11] This becomes clear when examining the history of British actors that have worked in the American film industry (e.g., Robert Donat and Eric Portman).[12] Despite actors' resistance to being typecast, the practice remained central to the operations of the Hollywood studio system since, as Jeanine Basinger writes, for 'the studios, it guaranteed factory efficiency but it also meant that a star's character was in place and movies called "vehicles" could be quickly assembled, made, and released by the factory' (Basinger 2007: 100).[13]

Vehicles

The Hollywood star vehicle emerged out of the studio system's attempt to reduce the uncertainty of the market appeal for films. A studio, having incurred all the costs of producing the film before its release, needed a way to maximise the probability that audiences would be willing to pay to see it on its release at the cinema. With no way of knowing in advance how many people would attend these screenings, film production was a huge gamble. Cinema was a gamble for audiences too, since there was no way of knowing if a film would provide a sufficiently pleasurable experience before purchasing a ticket at the box office. This was less of an issue when films were short and ticket prices cheap but once films exceeded ninety minutes and the price of admission increased, moviegoers required a guarantee that their money would be well spent. The main function of the star was to persuade large numbers of people to part with their money in advance of seeing a movie in order to ensure a profitable return on the production, distribution and exhibition of a film. The star vehicle was a film designed to exploit the popularity of a particular performer by accommodating their established 'type' and both reworking and advancing aspects of their previous work

that had already proven popular with an audience, providing a delicate balance between novelty (originality) and familiarity (repetition).

Gerben Bakker, in 'Stars and Stories: How Films Became Branded Products', notes that from 'the early 1910s, stars were increasingly used to brand films' due to the fact that stars generated greater brand loyalty than other trademarks (e.g., the studio's name and logo) and because 'stars also had a longer product life-cycle than the films or serials themselves' (Bakker 2001: 470). He also notes that even 'if a film failed, the star as brand had done his or her work by attracting people to the cinema in the first week' (ibid.: 493). Longer and more lucrative runs would depend on word-of-mouth appreciation and good reviews, which depended largely on the overall quality of the film and the strength of the story rather than the star's performance. In most cases, a box-office failure would not end a star's career nor result in the termination of their contract with a studio nor even damage their popularity, so long as their next film proved more successful. Most major stars throughout the studio era regularly appeared in films that performed poorly at the box office in addition to their hits. This was how the system worked. If a studio could produce three or four films a year starring a particular actor and at least one of these was successful then the studio would gain a sufficient return on its investment in that star over a period of several years.

A studio's production of several star vehicles a year inevitably led to standardised products. However, while this invariably involved tried and tested means of delivering audience satisfaction, it always offered something different. For instance, the star might appear in a film of the same genre as her previous one (e.g., romantic drama), playing a similar character (e.g., a virtuous heroine) but in a different historical and geographical setting, paired opposite a different co-star. Alternatively, the star might appear in a different genre (e.g., romantic comedy), being 'off-cast' by playing a different kind of

character (e.g., a temptress) although, to retain some degree of continuity, in a similar geographical and/or historical setting and with the same co-star as her previous film. The key was always to provide some aspect of consistency, while introducing something new. Consistency was often achieved by having stars work within a specific genre, a limited range of genres or by devising star vehicles that incorporated aspects of two distinct genres.[14]

Star vehicles have long been a feature of Hollywood cinema but they were also developed in Europe, usually when a country's cinema was booming and mostly in relation to comedy and musical stars: hence the Jessie Matthews, Gracie Fields and George Formby films in Britain in the 1930s, the Zarah Leander films in Germany from 1937–9 and the Rena Vlahopoulou films and Aliki Vougiouklaki films in Greece in the 1960s (Papadimitriou 2009). Often, however, European film industries cannot support the continuous production of a series of films built around a single star. Consequently, even during the studio era, most European stars were cast in a range of different types of role in different genres. It was usually only when working in Hollywood that they were typecast or, if successful, appeared as the same 'type' in a series of star vehicles, sometimes working with the same director. So, for instance, when Marlene Dietrich left the Ufa studio in Germany to join Paramount in 1930, she found herself successively cast as a femme fatale in Josef von Sternberg's *Morocco* (1930), *Shanghai Express* (1931), *Blonde Venus* (1932), *The Scarlet Empress* (1934) and *The Devil is a Woman* (1935), having little control over her parts or her image. It was only after her contract expired and the studio system broke down that stars like Dietrich assumed greater autonomy (see Doty 2011). Since the 1950s, many stars have operated as freelance artists, their agents and managers negotiating non-exclusive contracts for individual films, often for an upfront (hence guaranteed) fee and sometimes with a percentage of the box-office takings. As this became common practice, the large Hollywood talent agencies (e.g., the Music

Corporation of America, the William Morris Agency, International Creative Management, United Talent Agency and the Endeavour Talent Agency) have played a major role in orchestrating package deals (e.g., a combination of star, producer, director and a script) for which they receive a commission from their clients (McDonald 2000: 78–81 and 96–100).

Talent agents are a feature of the film industry in many parts of the world, especially in Europe, although they were only permitted in Germany from 1994 (Hagener 2002: 100). However, agents are not alone in mediating between stars and studios, stars and the media. Since the 1990s, managers have played an increasingly important role, procuring work for stars and establishing the basic terms of their contracts with production company executives, offering career guidance and business advice (McDonald 2008: 171). Managers usually offer stars a more personal service than agents, sometimes working exclusively for just one client. Although a small number of large-scale management companies do exist, this sector is characterised by a high proportion of medium and small-scale operations, providing specialised services to emerging and middle-ranking stars that would otherwise be neglected by agents in favour of the top stars.

Associates, hyphenates and collaborators

In India in the 1940s and 50s, it was possible for successful film stars to become directors, directing their own star vehicles but also those of their colleagues, with whom they formed close associations. This was certainly the case with Raj Kapoor who, after making a name for himself as an actor in *Dil-ki-Rani* (*Sweet-Heart*, Mohan Sinha, 1947), went on to become a major star of Bombay Cinema. In 1948, he made his directorial debut with the film *Aag* (*Fire/Desire*), in which he starred alongside the actress Nargis. The second film he directed,

Barsaat (*Monsoon*, 1949), was a joint star vehicle for himself and Nargis, the couple also appearing together in Mehboob Khan's *Andaz* (*Style*, 1949) that same year. While the actor Dilip Kumar played the leading male role in *Andaz*, it was Kapoor with whom Nargis went on to collaborate more closely throughout the 1950s (see Majumdar 2009: 150–72). Their nine-year association consisted of an off-screen romance and a total of sixteen films, including Kapoor's best-known and most internationally celebrated film *Awara* (*The Vagabond*, 1951), as well as *Aah* (*Sighs of the Heart*, Raja Nawathe, 1953) and *Shree 420* (*Mr. 420*, Raj Kapoor, 1955). Their last film together was *Chori, Chori* (Anant Thakur, 1956), the Hindi remake of Frank Capra's *It Happened One Night* (1934), after which they separated, personally as well as professionally, due to Nargis's affair and subsequent marriage to Sunil Dutt, who played her son in *Mother India* (Bose 2007: 172–89).

Nargis was also closely linked to director Mehboob Khan, regularly appearing in his films and often working for his production company. Prior to forming her attachment to Kapoor, she had also been closely associated with the actor Dilip Kumar, with whom she co-starred repeatedly in the late 1940s, in such films as *Mela* (*The Fair*, S. U. Sunny, 1948). Such associations emerged as a result of the family structure that characterised Bombay cinema, making director–star associations and star pairings a frequent occurrence, even persisting into the 1990s and 2000s: for instance, Shah Rukh Khan has maintained close working relationships with director Karan Johar and also Yash and Aditya Chopra. However, the association of stars and directors is not something peculiar to Bollywood and can be found the world over, in Europe, China and Hollywood. In France, they became a common feature of the New Wave cinema of the late 1950s and 60s (e.g., Jean-Paul Belmondo and Jean-Luc Godard, Jeanne Moreau and Truffaut) (see Vincendeau 2000: 115). Such associations, moreover, persisted beyond the New Wave and into the 1980s and 90s, most notably in the case of actress Juliette Binoche

and director Léos Carax on the films *Mauvais sang* (1986) and *Les Amants du Pont-Neuf* (1991) (ibid.: 244).[15]

Star–director associations are, as Michael Lawrence has pointed out, a key feature of art-house cinema from around the world.[16] They can, however, also be found within the commercial sector, including (studio and post-studio) Hollywood. Pamela Robertson Wojcik notes that during the studio era 'certain directors and producers, like Preston Sturges, John Ford, and David Selznick, maintain[ed] their own stable of players within the studio' (Wojcik 2004b: 182). Alfred Hitchcock could be added to this list, along with Orson Welles, Frank Capra and Howard Hawks, as all these directors have become associated with certain actors: Hitchcock with James Stewart, Cary Grant and Grace Kelly; Welles with Joseph Cotten and Agnes Moorehead; Capra with James Stewart and Barbara Stanwyck; and Hawks with Cary Grant. In post-studio Hollywood, associations have emerged between directors and stars, such as Robert Altman and Sissy Spacek, Keith Carradine and Shelley Duvall, as well as Steven Soderbergh and George Clooney. Nevertheless, it is clear from looking at the full list of films made by each of these directors that in every case the number of films they made with their associated actor is relatively small. The reality for most directors working in Hollywood is that they work with a wide range of stars and actors, just as stars work with a wide range of directors.

Sharon Marie Carnicke, in her essay 'Screen Performance and Directors' Visions', writes that, 'in moving from film to film, character to character, and director to director, the same actor can employ technique quite differently by adjusting physical means, if not anatomy, to the needs of the narrative and aesthetic style', adding that such 'adjustment lies at the heart of the performer's art' (Carnicke 2004: 49). This indicates that a key feature of stardom in commercial cinema is an actor's flexibility. Even if they present more or less the same 'type' in virtually every film, a star actor must adapt to the specific working methods of different kinds of director who

work in very different ways. Carnicke states that many film 'actors see their ability to adapt to narrative and directorial demands as the special expertise for which they are hired' (ibid.: 47). She also demonstrates this through her analysis of performances by the stars Jack Nicholson in Antonioni's *The Passenger* (1975) and Kubrick's *The Shining* (1980), Shelley Duvall in Altman's *Nashville* (1975) and Kubrick's *The Shining*, and Tom Cruise in Kubrick's *Eyes Wide Shut* (1999) and Neil Jordan's *Interview with the Vampire* (1994), each director requiring the star actor to work in different ways and produce different kinds of performance.

Very few stars enjoy the luxury of working consistently with the same director throughout their career, particularly since 1960, and almost any research project on a particular film star is likely to reveal different kinds of performance in films made by different directors. Of course, one way for film stars to gain greater levels of consistency and control over their work is to become their own director. While Raj Kapoor attained hyphenated status as star-director in Bollywood in the late 1940s and early 50s, Hollywood film stars became 'hyphenates' in the late 1950s and 60s as the studio system was disintegrating. Jeanine Basinger has observed that while Clint Eastwood was one of the 'last legendary stars to be born *inside* the studio system', he also thrived as the studio system collapsed, gaining 'Oscar winning producer-director-actor-composer quadruple-hyphenate status' (Basinger 2007: 523, emphasis in original). Eastwood is not alone in making the transition from star to star-director, star-producer or even star-director-producer. Burt Lancaster, Kirk Douglas and Marlon Brando all set up their own production companies and directed and/or produced their own films during the 1950s and 60s (McDonald 2000: 75–6). This trend continued thereafter, with many female stars becoming directors in order to obtain more control over their work, casting and performances: most notably, Jane Fonda, Jodie Foster, Whoopi Goldberg, Sandra Bullock and Drew Barrymore.[17]

Multi-hyphenated star: Barbra Streisand
co-wrote, produced, directed, acted and sang in
Yentl (1983)

In the 1970s Barbra Streisand became one of Hollywood's most successful stars, garnering a string of Oscar, Golden Globe, Emmy and Grammy awards and nominated as an actress and singer for her roles in *Funny Girl* (William Wyler, 1968), *Hello Dolly!* (Gene Kelly, 1969), *On a Clear Day You Can See Forever* (Vincente Minnelli, 1970), *What's Up Doc?* (Peter Bogdanovich, 1972), *The Way We Were* (Sydney Pollack, 1973) and *A Star is Born* (Frank Pierson, 1976). In the 1980s she became a director, making her own star vehicles *Yentl* (1983), *Prince of Tides* (1991) and *The Mirror has Two Faces* (1996). As Michele Aaron has noted, '*Yentl* made Streisand the first woman to direct, produce, co-write and star in a Hollywood film, but the Academy neither acknowledged nor rewarded this achievement' (Aaron 2006: 301). Indeed, the film has divided opinion of Streisand as either an extraordinarily creative and original talent or as an egomaniac intent on assuming total control over her work as an

artist, whatever the cost in aesthetic and financial terms (Wojcik 2000: 195).

Much greater respect has been afforded Oscar-winning actor George Clooney, who transformed himself from television star (most notably on the series *E/R* in 1984–5 and 1994–2009) to film star with his appearances in Robert Rodriguez's *From Dusk till Dawn* (1995), Michael Hoffman's *One Fine Day* (1996), Joel Schumacher's *Batman & Robin* (1997), Ethan and Joel Coen's *O Brother, Where Art Thou?* (2000) and Steven Soderbergh's *Ocean's Eleven* (2001). Thereafter, he effected a further transformation from film star to star-director with *Confessions of a Dangerous Mind* (2002) and even writer-director-star with *Good Night, and Good Luck* (2005), producing *The Jacket* (John Maybury, 2005) and, ultimately, becoming the co-writer-director-star-producer of *The Ides of March* (2011). Similarly, in Mumbai, Shah Rukh Khan joined forced with actress Juhi Chawla and director Aziz Mirza to form a production company, Dreamz Unlimited, in 1999. Although their first production, *Phir Bhi Dil Hai Hindustani* (*But the Heart is Still Indian*, Aziz Mirza, 2000) was a flop, their second, an expensive historical drama, *Asoka* (Santosh Sivan, 2001), attracted attention at the Venice and Toronto film festivals and was widely promoted in the UK, doing modest business. However, *Chalte Chalte* (*While We Were Walking*, Aziz Mirza, 2003), the company's third and final film, proved much more successful. Galvanised by this success in 2003, Shah Rukh Khan set up his own company, Red Chillies Entertainment, and hired his former choreographer Farah Khan to direct *Main Hoon Na* (*I Am Here for You*, 2004), along with several other Red Chillies productions, including *Om Shanti Om* (2007). Becoming a producer has not only enabled Khan to take much greater control over his work and image but also to extend his ambition. According to his biographer, Anupama Chopra, his goal is to create a variety of films with production standards and special effects on a par with Hollywood blockbusters, an ambition that lay

behind his setting up a special effects division called Red Chillies VFX in April 2006 (Chopra 2007: 221).

Conclusion

The world's most successful film stars gain power (including control of their work), wealth and international fame, their journey to the pinnacle of stardom tending to be long and arduous, requiring patience, stamina and determination as well as talent and star quality. This usually involves various stages: a period of training and work in other forms of entertainment (e.g., television, theatre, sport, etc.); early film roles that include a 'breakthrough', followed by typecasting in a series of star vehicles and, occasionally, a move into directing and/or producing. Along the way, stars gather reviews, sometimes awards, graduate to star billing, see their marquee values rise and then, most likely, fall as they experience decreasing box-office returns as a result of ageing, miscasting, over-exposure or bad publicity (e.g., scandal). The way in which stars attempt to manage their careers (aided by agents, managers, publicists and lawyers) is an important feature of star scholarship. Just as important is the way that stars acquire, develop and perfect their acting technique, including how they are distinguished from members of the supporting cast and how they are assisted by acting coaches and other collaborators. How screen performances impact upon their wider reputation and public profile is also relevant to understanding how stars acquire an image and a reputation. Just as important, however, is the way that public knowledge of a star's personal life feeds into the creation of his or her identity, an identity that circulates widely, not only through promotional materials, publicity, criticism and commentaries but also through the grapevine, circulating in different ways among different sectors of society.

5 STAR IDENTITIES: FROM IMAGE TO PERSONA AND PUBLICITY TO GOSSIP

Introduction

Stars may stand out because of some ineffable quality that, although hard to put into words in any precise way, seems (almost) tangible. This quality may have attracted the attention of a casting director, director, producer or agent who is subsequently responsible for launching the individual's rise to stardom in a film, a vehicle or string of vehicles tailor-made to showcase their skills and qualities to best advantage. Ultimately, however, the individual's attainment of stardom rests on being pigeon-holed, labelled, publicly dissected and analysed, scrutinised, exposed, charted, mapped, positioned, identified and evaluated. This is made all the more challenging and interesting by the fact that stars possess several identities and several different kinds of identity, determined by the various aspects of their character and the various characters that they play. For Edgar Morin, the 'star is not only an actress' and the 'characters she plays are not only characters' but rather, the 'characters of her films infect the star' and, reciprocally, 'the star herself infects these characters' (Morin 2005: 27). This can make it hard to disentangle the various identities brought into play in films by stars. Indeed, it is virtually an impossible task to distinguish between the character and the star, the public persona and the private personality of the actor, as these separate and

overlapping identities are both revealed and disguised from moment to moment throughout a film.

This chapter explores the way in which stars construct (or have constructed for them) a series of identities as a consequence of the various roles they play in films and their public appearances, as well as the discourses that circulate about them in magazines, on television, radio and the internet. Behind this public persona lies a private person with a unique personality, one that is rarely glimpsed by fans and audiences, one that fascinates and intrigues. The relationship between private person and public persona is complex and confusing, and it has led to much complexity and confusion within the research on stars and stardom in film studies. This chapter will seek to clarify some of these issues, examining the ways in which a number of film scholars have attempted to understand the various aspects of star identity, the ways in which these are articulated and constructed within the film industry, as well as the ways in which they are received and enjoyed by audiences. While discussing the significant role played by publicists and public relations companies in managing and controlling star images, this chapter notes the value of archives and libraries that hold collections of publicity and promotional materials, press books, scrapbooks, movie and fan magazines, noting how increasingly star scholars are making use of such resources to conduct their research into stars and stardom (e.g., see Pugh and Sandler 2010). This suggests that such archival material is likely to play an increasingly central role in star studies in future.

Image and persona

Edgar Morin, in *Les Stars* (1957), noted that the star is incarnated in the characters of his or her films but also transcends them (Morin 2005: 27). Moreover, these characters transcend the star. Thus,

Garbo's characters become even more fascinating than Garbo herself, yet rely entirely upon the real Garbo, rendering the real Garbo even more fascinating (ibid.: 28). Morin goes on to state that the 'star cannot appear when this reciprocal interpretation of actor and hero fails to occur' for, in that case, they are merely character actors (ibid.). He also notes that the star incarnates a private life in her movies while 'in private she must incarnate a movie life' (ibid.: 45). For him, it is from the superimposition of the actor's and their characters' personalities that the star is born, the 'actor contribut[ing] the capital of his own personality' (ibid.). This 'personality' is in part fabricated (ibid.: 141). Largely imitative, personality is considered here as a mask, 'a mask that allows us to make our voices heard' (ibid.). Herein lies, for Morin, the true value and importance of stars: the fact that they tell us something about identity formation more generally but also the fact that they play a key role in helping us to form our own identities.

Similarly, Richard Dyer has observed that what is particularly interesting about stars is not simply their creation of characters on screen but the very 'business of constructing/performing/being' (Dyer 1979: 20). He writes that what 'was only sometimes glimpsed and seldom brought out by Hollywood or the stars was that personality was itself a construction known and expressed only through films, stories, publicity, etc.' (ibid.). He goes on to note that different stars evoke different relationships between their screen roles/image and their real personality, identifying a useful way of distinguishing between types of star. While some (e.g., John Wayne and Shirley Temple) root their characters in their own sense of self (or who they really are) and star image, others (e.g., Bette Davis and Lana Turner) maintain a gap between, on the one hand, their sense of self or star image and, on the other, the characters they play on screen (ibid.: 21). The relationship between star images, screen characters and the real person or personality of the star has attracted considerable academic interest among film scholars since the

publication of Dyer's *Stars*. One of the most fully worked out (if complex) articulations of the relationship between character, person and image (along with definitions of these and other related terms such as 'persona' and 'personality') can be found in the work of Barry King.[1] In his essay 'Articulating Stardom' (originally published in 1985), King draws upon Dyer's terminology in *Stars*, while proposing some modifications by retaining his notion of *character* as a constructed personage in film, but suggesting the term 'personality' (originally used by Dyer to describe the set of traits and characteristics with which the film endows a character) be replaced by the terms *person*, *image* and *persona*.

The term person should be taken to include an understanding that the physical presence of the actor is already coded in the general sense of having the socially recognised attributes of an individual in the host culture … a 'personality', and in the specific sense that this 'personality' is adapted to the exigencies of acting. (King 1991: 175)

King therefore suggests that the term 'image' is best used in a more restricted way to describe the visual impact of a star's films on their off-screen personality, 'so that the coherence of the actor's image on screen is clearly identified as a technologically based construction' (ibid.). Finally, he uses the term 'persona' to describe (and distinguish more clearly) the amalgamated entity that is the person and the image or, in his own words, 'the intersection of cinematic and filmic discursive practices in an effort to realise a coherent subjectivity' (ibid.).

Barry King's use of terms 'image', 'personality' and 'persona' in relation to film stars was subsequently extended by Christine Gledhill in her essay 'Signs of Melodrama' (1991). Here she distinguished between the 'real person', the 'characters' or 'roles' they play in films, and the star's 'persona', which exists as a separate entity from either the real person or film character, while combining

elements of both (Gledhill 1991b: 214). She described the 'real person' as 'the site of amorphous and shifting bodily attributes, instincts, psychic drives and experiences' (ibid.: 214–15). In contrast, the 'film character' or 'role' is described as being 'relatively formed and fixed by fictional and stereotypical conventions' (ibid.: 215).[2] On the other hand, the 'persona', Gledhill argues, 'forms the private life into a public and emblematic shape, drawing on general social types and film roles, while deriving authenticity from the unpredictability of the real person' (ibid.). The 'persona', then, is a crafted and consolidated public projection of the real person, built in part out of film roles and other public appearances. It can operate as a mask to ensure consistency (i.e., off screen) but it can also be used as an element of performance (in film and elsewhere).

Gledhill describes 'image' (the fourth component of the star structure) as being 'spun off from the persona and film roles, both condensing and dispersing desires, meanings, values and styles that are current in culture' (ibid.). She notes that, 'this range of meaning-producing agencies and the internally composite structure of the star mean that the image itself is fragmented and open to contradiction' (ibid.: 217).[3] For Gledhill, 'image' designates an identity over which a star has less control (i.e., than persona) as it results not only from their personal attributes and aspects of the characters they have played in films but also what is circulated in publicity, including what is said in reviews. As she has written elsewhere, this is largely 'the conceptualization of critics, fans and the public, projecting onto the star specific ideals, aspirations, desires, and so on' (Shingler and Gledhill 2008: 68). Jane Gaines has discussed the value of Gledhill's distinction between image and persona, noting that in her articulation, 'the persona, as in King, is separate from the real person and the character roles, but it draws from both – "authenticity" from the former and "typicality" from the latter' (Gaines 1992: 33). She suggests that the 'advantage to theorizing a public "persona," as King and Gledhill show us, is that such a theory emphasizes that a star

persona is as much a constructed "character" as any film role and also that it can contradict as well as reinforce screen roles' (ibid.: 34).

While there have clearly been advantages in discussing star identities in terms of 'persona' and 'image', this has also presented problems and challenges. As Alan Lovell has noted, these terms 'are used in confusing ways', largely as a result of being used to designate rather different things by individual scholars, introducing a degree of inconsistency into the debate on stars and stardom (Lovell 2003: 265).[4] Similarly, Tytti Soila, in the introduction to *Stellar Encounters* (2009), notes that across the twenty-two essays included in this anthology the term 'personality' is used in very different ways by the authors to describe stars, resulting not from any linguistic differences between writers from various countries so much as reflecting the diverse ways in which this term is understood and employed by film scholars generally. She notes that while some writers 'distinguish the two expressions – celebrity and personality', others use the word 'personality' to refer 'to the "iconic" persona of the star, while at other times the word encompasses the star's skills as a professional, too' (Soila 2009: 6). She further points out that, 'the iconic star image has become an amalgam where the ever unstable demarcation line between private *life* and private *body* on the one hand, and media *image* and screen *character* on the other has increasingly disbanded' (ibid., emphasis in original). In order to limit further confusion, it is important for star scholars to define the precise meanings of the terms they are using to describe star identity and to remain alert to inconsistent uses of terms such as image, persona and personality when conducting research into stars or stardom.

Publicity and promotion

In the twenty-first century information about film stars, both official and unofficial, circulates widely across the media. Barry King has

spoken of an increase in 'textual curiosity' through internet, print and broadcast media, which promulgate insider gossip, effectively dramatising star biographies to the extent that they become 'characters in the drama of their own biographies' (King 2003: 51). Writing in 2000, Paul McDonald declared that 'television and print media continue to actively circulate the discourses of film stardom, yet the most rapid growth in the dissemination of those discourses has come with the widespread adoption of the Internet' (McDonald 2000: 113).[5] Official websites provide details of new releases, featuring trailers, competitions, merchandise, along with a plot synopsis and profiles of the stars.[6] However, McDonald also noted that film stars were being used on other kinds of websites, including celebrity porn sites, featuring both authentic nude images taken from earlier stages of a star's career or faked images in which their heads are digitally attached to a naked body. In the age of the internet, the authenticity of star images has been ever more challenged and audiences have played a far greater role in determining them.

In 2010, Olga Kourelou reported that, 'one of the most popular Chinese web forums, Tianya, posted several poor-quality nude pictures, purporting to show Zhang Ziyi and Ken Watanabe, her co-star in *Memoirs of a Geisha*, copulating in one of the film's scenes' (Kourelou 2010: 123). She noted that these were accompanied by hostile commentary, criticising the Chinese actress for playing a Japanese prostitute and for performing sex with a Japanese man. This is one of many examples where audiences around the world are using the internet to directly interact with and challenge the official star images, which traditionally have been largely controlled by film studios. This example indicates that in many parts of the world the established systems of controlling (generating and protecting) star images have been undermined in recent times. During the early days of cinema, relatively little information about leading players was publicly disseminated. In the USA, film actors were seldom named or credited prior to 1909, although by 1911, as Richard deCordova

has observed in *Picture Personalities* (1990), numerous American film companies promoted their leading players in their literature about their films. At first the published literature about picture personalities concentrated exclusively on the characters they played on screen and the actors' professional work in film and (if appropriate) on stage (deCordova 1990: 86–7). However, by 1913, the details of the actors' off-screen lives began to emerge in this literature, so that some film performers had begun to gain public identities independent from their picture personalities or film roles, constructing a 'private' life for these players (ibid.: 101–2).

While these developments were taking place in the USA, similar practices were emerging in Europe. Ginette Vincendeau writes that in France, 'a shift in the film industry's promotional discourse took place around the years 1908 to 1912, from the technicalities of the film apparatus and the films' stories to the actors' (Vincendeau 2000: 4). She notes, for instance, that in 1909, Pathé began using Max Linder's name in advertisements for his film comedies and, the following year, started to produce publicity photographs, 'beginning with an advertisement expressing best wishes to Linder (after an appendectomy)' (ibid.: 5). She claims that by the 1920s, French stars featured heavily in the press, observing that the first popular magazine, *Cinémagazine*, was launched in 1921, followed soon after by *Mon-Ciné* and *Ciné-Miroir* (ibid.: 14). These were joined by *Cinémonde* in 1927 and *Pour-vous* in 1928.[7] During the 1930s and 40s, illustrated magazines, such as *L'Illustration* and *Match* (later *Paris-Match*), and women's magazines, such as *Marie Claire* (1937) and *Elle* (1945), regularly included features on film stars. Along with gossip magazines, such as *Point de Vue Images* and *Jours de France*, these popular publications 'projected images of French stars, like their Hollywood models, as simultaneously extraordinary and ordinary, mixing the allure of a glamorous life with intimate details of domesticity' (ibid.: 15). Vincendeau notes that French popular film magazines were much like American and British

versions, being aimed squarely at women up until the 1960s, relentlessly upbeat in tone but with a heavy emphasis on food and cookery.

Similarly, Jackie Stacey has noted the popularity of film magazines with women in Britain in the 1940s and 50s, noting that, while there were 'numerous publications about the cinema which were read regularly by cinema-goers during the 1940s', the one that stood out was *Picturegoer*, launched in 1911 but acquiring its most popular format in 1931 (Stacey 1994: 107). Other popular film magazines included, *Film Fantasy and Fact* (formerly *Film-Fan Fare*), *Film Post* (1947–51), *Film Forecast* (1948–51) and *Screen Stories* (1948–9), many of which were, as Stacey writes, 'devoted to representing the lives of the stars, as well as to other features on topics such as new releases, fashion tips and results of audience polls' (ibid.). Photographs of Hollywood star homes and snippets of gossip featured alongside news of the latest film releases. Hollywood featured heavily in British film magazines, with many issues having a greater proportion of coverage of American than British stars. In part, this reflected the dominance of Hollywood in British cinema culture more generally but it was also due to a reticence on the part of many British film stars that made them wary of promotion and publicity. Bruce Babington has written that, 'cultural attitudes towards the vulgarity of self-display played a deep-seated part in inhibiting publicity' in Britain before and during World War II (Babington 2001: 13). Nevertheless, as Pam Cook's contribution to *British Stars and Stardom* reveals, Diana Dors decisively broke with this tradition after the war (Cook 2001: 167).

Pam Cook's essay 'The Trouble with Sex: Diana Dors and the Blonde Bombshell Phenomenon', reveals that, from the 1950s to the 80s, British cinema's most successful sex symbol sustained a high-profile career despite scandals in her private life, a failed bid for Hollywood stardom and, in later years, a weight problem by working in television, theatre and cabaret, making regular appearances on

ASSOCIATED BRITISH PRESENTS

DIANA DORS
AND
YVONNE MITCHELL

WOULD **YOU** HANG MARY HILTON?

CERT X

YIELD TO THE NIGHT

WITH
MICHAEL CRAIG · GEOFFREY KEEN · ATHENE SEYLER

A KENNETH HARPER PRODUCTION · SCREENPLAY BY JOHN CRESSWELL
AND JOAN HENRY · Based on the Book by Joan Henry
PRODUCED BY KENNETH HARPER · DIRECTED BY J. LEE THOMPSON
DISTRIBUTION BY ASSOCIATED BRITISH PATHE

Diana Dors, British blonde bombshell and star
of *Yield to the Night* (1956)

chat shows, featuring in magazine articles and advertising, by
publishing her autobiography and through public appearances.
Similarly, Christine Geraghty has noted that, like many sex symbols
(e.g., Marilyn Monroe and Brigitte Bardot), Dors' star image was
'constructed not only out of film and pin-up material but also out of
the drama of her off-screen life' (Geraghty 1986: 341). Thus, she
writes that 'the tissue of love affairs, scandals, marriages and divorces
provided much of the material' from which her star image evolved
(ibid.). Consequently, publicity played a major role in the
construction of Dors as a star and also meant that she operated
within the wider celebrity culture. Career setbacks, bankruptcy,
divorces, weight gain and ill health all became key features of her
image, as much as her platinum blonde hair, pouting lips and
curvaceous figure. In fact, as Pam Cook states, Dors was 'something

of an anomaly in traditional star study' in that her image, established through publicity and self-promotion, 'was more powerful and influential than her onscreen performances' (Cook 2001: 168).

Pam Cook notes that Diana Dors first attracted public attention as a Rank starlet at the age of seventeen, singled out as a promising dramatic actress and graduate of the London Academy of Music and Dramatic Art. While her small role in David Lean's *Oliver Twist* (1948) was prestigious and unglamorous, her appearances in the comedy films *Holiday Camp* (Ken Annakin, 1947) and *Here Come the Huggetts* (Annakin, 1948) showcased her sexy image. Meanwhile, her minor roles in social problem films such as *Dancing with Crime* (John Paddy Carstairs, 1947) and *Good Time Girl* (David MacDonald, 1948) lent her a rebellious persona. Throughout this period, the press 'focused on her physical attributes, excessive sexuality and talent for publicizing herself' (ibid.: 172). This included considerable media attention given to the publication of a photographic book called *Diana Dors in 3-D* in 1954, which was accused of being obscene, and her appearance that same year at the Venice Film Festival in a gondola wearing a mink bikini, a highly successful publicity stunt that brought her to international attention. By this time, she was regularly headline news in the British tabloids, due largely to a series of scandals concerning the criminal activities of her first husband Dennis Hamilton. Cook also notes that during the early 1950s press coverage and publicity frequently 'emphasized her acquisition of the kind of wealth and luxury more characteristic of Hollywood than a Britain tentatively emerging from postwar austerity' (ibid.: 173). Frequent comparisons were made with Dors and Hollywood stars to the point where she was dubbed the 'British Marilyn Monroe' (ibid.).

By the mid-1950s, Dors' publicity was clearly overshadowing her work as a screen actress, so that her distinguished performance in *Yield to the Night* (J. Lee Thompson, 1956) was ignored by most critics despite the efforts of the actress and her studio to promote the

Diana Dors the actor, in *Yield to the Night*
(1956)

film as her breakthrough into serious dramatic acting (ibid.: 176). Playing a young woman imprisoned and finally executed for murder, the actress was de-glamourised in her prison scenes, the dark roots of her bleached hair showing through and costumed in a shapeless, drab prison uniform. In other scenes, however, the more conventional Dors blonde bombshell image was retained (i.e., in the flashback sequences leading up to the murder), thereby presenting two very different incarnations, the actress and the star. However, Cook points out that as 'a bid for critical recognition, *Yield to the Night* was not entirely successful', with the British press unable to accept her in a serious role (ibid.). Nevertheless, she notes that the film 'took the Cannes Film Festival by storm, and Dors was much in evidence, posing with furs and Cadillac, waving to photographers and acknowledging the cameras at every opportunity, in true pin-up style' (ibid.: 167). For Cook, this marked the high point of Dors' film career, on the back of which she secured a three-film contract with RKO in Hollywood, resulting in *The Long Haul* (Ken Hughes, 1957), *The Unholy Wife* (John Farrow, 1957) and *I Married a Woman* (Hal Kanter, 1958) (ibid.). Cook blames the failure of these films on a hostile American press reaction, which responded negatively to Dors' attempt to rival Marilyn Monroe, as well as to her extra-marital affair with Rod Steiger. After returning to Britain in the late 1950s, Dors' film career may have declined but she was able to sustain a career as a star well into middle age with character parts in films, live cabaret appearances and television work, including the hit comedy series *The Two Ronnies* in 1980. Throughout the 1960s, 70s and 80s, she maintained both her celebrity status and her glamorous blonde image, although in a more camp fashion, most notably with her appearance as a glamorous fairy godmother in the pop video for Adam and the Ants' number-one hit single 'Prince Charming' (1981), bringing her to the attention of a new generation of fans. Perhaps more than any other British star, Diana Dors' career was both dependent upon and limited by publicity and promotion, with

audiences accepting her as a British sex symbol but refusing to accept her as a serious actor or as a Hollywood star.

While in Britain and Hollywood during the late 1950s, Dors struggled to reconcile the competing demands of maintaining her star persona while enhancing her reputation as an actor, in India Nargis's established reputation as a film star was rocked by scandal, widely reported in the press. For years the Hindi press and movie magazines had largely drawn a veil over the actress's long-term affair with her married co-star and director Raj Kapoor. However, her affair with her *Mother India* (1957) co-star Sunil Dutt became a scandal that threatened to destroy her career, despite their subsequent marriage. During the 1950s, 'there was a far wider circulation of stories about the off-screen lives of the stars' in India than in earlier decades (Gandhy and Thomas 1991: 116).[8] Consequently, Fearless Nadia (the Australian-born Mary Evans), a major star of Hindi cinema of the 1930s and 40s, was known publicly only in terms of her film appearances and 'little publicity was known about her personal life', which enabled her to keep 'the fact that she was an unmarried mother a secret throughout her screen career' (ibid.: 114). However, Gandhy and Thomas note that even the fan magazines of the 1950s remained 'comparatively bland and sycophantic and most of the salacious material was told through innuendo or by word of mouth' (ibid.: 119). By contrast, from the 1970s, gossip about film stars circulated much more freely in magazines and newpapers. Gandhy and Thomas note that the actress Smita Patil owed her initial stardom to 'the circulation of gossip through the film fan magazines, newspapers and journals' which fuelled interest in her as a news presenter on Bombay television (ibid.: 126). Patil, the award-winning star of Shyam Benegal's *Bhumika* (1977), Rabindra Dharmaraj's *Chakra* (1981) and Sagar Sarhadi's *Bazaar* (1983), attracted considerable press attention as the emancipated daughter of a prominent government minister. Her successful film career during the late 1970s and 80s was frequently

Proclaiming itself to be the number 1 Asian celebrity and lifestyle magazine, *Masala!* features Bollywood godfather, Amitabh Bachchan, on the cover (vol. 9, issue 400, August 2011)

accompanied by stories about her 'immorality', due to her advanced western ideas, as well as her affairs with men, some of whom were married.

Vijay Mishra, in *Bollywood Cinema: Temples of Desire*, notes that Indian fanzines in English (such as *Filmfare*, *Stardust*, *Cine-Blitz*, *Movie*, *Showtime* and *Screen*) are generally aimed at middle-class readers, combining glossy advertisements (including for western brands) with salacious gossip about Bollywood and Hollywood stars. In contrast, Hindi-language fanzines (such as *Jī-Stār)* 'have fewer salacious details ... present material in a more subdued, suggestive manner, and they don't carry glossy advertisements of expensive luxury items' (Mishra 2002: 130). 'The contrast between Hindi and English fanzines', he writes, 'illustrates the differing levels of reception of Bombay Cinema' (ibid.). Mishra notes that slum dwellers, who make up a large sector of India's filmgoing population,

do not read fanzines (largely consuming star information and film publicity from radio) and yet, nevertheless, 'it is clear that fanzine constructions of stars grow out of slum responses to them' (ibid.: 147). In chapter 5 of his book, Mishra examines the relationship between Bollywood mega-star Amitabh Bachchan and his fans through the circulation of his publicity and gossip in film magazines and fanzines. Noting that Bachchan 'was the dominant figure in Bombay Cinema' from 1973 to 1990, Mishra identifies the appeal of the star's distinctive brand of anti-heroism with the slum dwellers of cities like Bombay and Calcutta as the reason for much of his popularity and the success of his films, arguing that his 'angry young man' persona (i.e., his dark, brooding, violent and rebellious underdogs) has resonated especially with the urban poor that have been replacing the more affluent middle classes as the main audience for films since the 1970s (ibid.: 127).

Mishra notes that, over the years, fanzines such as *Cine-Blitz* and *Movie* focused on Bachchan's temperament (his brooding melancholy and explosive anger), as well as his introverted and shy persona. Meanwhile, rumours of his off-screen and extra-marital affairs with a Miss India winner, as well as the film star Rekha, were only ever obliquely hinted at and largely disavowed. During the 1980s, fanzines concentrated on his professionalism and dedication to his work as an actor and producer. After the decline in his film career in the late 1980s and early 90s, the fanzines turned their attention to a younger generation of stars (most notably, Shah Rukh Khan) but, as Mishra notes, from the mid-90s, the internet played a major role in Bachchan's revival. He writes that, in 'cyberspace Bachchan has been suddenly reconstituted through his own website, through Internet fan clubs (the Cyberbollywood Amitabh Bachchan site, for instance), and through discussion portals' (ibid.: 154). This has enabled Bachchan to exercise a greater degree of control over his image, forge more direct links with his audience, while providing his fans with more immediate, extensive and direct information about

Shah Rukh Khan on the cover of *Filmfare* (8 December 2010), India's most important movie magazine

the star and enabling them to contribute to the Bachchan discourses in public circulation around the world.

Shah Rukh Khan's rise to stardom in the early 1990s resulted largely as a result of Bollywood's publicity machine. Brash, outspoken and impulsive, the young star quickly became 'prime film-magazine fodder', according to his biographer Anupama Chopra (Chopra 2007: 107). Even before his first film was released, magazines were full of articles about him, particularly *Stardust* (launched in 1971 and based on American *Photoplay*) which 'filled up to five pages' on him in September 1991 (ibid.: 108). Chopra notes that in the December 1994 edition of *Movie* magazine, Shah Rukh's picture appeared on the cover alongside that of Amitabh Bachchan with the headline 'Heir Apparent?' (ibid.: 135). This question was answered positively when Aditya Chopra's

phenomenally successful *Dilwale Dulhania Le Jayenge* (*The Brave-hearted Will Take the Bride*) was released on October 1995, breaking the box-office record previously set by Bachchan's *Sholay* (Ramesh Sippy, 1975).

By 1996, Shah Rukh Khan was not only one of the hottest stars in Bollywood but he was also the Indian face of Pepsi (one of the USA's largest manufacturers of fizzy drinks). Although the company employed other major Bollywood stars in the 1990s (most notably, Aamir Khan and Aishwarya Rai), it was Shah Rukh Khan who became 'the company's most frequently used celebrity endorser in India' (ibid.: 159). SRK's biographer notes that, from the very start of his career, advertising and endorsement 'played a key role in the branding of Shah Rukh Khan', noting that, 'over the years he advertised a bewildering array of products ranging from a local biscuit to international brands' (ibid.: 7). By 2005 he commanded one of the highest fees for endorsements among Indian celebrities (along with Amitabh Bachchan and cricket superstar Sachin Tendulkar) and, in this year alone, he endorsed approximately 34 different products, becoming the first male star used to endorse Lux soap, which had maintained Hindi star endorsements since 1929 (ibid.: 160).

Throughout the 1930s, 40s and 50s, Lux soap was closely associated with Hollywood and it would seem that virtually every major female star of the studio era has appeared in an advertisement for the product at one time or another, extolling the virtues of its soft gentle lather, with their perfect skin used to illustrate its potential benefits. Lux's longstanding association with Hollywood made it a superior brand of soap (i.e., an inexpensive domestic commodity, universally used on a daily basis). Jane Gaines has noted that, from the start of the 1920s, Hollywood 'studios were besieged with requests for star product endorsements' (Gaines 1992: 159). She also notes that under the studio contracts of the 1930s and 40s, few stars had any control over how they were used in advertisements, with

decisions about which stars were used to advertise which products being made by staff with the studio's publicity department.

By the 1930s all the Hollywood studios had publicity departments, staffed by large numbers of people responsible for 'constructing and disseminating a star's image across the media of posters, photographs, newspapers, magazines and radio' (McDonald 2000: 52). These departments were the 'key to the star-building process' and, as a reflection of their importance within the studio system, they were huge (Basinger 2007: 45). Each studio had a head or director of publicity in charge of organising marketing campaigns, such as Howard Strickling at MGM, Harry Brand at 20th Century-Fox and Bob Taplinger at Warner Bros. MGM's publicity department employed no less than sixty members of staff, each taking responsibility for three or four stars (McDonald 2000: 52). According to Robert Sennett, 'Howard Strickling's staff turned the business of motion picture publicity into a campaign as complex, widespread, and unavoidable as a military invasion', involving personal appearances, posters, trailers, song recordings, newspaper and radio advertisements, product endorsements and book tie-ins (Sennett 1998: 69).[9]

A 'unit publicist' was ordinarily assigned to a film, their job being to create and manage the publicity surrounding it from the moment it began production to its release across the world (McDonald 2000: 52). Articles, gossip and news stories would be placed in the trade press and the general news media by 'planters' to gain maximum exposure, intensifying audience interest to ensure a sell-out opening weekend at the first-run movie theatre, which charged the highest admission prices. Hollywood publicity departments also employed photographers to take flattering portraits of the stars, many of which would be signed (apparently by the star) and sent out to fans and fan clubs.[10] Part of the publicity team responded to fan mail and liaised with fanzine editors, others produced the previews of forthcoming releases, writing articles for

magazines and newspapers, while another group organised merchandising tie-ins, solicited product testimonials and endorsements, organised fashion shoots and arranged personal appearances and radio assignments. Other members of the team concentrated on designing all the movie ads and posters for the new releases, providing a range of designs, including international variations.[11]

Paul McDonald identifies the Hollywood studio press book as the 'primary publicity tool', being comprised of a wealth of information about a particular film, including articles and images, cast interviews, advertisements and posters (McDonald 2000: 55). Studio-era press books could contain as many as thirty pages of such material, which would be sent to exhibitors and local newspapers and radio stations in advance of the film's release, providing them with ready-made (and positive) reviews (Sennett, 1998: 71). Studio press books provide a rich source of historical information about a film and its marketing, especially about the way the contribution of certain stars was highlighted at the time of the film's original release (e.g., the extent to which the film was sold as a star vehicle), about the status of a particular performer in relation to the rest of the cast, as well as providing a resumé of their career that identifies the main films (as well as the genres) that they were known for. These provide a clear sense of a star's established 'type', indicating something about their fans' expectations at the time of the film's release, providing also a sense of who their fans were (particularly in terms of age and gender).[12]

The extensive amount of work undertaken by the Hollywood studio publicity departments indicates the extent to which star images were contrived and controlled throughout the studio era. However, as Paul McDonald notes, both major stars and even relatively unknown performers would hire an external publicity agent (i.e., from outside the studio) in order to assume some measure of control over their public image, although often this was

also intended to generate competitive interest between a number of studios who were bidding for a star's services (McDonald 2000: 53). McDonald, in his essay 'The Star System: The Production of Hollywood Stardom in the Post-Studio Era' (2008), describes the role played by publicists in Hollywood from the 1980s, noting that when the in-house (studio) publicity departments were downsized during the 1950s and 1960s, their operations were increasingly taken over by independent publicity firms (McDonald 2008: 173). Since publicists seek to generate exposure for stars at minimal cost, McDonald notes that their work chiefly involves creating and managing 'relationships between film stars and the array of other media channels through which the identities of stars are circulated', such as personal appearances at press conferences, premieres and charity events, in magazine interviews and on television chat shows (ibid.: 174).[13]

Just as stars are hired to perform in front of cameras and microphones, they are also contractually obliged to make public appearances and participate in media interviews to promote their films, and a whole genre has emerged within television broadcasting to capitalise on the availability of major film stars. This is the live chat show, most famously hosted in the USA by Steve Allen, Jack Parr, Johnny Carson, Jay Leno and David Letterman (Marshall 1997: 125–6). Although a star will invariably enact and maintain their established public persona when making such appearances, these do also provide some opportunity for stars to reveal (and audiences to glimpse) aspects of the 'real person' or, at least, they promise this opportunity even when it is seldom granted. However, a stronger sense of the star as a 'real person' is provided through their involvement in charity work or political campaigning (e.g., Sean Penn) or, more negatively, through court appearances as a result of legal transgression, from driving offences to rape and murder. When such events occur, a star's publicist or PR team will spring into action to limit the potential damage to their client's career. Such events,

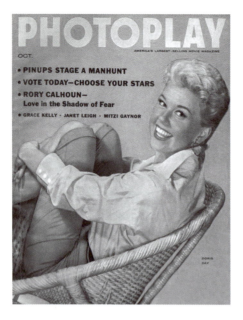

Doris Day on the cover of *Photoplay* (October 1955), the most popular American film magazine of the 1940s and 50s

however, are relatively rare, with agents, managers, lawyers and publicists working constantly to prevent such things happening and ensuring that potentially damaging information about a star is carefully buried. Since the rise of celebrity magazines, gossip columnists and the paparazzi, this has become increasingly hard to achieve but, at the same time, it has made the role of a star's publicity and management team more important and lucrative.

While the intensity of media scrutiny of film stars and their lifestyles appears to have increased in the modern era, Hollywood stars have generated intense public interest since the 1930s; by the end of that decade there were more than 300 members of the press based in Los Angeles. Many of the biggest names in journalism of the 1930s and 40s were associated with Hollywood, including syndicated columnists and radio broadcasters, such as Walter Winchell and Dorothy Kilgallen; trade reporters, such as Edith Gwynne of the

Hollywood Reporter and Mike Connelly of *Variety*; *Photoplay* interviewers, such as Adele Rogers St John and Sheila Graham.[14] By the 1940s, the most important film magazine in the USA was *Photoplay*, set up and edited by James R. Quirk, while the most important daily trade paper was *The Hollywood Reporter*, founded by Billy Wilkerson (Sennett 1998: 51).[15] However, just as important to an actor's career in Hollywood were the gossip columns and, in particular, those of Louella Parsons in the *San Francisco Examiner* and Hedda Hopper in the *Los Angeles Times*.[16]

Rumour and gossip

Edgar Morin describes gossip columns as 'the nutritive plankton of the star system', insisting that they are far more than mere by-products of the film industry. He states that, 'journalists of the cinema are more interested in the stars than in films, and more interested in gossip about the stars than in the stars', adding that they 'smell out, track down, and kidnap rumours and, if need be, invent them' (Morin 2005: 73). Meanwhile, P. David Marshall has noted that transgression is fundamental to a film star's attainment of celebrity status, observing that, alongside the intensification of media scrutiny of film stars during the course of cinema's history, 'a whole discourse on their transgressions of the norms of behavior became available to the public' (Marshall 1997: 105). Increasingly, information about film stars' marriages and divorces, with intimations of extra-marital affairs, sex scandals and unusual sexual proclivities became commonplace in the press. At the same time, the morally questionable status of gossip writing has tended to be off-set by an insistence upon its role as one of the guardians of Hollywood's morality (ibid.: 106). As Marshall has also observed, gossip columnists and the paparazzi operate in the space between a star's personality and his or her image, continually promising to expose the

real person behind the persona. Consequently, the star 'is "caught" by these film investigators of public personalities as he leaves special events, restaurants, and film premieres, where the defenses of publicity agents are supposedly lacking' (ibid.: 108). Almost as a way of counteracting these 'invasions' of their privacy, many stars have taken to writing personal blogs on the internet, creating online social networking sites (such as Facebook) or using Twitter as a means of providing audiences with personal information about their lives. While these actions undermine the role of gossip columnists and the paparazzi, they also effectively reduce the gap between the star and his or her fans, also closing the gap between their persona and personality. A key motivation for an established movie star's involvement with online social networking etc., is to scotch rumours that might prove damaging to their image and to the performance of their films at the box office, as well as the sale of associated merchandise (i.e., through endorsements or tie-ins).

Paul McDonald has suggested that the authenticity of gossip (i.e., scandalous gossip circulating on the internet and via word of mouth) has little bearing on its effects, with oft-repeated but proven to be false accusations becoming core components of a star's enduring image (McDonald 2000: 7). He also notes that scandal has long been a feature of Hollywood, dating back at least as far as the divorce stories of such stars as Clara Kimball Young and Douglas Fairbanks (1920–1) and the notorious Roscoe 'Fatty' Arbuckle rape and murder trial of 1921–3 (ibid.: 33). Consequently, scandal, gossip and rumour can be regarded as key elements of stardom.[17] Moreover, as McDonald points out, the significance of star scandal lies in the way that it divides a star's private life into two distinct components: 'a publicly controlled private-image and a hidden secret private-image' (ibid.: 39). While the former (i.e., a 'private' life) is intended for public consumption, the latter (i.e., the real private life) is kept off-limits and fiercely protected. Once exposed, the private life becomes a star's 'private' life and a significant part of their publicity and persona.

While scandal can split a star's private life in two, rumour and gossip can divide audiences into two groups: those 'in-the-know' and everyone else. Being 'in-the-know' has long been a feature of the gay subcultures of Europe and America in the sense of gay people's knowledge of which prominent and apparently heterosexual public figures are reputed to be homosexual (or 'closet queers'). 'Rumour and gossip constitute the unrecorded history of the gay subculture', writes Andrea Weiss, adding that something that 'is commonplace knowledge within the gay subculture is often completely unknown on the outside, or if not unknown, at least unspeakable' (Weiss 1991: 283). Weiss argues that it is this insistence 'on making homosexuality invisible and unspeakable that both requires and enables us to locate gay history in rumour, innuendo, fleeting gestures and coded language' (ibid.: 286). She also notes how Hollywood studios have gone to considerable lengths to conceal the homosexuality of their stars, fabricating the impression of heterosexual romance (as MGM did for Greta Garbo in the 1930s) while simultaneously teasing the public 'with the *possibility* of lesbianism', provoking 'curiosity and titillation', not to address lesbian audiences but rather to 'address male voyeuristic interest in lesbianism' (ibid.).[18] Nevertheless, as Weiss points out, this use of innuendo 'worked for a range of women spectators as well, and in the safety of their private fantasy in a darkened theatre' (ibid.). In her study of lesbianism in the Hollywood movies of Greta Garbo, Marlene Dietrich and Katharine Hepburn of the 1930s, Andrea Weiss stresses that the knowledge of the moviegoing public, whether straight or gay, about these stars' 'real lives' is inseparable from their 'star image' and that, irrespective of whether or not these three actresses were lesbian, their star personae were sufficiently ambiguous to be perceived as such by lesbian audiences, enabling them to 'appropriate cinematic moments which seem to offer resistance to the dominant patriarchal ideology' (ibid.: 297). Consequently, as Weiss's essay reveals, even unsubstantiated rumours and gossip have an important role to play

in the work of scholarship and should be regarded as an important constituent in a star's image.

Since the very beginning of his film career, Shah Rukh Khan has been dogged by rumours of homosexuality, which have persisted in spite of his highly publicised marriage and fatherhood. Several factors have contributed to this. First, his early appearance as a gay college gossip in Pradip Krishen's TV movie *In Which Annie Gives It Those Ones* (1989). Second, his complex star persona, which includes traditionally feminine aspects, such as his tendency to cry, become hysterical or histrionic, as well as his sensitivity and tenderness. Third, his close association with the flamboyant director Karan Johar, who SRK's biographer Anupama Chopra variously describes as baby-faced and fey-mannered, 'a consummate fashionista' and 'giddily gregarious' (Chopra 2007: 151, 146 and 150). Chopra notes that 'Karan became Shah Rukh's confidante' during the making of *Dilwale Dulhania Le Jayenge* in 1995 and that, thereafter, their 'enduring professional and personal proximity led to rumors that Shah Rukh and Karan were lovers' (ibid.: 151–2). She further notes that while 'magazines occasionally linked him [SRK] to his heroines … [the] industry grapevine mostly linked him to Karan' (ibid.: 153). Despite these sustained rumours, which if confirmed could ruin his career, Shah Rukh Khan has enjoyed unprecedented success, popularity and acclaim in Bollywood since 1995, clearly demonstrating that a little salacious gossip, so long as it remains unconfirmed, can be a huge advantage to a film star.

Joshua Gamson's sociological study of celebrity, *Claims to Fame* (1994), which includes an ethnographic study of fans (i.e., fan culture, behaviour and practices), contains much fascinating material on fans of film stars and, in particular, the way in which gossip is used within fan culture as part of the pleasures that stars and celebrities offer audiences, constituting a major part of the game that structures much fan behaviour. Rather than see fans as being duped by publicity and media hype about stars, Gamson reveals how many

fans are fully aware of the hype and ballyhoo associated with stardom (including the mechanisms of the publicity machine) and are able to enjoy this irrespective of whether or not they believe what they read, see or hear to be true.[19] Knowledge of how star images are contrived and managed is as much part of the pleasure of stardom as knowing the truth of a star's 'real person' or 'private life'. Thus, he writes that, '[i]t is not necessary for the gossip game that the information be demonstrably true; in fact, too much truth can stop the game' (Gamson 1994: 176). Ultimately, for him, what stars and celebrities offer fans is a space in which to engage in gossip with little redress or consequence because, ultimately, stars do not matter (ibid.: 184). What this study has revealed is that, while the main industrial function of stars is to sell films (i.e., guaranteeing audiences for new releases), their main cultural function is to provide a focus for playful and inconsequential gossip.

Conclusion

Publicity and promotion are crucial means by which stars acquire their public personae and how these are established and disseminated, involving the creation of their 'image'. Journalism plays a major role here, in terms of mainstream and specialist press, but so too do websites, online forums and chat-rooms. Star interviews, autobiographies and biographies also feature as key aspects of publicity, as does rumour and gossip (in and beyond gossip columns). Much work has been done on the relationship between the very public life of film stars and their private lives and off-screen activities (e.g., politics, campaigning and charity work) and how all these domains are ultimately involved in the construction of a star's identity. P. David Marshall's *Celebrity and Power*, for instance, reveals how the consumption of publicity and promotional materials stems from the audience's desire to know the 'real' person

behind the image and also how the film industry maintains a perpetual distance between the star and their audience. Marshall argues that the 'extratextual domains of magazine interviews, critical readings of the films, television appearances, and so on … that try to present the "real" film star are in themselves actively playing in the tension between the film celebrity's aura and the existence of the star's private life' (Marshall 1997: 117). He also claims that the bond between star and audience goes beyond knowledge or the desire for more (intimate) knowledge as it is, crucially, one of affect and, as such, is chiefly an emotional attachment (ibid.: 83). Nevertheless, although stars and their audiences may be bound by an affective connection, they remain separated by a crucial gap in which both desire and identification circulate. Furthermore, the possession of more intimate knowledge may offer the potential to bridge that gap but invariably it intensifies the sense of distance between a fan and a star.

While publicity materials fill the gap (or purport to bridge the gap) between stars and audiences, they also distinguish between the various overlapping identities of stars: constituting their image and persona, providing a sense of their personality. These identities and the terms commonly used by film scholars to describe them are complex and sometimes confusing, particularly when terms such as 'image', 'persona' and 'personality' are used variously to mean different things. Nevertheless, used with clarity and caution, these can be valuable tools and concepts for any investigation into the construction of star identities across a large range of texts and media, particularly when they are constructed differently for different types of audience or for audiences in different parts of the world, remaining central to the project of star studies.

6 UNSTABLE SYMBOLS: ON THE REPRESENTATIVENESS OF FILM STARS

Introduction

Andy Medhurst suggests that 'the fascination with a star image is probably the most seductive method that narrative cinema has developed in order to catch and bind its audience', adding that after 'that initial pull, though, certain star images begin to set off resonances that have deeper social implications' (Medhurst 1986: 347). Many theorists have explored these, investigating how film stars represent different kinds of identity, including nationality, regional identity, gender, race, age and class.[1] This often involves a consideration of the star's cultural significance and the ways in which they incarnate or embody ideological values, coming to define specific moments in history: for instance, Jean Gabin as '*the* emblematic hero of the Popular Front years' in France (Vincendeau 2000: 65, emphasis in original), Gracie Fields as an embodiment of northern English working-class femininity of the 1930s (Landy 2001: 56) or Sidney Poitier as an icon of the American postwar integrationist movement and black middle-class masculinity (Bogle 2004: 199–204). Richard Dyer's work, especially *Heavenly Bodies*, has done much to promote such an approach to stardom, such as his assertion that stars 'enact ways of making sense of the experience of being a person in a particular kind of social production (capitalism)', stars representing 'typical ways of behaving, feeling and thinking in

contemporary society, ways that have been socially, culturally, historically constructed' (Dyer 1987: 17). One of his most influential claims is that stars are 'embodiments of the social categories in which people are placed and through which they have to make sense of their lives, and indeed through which we make our lives – categories of class, gender, ethnicity, religion, sexual orientation, and so on' (ibid.: 18). Many star scholars have developed their research directly out of this notion of stars as embodiments of social types, building upon Dyer's conception of 'structured polysemy' to articulate the ways in which stars simultaneously embody different and often contradictory ideologies, reinforcing both dominant and alternative values, along with gender and sexual ambiguities, as well as ambivalent attitudes towards class, race and ethnicity.

In this chapter, some of the studies that have adopted this approach to understanding the cultural significance of stars will be considered in order to demonstrate the diverse ways in which films stars become meaningful and acquire social significance. This will also reveal how stars are not only made sense of in terms of cultural significance but are constructed in this way, so that some aspects of a star's image and films are privileged over others in order to make a star seem more representative of social groups or historical contexts. What emerges here is the sense of the heavy burden of representation that some stars have been made to carry, sometimes by the film industry, sometimes by their audiences and fans, but most often by film critics, historians and academics.

Zeitgeist icons

[T]he 'stars' of a given historical period or moment capture their era for us in a range of ways ... the preoccupations, values, conflicts and contradictions of a particular culture, its 'climate of feeling', are vividly expressed through its celebrities. (Gaffney and Holmes 2007a: 1)

John Gaffney and Diana Holmes, in the introduction to *Stardom in Postwar France,* describe stardom as 'a symbolic portal into the nature of a culture', referring to stars as 'that culture's ultimate expression' (ibid.). However, they also recognise that stars are atypical, being 'symbolic *negations* of a given culture' (ibid., emphasis in original) in that they offer something new, something more exciting and aspirational, more glamorous than the reality of life in the culture to which they belong. Studies of stardom that investigate a star or stars of a particular era therefore have a tendency to reveal not so much what was happening socially and culturally at the time but, rather, what was coming into being or what was being left behind. 'Stars can restate, often in new and modern forms, old identities and values, as well as calling a society towards newer, and perhaps confused, emergent values and value systems' (ibid.). This is illustrated in Diana Holmes's essay, '"A Girl of Today": Brigitte Bardot', which examines the French star in terms of zeitgeist, situating Bardot's fame within the context of rapid social change in 1950s France and, in particular, the growth of youth culture. She suggests that the actress 'incarnated' the values of a young generation in the mid- to late 1950s but that she did so in complex and contradictory ways (Holmes 2007: 46). Holmes notes 'a tension between, on the one hand, a prescriptive definition of modern femininity as domesticity and maternity in a more stylish guise and, on the other hand, a sense that femininity might also be compatible with citizenship, education, opportunity, mobility – and a self-defined, pleasurable sexuality' (ibid.). Her reading of a number of the star's key films from this period and publicity in magazines such as *Paris-Match* and *Elle* demonstrates that 'Bardot's appeal as a star seems to have depended, at least in part, on her capacity to hold together a tension between contradictory discourses on sexuality and femininity: between, on the one hand, a nascent female desire for sexual freedom ... and on the other hand, a powerful ideology ... that defined women as by nature dependent, monogamous and maternal'

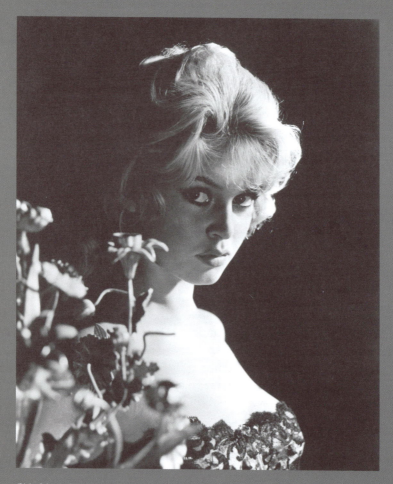

Girl of the 1950s?: Brigitte Bardot in *Les Bijoutiers du Clair de Lune* (1958)

(ibid.: 62). She also notes that, in the mid-1960s, when 'this conflict began to be more clearly articulated, and signs of the second-wave feminist movement began to appear, Bardot's popularity declined', thereby rendering Bardot a woman of yesterday rather than a 'girl of today' (ibid.).

Bardot makes for a convincing case regarding the ability of stars to embody the cultural contradictions of a specific era, just as Marilyn Monroe does in Richard Dyer's case study in *Heavenly Bodies* (Dyer 1987: 19–66). Elsewhere, however, attempts to construct stars as icons of a moment in a culture's history have been forced to acknowledge the instabilities and limitations of this approach. For instance, Ulrike Sieglohr's examination of the way in which the German actress Hildegard Knef became constructed as an icon of West German postwar reconstruction in the mid- to late 1940s is particularly revealing of how such accounts privilege certain aspects of a star's career and image while ignoring others (Sieglohr 2000b). Knef's unglamorous portrayals of young women in such films as *Die Mörder sind unter uns* (*The Murderers Are Among Us*, Wolfgang Staude, 1946), *Zwischen Gestern un Morgen* (*Between Yesterday and Tomorrow*, Harald Braun, 1947) and *Film ohne Titel* (*Film without a Title*, Rudolf Jugert, 1947–8) have resulted in her construction as the quintessential 'rubble girl': that is, a representative of the millions of women who undertook the task of clearing away the debris in cities across postwar Germany, symbolising the German nation's attempts to rebuild itself after the Third Reich had been obliterated.

Ulrike Sieglohr observes how Knef's rise to stardom has been linked in critical appraisals and biographies to the birth of the new (post-Nazi) Germany that emerged after May 1945. However, she also notes that Knef's reputation as the 'new face of Germany' ignores a number of important factors: namely, the fact that the actress had been trained at the Nazi-controlled studios of Ufa during the war, making a number of films there, such as *Träumerei*

(*Dreaming*, Harald Braun, 1944). It also ignores the fact that Knef quickly became an international star by adopting a more subversive and glamorous image, most notably in Willi Forst's *Die Sünderin* (*The Sinner*, 1951). Sieglohr notes that in 1948, after winning the Best Actress prize at the International Film Festival in Locarno, Knef signed a contract with Hollywood producer David O. Selznick and moved to the USA and that, although she returned to Germany in 1950 to star in *Die Sünderin*, the transnational course of her career was already set. After appearing in 20th Century-Fox's *Decision before Dawn* (Anatole Litvak, 1951), she made films in Hollywood, France and Britain, as well as Germany – most notably, *The Snows of Kilimanjaro* (Henry King, 1952), *Svengali* (Noel Langley, 1954) and *Fedora* (Billy Wilder, 1978), often playing beautiful and glamorous characters that were a far cry from her rubble girls of 1946–7. Consequently, Knef's incarnation of postwar Germany's reconstruction was not only brief but also largely in contrast to the work she produced and the image she acquired during her career as a film star, this being a formative but unrepresentative phase.

Sex symbols and muscle men

In order to claim a place in the pantheon of international stardom in the 1950s, Hildegard Knef had to compete for roles in Hollywood films and European co-productions alongside a growing roster of pneumatic sex symbols: most notably, Marilyn Monroe, Kim Novak, Sophia Loren, Brigitte Bardot, Diana Dors and Anita Ekberg, many of whom were 'blonde bombshells'.[2] These were not only symbols of sex (i.e., gender *and* sexuality), but also of class, nationality, ethnicity and race. The sex symbol was 'defined in terms of her excessive sexuality, which is seen as a manifestation of, and commentary on, shifting social relations of class, gender and sexuality' (Cook 2001: 169). A transgressive figure, the sex symbol challenged 'traditional

social boundaries, and is often demonised or criminalised as an instrument of consumerism, even if she is celebrated for her independence' (ibid.). Combining 'sexual transgression, mercenary motives and hedonistic lifestyle', Pam Cook notes that 'the postwar, post-Kinsey sex symbol was an international phenomenon that could be found in many … female stars of the period, from continental Europe as well as Britain and the USA' (ibid.: 169–70). She further notes that the 'blonde bombshell … played a significant role in the process of redefining cultural attitudes in the shifts towards modernity that took place during the 1950s' (ibid.: 171).

Since Dyer produced his case study of Marilyn Monroe in *Heavenly Bodies*, the sex symbol has become as major area of star scholarship, with a number of studies devoted to the likes of France's Brigitte Bardot, Britain's Diana Dors and Italy's Sophia Loren (Dyer 1987: 42–5). Christine Geraghty, in her study of Dors, writes that at 'the crux of this construction of a sex symbol are the contradictory ideas of vulnerability and knowingness which allow the female star to be perceived as sexually active and challenging but not held responsible for how she behaves' (Geraghty 1986: 341). She goes on to explain how the knowingness of the sex symbol derives largely from the sense of her 'deliberate dressing up, an emphasis on expense and sensuality – diamonds, sequins, furs', as well as her portrayal of knowing and calculating characters in films (ibid.). Meanwhile, vulnerability is usually suggested through 'a certain childishness which is partly indicated by an emphasis on being natural and direct' but also through publicity suggesting that the stars are greatly influenced or even controlled by their husbands (ibid.: 342). Geraghty argues, however, that no two sex symbols 'will fit this knowingness/vulnerability axis in the same way' (ibid.).

Pam Cook has observed that Diana Dors acquired a star persona in the 1950s that encapsulated the 'conflicting cultural and social values surrounding class, gender and sexuality' (Cook 2001: 167). By the mid-1950s, Dors was one of Britain's best-known

female film stars, distinguished from the majority of her compatriots by being unashamedly sexual, epitomising working-class aspirations of social mobility in a new age of affluence and consumerism. Identified as a working-class woman, she was straight-talking and outspoken, especially against middle-class English hypocrisy and petit-bourgeois morality. For Cook, 'she was emblematic of conflicting forces of social change in a way no other British star was able to achieve', bringing this unique and challenging aspect to her roles in such films as *The Weak and the Wicked* (J. Lee Thompson, 1954), *A Kid for Two Farthings* (Carol Reed, 1955), *Value for Money* (Ken Annakin, 1955), *An Alligator Named Daisy* (J. Lee Thompson, 1955) and *Yield to the Night* (1956) (ibid.: 175). By 1956, Dors had developed an iconic status through the 'self-conscious performance of sexuality' that included a '[s]tylized body language, gesture and stance combined with exaggerated physical attributes such as a tightly corseted, statuesque figure' (ibid.: 168). Although she was not the only British sex symbol (others included Sabrina and Belinda Lee), she was 'the only one who has been given a place in the blonde bombshell international pantheon, along with Marilyn Monroe and Brigitte Bardot' (ibid.).

Diana Dors' international reputation, particularly after making three films in Hollywood in the mid- to late 1950s, made her seem less British as a star than many of her contemporaries, such as Kay Kendall, Virginia McKenna, Sylvia Sims or Yvonne Mitchell. From the start of her film career, Dors had presented an image that was modelled on Hollywood glamour and, in many ways, was opposed to the conventional standards of British femininity, which was dominated largely by notions of restraint (even repression) and authenticity. Melanie Bell, in *Femininity in the Frame* (2010), has observed that Dors' star image as a sex symbol and blonde bombshell in the late 1950s was uncharacteristic of British female stars and enabled her to be cast in unconventional roles more typically associated with European (mainly French and Italian)

actresses (Bell 2010: 147). Bell suggests that Dors reached her peak as an international icon following her return from Hollywood after her RKO contract expired,[3] appearing in Luigi Zampa's Italian comedy *La regazza del palio* (1958, released in USA in 1960 as *The Love Specialist*), Gordon Parry's *Tread Softly Stranger* (1958) and Alan Rakoff's *Passport to Shame* (1959). Of the latter, Bell notes the significance of Dors' casting as a prostitute, claiming that she was the only British film actress in the 1950s who could convincingly take on this highly sexualised role (ibid.: 146). This is suggested by the casting of Dors alongside a number of international stars, the Czech-born actor Herbert Lom, American star Eddie Constantine and Parisian actress Odile Versois. While Versois was cast as the good girl (Malou, a French waitress), Dors was cast as bad girl Vicky, a glamorous but tough prostitute in tight, figure-hugging costumes that accentuate her curves. Despite being the bad girl, however, as Bell points out, Dors' character is treated sympathetically and with some respect, the film being unusual in its frank depiction of contemporary prostitution. Furthermore, in her role as the prostitute (or 'pneumatic tart', as Bell describes her) Dors embodied a modern conception of female sexuality, operating both as 'an ambiguous figure' and as a 'site where concerns, anxieties and new understandings of female sexuality were being worked through in a manner that was palatable to audiences', the kind of figure that would play a more prominent role in British New Wave films of the 1960s: most notably, *The L-Shaped Room* (Bryan Forbes, 1962) (ibid.). During the 1960s, however, Dors was eclipsed by a new generation of British actresses that, in various ways, departed from the image of the international sex symbol or 'blonde bombshell': most notably, Rita Tushingham, Lynn Redgrave, Rachel Roberts, Claire Bloom, Shirley Ann Field and Julie Christie.

Italy's most successful sex symbol, Sophia Loren, came to prominence at roughly the same time as Diana Dors. Having begun her film career in 1950, she attracted international attention as the

Ethiopian slave girl in Clemente Fracassi's film version of Verdi's opera *Aida* (1953).[4] Her subsequent appearance as the pizza girl (la pizzaiola) in Vittorio de Sica's episodic *L'Ora di Napoli* (*The Gold of Naples*, 1954) transformed her into a major star in Italy and made her the 'embodiment of a highly subversive idea of unabashed female sensuality', one that mixed defiance and flirtatiousness (Gundle 2004: 81). Her international profile was raised significantly by her roles as the dark-skinned, raven haired Greek peasant girl in Jean Negulesco's *Boy on a Dolphin* (1957) with Alan Ladd, and as a Spanish woman in Stanley Kramer's *The Pride and the Passion* (1957). Other Hollywood productions, including John Wayne's *Legend of the Lost* (Henry Hathaway, 1957) and Cary Grant's *Houseboat* (Melville Shavelson, 1958), advanced Loren's international success at the same time that Diana Dors' RKO films failed. Moreover, as Dors was being eclipsed by a new generation of film actresses in Britain, Loren's popularity and success in Italy endured: most notably with her starring roles in Vittorio de Sica's *La Ciociara* (*Two Women*, 1960), *Ieri, oggi, domani* (*Yesterday, Today and Tomorrow*, 1963) and *Matrimonio all'italiana* (*Marriage, Italian Style*, 1964), as well as in Italian-Hollywood co-productions, such as Anthony Mann's *El Cid* (1961). Not only did Loren dominate notions of Italian national identity during this period, she also established an enduring model for female film stars in Italy. 'Even today,' writes Maddalena Spazzini, 'Sophia Loren still dominates the Italian star system', remaining 'the country's most successful star' (Spazzini 2009: 161). She further notes that Loren has become the 'prototype' to which successive generations of Italian actresses have been compared, many of whom have found themselves dubbed the 'new Sophia Loren' (ibid.). Noting that Loren was responsible in the 1950s for spreading abroad stereotypical images of the country based on family values, food and beauty, Spazzini also records that these 'are now more important in keeping alive the sense of national identity in the country more than other cultural elements' (ibid.: 165).

Bronze bombshell: Dorothy Dandridge, the
star of *Carmen Jones* (1954)

Stephen Gundle, in his essay 'Sophia Loren, Italian Icon', has revealed a rather different picture, noting that at the beginning of her film career Loren was not considered Italian enough, being cast therefore as gypsies, non-white 'ethnic' types and 'exotics', including Africans (Gundle 2004: 80–1). He also notes that her status as Italy's national icon has fluctuated over time, so that while in the 1950s she became a 'cultural icon and even a national symbol', there was a 'dramatic erosion of Loren's personal popularity' in the late 1970s and early 80s (ibid.: 86 and 92). However, having fallen out of favour, Gundle reports that Loren returned to popularity in Italy in the late 1980s as a 'woman of strength and courage', being voted a national idol in 1989 (ibid.: 93). This indicates the way in which certain histories, images, films and performances are often eradicated in the construction of a star as a national symbol (i.e., in Spazzini's account). It also indicates the way in which the sex symbol is not only a national, class, gender and sexual icon but also one of ethnicity and race, most often embodying notions of whiteness in the case of 'blonde bombshells' such as Marilyn Monroe, Brigitte Bardot, Diana Dors and Anita Ekberg (Dyer 1987: 42–5).

Sophia Loren stood out in the pantheon of international sex symbols in the 1950 and 60s as a darker version of the type. Hollywood, meanwhile, produced a darker version around the same time. Dorothy Dandridge, the star of *Carmen Jones* (Otto Preminger, 1954), was Hollywood's first 'black bombshell' (or, given the light tones of her skin, 'bronze bombshell'), whose beauty, shapely figure and sex appeal could match those of many of the 'blonde bombshells' of the 1950s. Donald Bogle has observed that she achieved recognition in Hollywood in 1951 as Melmendi, Queen of the Ashuba, in Lex Barker's *Tarzan and the Jungle Queen* (Byron Haskin, 1951), stating that 'it was apparent that never before had the black woman been so erotically and obviously used as a sex object' (Bogle 2004: 196). Thereafter she was cast opposite Harry Belafonte in three films: MGM's all-black musical *Bright Road* (Gerald Mayer,

1953); *Carmen Jones*, Oscar Hammerstein II's African-American version of Bizet's opera Carmen; and *Island in the Sun* (Robert Rossen, 1957). Of these three, it was *Carmen Jones* that boosted Dandridge's star status, earning her an Oscar nomination for Best Actress of 1954 for her starring role in the 'most lavish, most publicized, and most successful all-black musical' of the 1950s (ibid.). By 1955, Dandrige was a major celebrity, her image appearing on the cover of magazines such as *Paris-Match* and *Ebony*, her private life being repeatedly 'reported on, probed, studied, dissected, discussed, scrutinized, and surveyed' with all kinds of incredible rumours circulating about her (ibid.: 197).

In addition to her talents as an actress and singer, Dandridge's stardom rested upon her 'combination of acceptably light-skinned good looks and an acceptable crossover repertoire', her incarnation of the 'Bronze Venus' stereotype (Alexander 1991: 48). Nevertheless, despite her talent, her beauty and her fascinating (even scandalous) private life, Hollywood was unable to sustain Dandridge's stardom after *Carmen Jones*, supplying her with few decent parts. The only time she was able to match this performance was when cast as Bess alongside Sidney Poitier and Sammy Davis Jr in Preminger's film version of Gershwin's opera *Porgy and Bess* (1959), for which she was nominated for a Foreign Press Golden Globe Award for best actress in a musical (Bogle 2004: 197). However, this commercially successful film was harshly criticised by much of the black community in the USA and, according to Karen Alexander, around this time the actress began to feel burdened by her image as Hollywood's strongest 'Black Woman', causing her to retreat into a marriage that ultimately left her 'morally destroyed and financially bankrupt' (Alexander 1991: 49).

Dorothy Dandridge's film career was relatively short-lived, being confined to the 1950s. While few of the great sex symbols of this era prospered in the 1960s, many of the 'blonde bombshells' (e.g., Marilyn Monroe and Jayne Mansfield) and the 'brunette

bombshells' (e.g., Jane Russell) have been reserved a place in film history as icons of the 1950s. However, in the pantheon of Hollywood sex symbols, Dandridge had largely been forgotten: that is, until recently. The HBO biopic *Introducing Dorothy Dandridge* (Martha Cooliage, 1999), starring Halle Berry in the title role, did much to reclaim Dandridge's public reputation. Meanwhile, her profile within film studies was significantly augmented in 2009 with the publication of Mia Mask's *Divas on Screen: Black Women in American Film*, which devoted a chapter to her. Mask chose Dandridge as one of five female stars to represent the history of black women in American cinema from the 1950s to the 2000s, the others being Pam Grier, Whoopi Goldberg, Oprah Winfrey and Halle Berry. Representing black female stardom in the 1950s, Dandridge is presented here as not only a culturally important representative of 1950s black bourgeois beauty but also as 'an icon admired by African Americans', as 'emblematic of the social and political climate' in the USA at this time, as 'represent[ing] the dominant culture's ideal concept of black femininity' and as an 'important icon for understanding black spectators and their class aspirations and identifications (Mask 2009: 14, 21, 30 and 56). The heavy burden that Alexander ascribes to Dandridge during the 1950s as Hollywood's strongest 'Black Woman' has subsequently been matched by the heavy burden of representation that her star image is now called upon to sustain in Mask's book. Nevertheless, it would seem that part of her reclamation as a significant Hollywood star of the 1950s lies with her ability to represent in numerous ways the peculiar social concerns of black *and* white America at this historical moment. It is in part the ambiguities and instabilities of Dandridge's star image that make her a prime candidate for representing America's racial ideologies of the 1950s, making her a fascinating, troubling and contentious symbol of gender, sexuality, race and nationality, and, therefore, making her an unstable symbol.

It is the lot of the sex symbol to be loved and loathed, worshipped as a sex goddess and ridiculed as a travesty of womanhood. While the rewards can be considerable for the actress who assumes this mantle (i.e., in terms of lucrative employment, fame and popularity), the costs are equally great (i.e., in terms of typecasting, a short shelf-life and a loss of credibility). The excessive nature of the sex symbol makes her not only the ultimate in heterosexual male desire but also a parody of conventional patriarchal ideals of femininity, incorporating some aspect of mockery and critique into her image and performances, accounting in part for the sex symbol's longstanding appeal for gay audiences. The sex symbol also seems redolent of America in the 1950s, an era in which prurience and repression were locked in a struggle for supremacy. Since the 1950s, only a handful of sex symbols have survived as major stars within mainstream commercial cinema (most notably, Raquel Welch), becoming increasingly associated with cult cinema, sexploitation films and pornography, making the sex symbol a devalued commodity. While the 1950s has come to signify a time of relative innocence or naivety in regard to gender politics, being associated with a period before feminism transformed the lives of women in the West, the 1960s has come to be characterised as a period of consciousness in which established ideologies were contested and eventually overturned. Since the 1960s, therefore, the sex symbol has symbolised retrogressive gender politics, which can only be salvaged via camp or parody. It is the ambiguities of the sex symbol that ultimately prove to be her saving grace, her idealised and parodic sexual identity lending her image a subversive edge. The sex symbol, moreover, occupies an ambivalent position between, on the one hand, more normative representations of femininity (personified by the likes of Lillian Gish, Claudette Colbert, Greer Garson, Betty Grable, Grace Kelly, Ava Gardner, Goldie Hawn and Julia Roberts) and, on the other hand, more challenging versions (most notably, Marlene Dietrich,

Mae West, Katharine Hepburn, Jane Fonda, Jodie Foster, Whoopi Goldberg and Hilary Swank).

The male muscle-bound stars of Hollywood action movies of the 1980–90s occupy a similar position between normative representations of masculinity (e.g., Clint Eastwood, Harrison Ford, Sean Connery, Mel Gibson, Denzel Washington, Daniel Craig and Matt Damon) and more unconventional masculine types (e.g., John Travolta, John Hurt, Richard Gere, Hugh Grant, Johnny Depp, Brad Pitt, Rupert Everett and Jude Law). The 1980s and 90s film star body-builder (most notably, Sylvester Stallone and Arnold Schwarzenegger) has taken the place of the 1950s sex symbol, his pumped-up and oversized physique replacing the blonde bombshell's pneumatic body, his spectacular pecks substituting for her ample bosom, his hyper-masculinity matching her ultra-femininity. In so doing, the body-built action star has elicited a similar degree of ambivalence among audiences and critics, being both admired and ridiculed (Tasker 1993: 76). The connection between these two types of star is such that Yvonne Tasker was able to successfully adapt and apply much of Richard Dyer's work on the 1950s sex symbol to her study of action heroes of the 1980s and early 90s: for instance, using his notion of cultural embodiment in her analysis of the images and performances of Stallone, Schwarzenegger, Jean-Claude van Damme and others (Tasker 1993: 76).

Tasker sets her analysis of male body-built stars against the background of a crisis in western masculinity resulting from the social advancement of feminism, on the one hand, and gay liberation, on the other. Consequently, Stallone, Schwarzenegger, Jean-Claude van Damme and their comrades emerge as embodiments of an overly elaborated form of male heterosexuality that is a response to the notion of the 'New Man' (i.e., sensitive to issues of equality, respectful of the demands of feminism and, to some extent, feminised) and homosexuality (or gay/queer identities), even though homoeroticism features heavily as part of their image and the

narratives of their movies (Tasker 1993: 128). Nothing if not contradictory, these symbols of hyper-masculinity are frequently feminised by being subjected to an eroticised gaze in films and publicity, so that the muscle-bound action hero consistently provokes ambivalent and complex reactions, producing a multiplicity of readings and pleasures among different kinds of audience.[5] Also (and, again, reminiscent of the 1950s sex symbol), these muscular stars of action movies come in a variety of forms that represent national, racial and ethnic characteristics: white American (Stallone), black American (Wesley Snipes) and white European (Schwarzenegger). Many of the Hollywood action movies of the 1980s and 90s were built around blonde, blue-eyed Nordic actors, presenting an extreme form of Aryan whiteness: most notably (the Swede) Dolph Lundgren. However, just as many Hollywood action movies feature black American stars (e.g., Eddie Murphy, Danny Glover, Denzel Washington and Will Smith), as Yvonne Tasker observes in her chapter 'Black Buddies and White Heroes' (Tasker 1993: 35–53). Furthermore, the action movie has increased demand for Asian stars in Hollywood, providing star vehicles for Jackie Chan and Yun-Fat Chow from Hong-Kong, and Joan Chen and Jet Li from China (see Stringer 2003).

Culture personified

Since 1918, Hollywood has been the most dominant film industry in the world, having a major impact on the film cultures of many countries. Consequently, Hollywood stars have traditionally been some of the biggest on the planet. However, the American film industry also has a long tradition of hiring leading film artists (directors, writers, cinematographers and actors) from around the world, making Los Angeles the global centre of film production. Drawing upon a diverse range of international talent and making

films for numerous national audiences, Hollywood has tended to overlook national, cultural, regional and ethnic differences in favour of more generalised identities, chiefly (and crudely), American and non-American. While Hollywood has tended to distinguish between Latins and Northern Europeans, Arabs and Asians (also between Indians and 'Orientals') under 'non-American', finer distinctions have tended to be ignored. Consequently, when an Italian dancer called Rodolfo Alfonzo Raffaello Pierre Filibert Guglielmi di Valentina d'Antonguolla became internationally famous as Rudolph Valentino in the early 1920s, he was cast as a Latin-American gaucho in *The Four Horsemen of the Apocalypse* (Rex Ingram, 1921), a Spanish matador in *Blood and Sand* (Fred Niblo, 1922), an Indian prince in *The Young Rajah* (Phil Rosen, 1922), Arabs in *The Sheik* (George Melford, 1921) and *The Son of the Sheik* (George Fitzmaurice, 1926), a Frenchmen in *Monsieur Beaucaire* (Sidney Olcott, 1924) and a Russian in *The Eagle* (Clarence Brown, 1925). Hollywood ignored his Italian nationality and rebranded him (very successfully) as a 'Latin Lover' (see Lawrence 2010b).

According to Christian Viviani, Swedish actress Greta Garbo only played Swedes in four of her Hollywood films of the 1920s and 30s (Viviani 2006: 95). Mostly, she played Russians (i.e., in five films) and French women (four films), although she was also Dutch in *Mata Hari* (George Fitzmaurice, 1931) and Polish in *Conquest* (Clarence Brown, 1937). Occasionally her nationality was unspecified, as in the case of *Flesh and the Devil* (Clarence Brown, 1926). In Hollywood during the studio era, nationality hardly mattered unless it was racially or ethnically marked. Consequently, while Margarita Carmen Cansino (better known as Rita Hayworth) rarely played Spanish or Mexican characters, American actress Rita Novella (also known as Rita Rio and Dona Drake) specialised in Latin American and Mexican characters throughout the 1930s and 40s. Even in the 1990s and 2000s, Latin American characters have frequently been played by Europeans in Hollywood films. For instance, Spanish actor Antonio

Banderas played a Cuban trumpeter in *The Mambo Kings* (Arne Glimcher, 1992) and a Mexican guitarist and dancer in *Desperado* (Robert Rodriguez, 1995). As Vicente Sánchez-Biosca has explained, there are simply more opportunities for Spanish actors to play South Americans and Mexicans in Hollywood than Spaniards, especially since the rapid expansion of the Hispanic community in the USA in the 1990s (Sánchez-Biosca 2006: 138).

Ginette Vincendeau has claimed that when French stars appear outside of France they invariably assume the 'burden' of national identity, finding themselves defined in terms of their Frenchness (Vincendeau 2000: 31). During the 1930s and 40s this burden was placed upon Maurice Chevalier and Charles Boyer, while during the late 1940s and 50s, it was assumed by Louis Jourdan (originally Louis Gendre). Jourdan began his Hollywood career in 1947, appearing in such films as *The Paradine Case* (Alfred Hitchcock, 1947), *Letter From an Unknown Woman* (Max Ophüls, 1948), *Madame Bovary* (Vincente Minnelli, 1949), *Anne of the Indies* (Jacques Tourneur, 1951), *Three Coins in the Fountain* (Jean Negulesco, 1954) and *Gigi* (Minnelli, 1958). However, while for many moviegoers Jourdan was regarded as the archetypal Frenchman (a suave, highly sexualised and sophisticated *bon vivant*), Hilary Radner argues that he was frequently used in Hollywood to represent an unspecified 'Un-American' identity, even noting that his ethnicity shifted between a range of 'foreign' identities, including an 'Oriental' villain in the James Bond film *Octopussy* (John Glen, 1983) (Radner 2006: 126). She concludes that Jourdan's persona in Hollywood lacked 'a clearly defined national self' and that what it represented was 'otherness', particularly in terms of sexuality (ibid.: 130). Jourdan's highly sexualised persona (or, for Radner, his 'hyper-sexuality') distinguished him from most American male stars of the studio era and, Radner argues, rendered him more feminine than masculine, lending him an ambiguous sexuality that had previously characterised Rudolph Valentino's persona in the 1920s.

While in 1983 it may have been acceptable for Jourdan to play an Asian character in a 007 movie, by the late 1990s such casting would have been deemed offensive and intrinsically 'Orientalist'. During the mid- to late 1990s, Hollywood producers abandoned the longstanding practice of casting non-Asian actors in leading Asian roles. At the same time, increasing numbers of Hong Kong and Chinese stars began to achieve major commercial success in the USA: most notably, Jackie Chan. Although Jackie Chan was one of the biggest stars of 1980s Hong Kong cinema,[6] his films received only limited release in the West and his first English-language films, such as *The Big Brawl* (Robert Clouse, 1980) and *The Protector* (James Glickenhaus, 1985), did poor business beyond Asia. However, that changed decisively in 1996 when *Rumble in the Bronx* received widespread distribution across the USA, earning $9.8 million during its opening weekend and making over $30 million during the course of its initial theatrical run (Gallagher 2004: 120). This significantly raised Chan's international profile, extending his fame beyond martial arts fans and making him one of the world's most popular action stars. His subsequent Hong Kong films, such as *Jackie Chan's First Strike* (Stanley Tong, 1997), were dubbed into English and the promotional campaigns for these played down potential cultural differences in order to enhance their appeal for mainstream American audiences.

Mark Gallagher has observed that Chan's first Hollywood film, *Rush Hour* (Brett Ratner, 1998), proved to be his biggest hit in the West, partly as a result of it being shot in English but also because it adheres closely to western stereotypes of Chinese people (Gallagher 2004: 127). In his essay, 'Rumble in the USA: Jackie Chan in Translation' (2004), he explores the various ways in which Chan's established star persona was adapted in order to attract American audiences by drawing attention to his characters' cultural difference rather than simply denying it, transforming him into a more comic, less masculine and more childlike figure (i.e.,

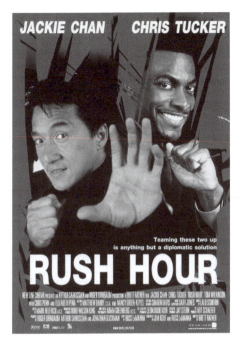

Cultural negotiations on display: Jackie Chan and Chris Tucker in *Rush Hour* (1998)

earnest, sincere and vulnerable), more likely to appeal to western viewers by pandering to their sense of racial superiority while simultaneously assuaging fears of Asia's emergence as an economic, as well as military, power (ibid.: 121–33). He also claims that part of *Rush Hour*'s huge success in the USA resulted from its appeal to black Americans, noting the vital role played by black actor Chris Tucker as Chan's sidekick, enabling an 'African-American protagonist and his Hong Kong Chinese counterpart [to] overcome their ethnic and cultural differences [in order to] defeat the Chinese-American gang led by the evil, white Hong Kong crime lord (Tom Wilkinson)' (ibid.: 128). While the film unites blacks and Asians in the face of a white enemy, much of its humour stems from culturally specific tastes (i.e., in food and

music) being exchanged between the film's black and Asian protagonists, promoting a deeper mutual respect.

Since the late 1990s numerous Chinese stars have become highly successful in Hollywood, being absorbed into the American film industry. In contrast, Bollywood stars have seldom crossed over to Hollywood despite acquiring some of the largest and most diverse international audiences of any stars since the early 1990s. During the latter half of the twentieth century, Bollywood became increasingly transnational, catering to steadily growing numbers of moviegoers outside India that made up the massive (and massively dispersed) Indian diaspora: most notably, in the USA, Canada, Australia, New Zealand and the UK. Many Bollywood stars have built their careers and their star status on their popularity with members of this diaspora. Nevertheless, few have been lured to Hollywood, the major exception being Aishwarya Rai who, in 2009, joined the supporting cast of Steve Martin's star vehicle *The Pink Panther 2* (Harald Zwatt), alongside British actors Emily Mortimer, Alfred Molina, John Cleese and Jeremy Irons, Japanese actor Yuki Matsuzaki and French action hero Jean Reno.

While few Bollywood stars have worked in Hollywood, the Mumbai-based film industry has been positioning itself as the international centre of global entertainment in the twenty-first century, with a number of Indian production companies attempting to match the international success of Ang Lee's *Crouching Tiger, Hidden Dragon* (2000) (Bose 2006: 12). Consequently, some Bollywood films have sought to capitalise on an international market beyond the Indian diaspora by producing spectacular action thrillers, such as Sanjay Gadhvi's *Dhoom:2* (2006), and sci-fi fantasies, such as Sujoy Ghosh's *Aladin* (2009), S. Shankar's *Endiran* (2010) and Anubhav Sinha's Shah Rukh Khan vehicle *Ra.One* (2011). In part, this is to exploit Mumbai's status as the international centre of special effects but this is also part of a more strategic attempt to rebrand 'Bollywood' as a high-tech purveyor of dominant cinematic

genres, placing the Hindi film industry more directly in competition with Hollywood. However, as Derek Bose argues in *Brand Bollywood*, Indian cinema may gain a more global reach by developing more international co-productions (i.e., with Europe, China and Hollywood). The ultimate aspiration, he suggests, should be a Bollywood–Hollywood co-production starring Shah Rukh Khan with either Brad Pitt or Nicole Kidman that could match the global success of *Crouching Tiger, Hidden Dragon* (Bose 2006: 57).

It was *Crouching Tiger, Hidden Dragon* that propelled Chinese actress Zhang Ziyi to international stardom in 2000. After further success in Zhang Yimou's *Hero* and *House of the Flying Daggers* in 2004, she became one of the most internationally famous Chinese stars and, according to Olga Kourelou, was widely regarded as an 'embodiment of the transformation of Chineseness in the age of global modernity' (Kourelou 2010: 123). Kourelou, in her essay '"Put the Blame on … Mei": Zhang Ziyi and the Politics of Global Stardom' (2010), adapts Richard Dyer's notion of the star text and his understanding of stars as embodiments of ideological contradiction in order to read Zhang Ziyi's star image in terms of its crystallisation of ideological conflicts, conflicts resulting from the transnationalism of Chinese films and stars in the global market and also in terms of China's recent transition to a post-Mao regime with closer links to the West. In 2005, Zhang Ziyi was both acclaimed as the 'face of China' in the twenty-first century (i.e., when she appeared as one of three prominent Chinese cultural icons on the cover of the American magazine *Newsweek*) and accused of being an 'Orientalist movie icon' (i.e., when her eyes were retouched and tinted blue to look more western for the billboard posters promoting her first Hollywood film, Rob Marshall's *Memoirs of a Geisha* [2005]) (ibid.: 123). Once she became the West's face of China *and* Japan, Zhang Ziyi's star image became not only contradictory but also contentious. In China, she was criticised for betraying and misrepresenting her country, with *Memoirs of a Geisha* being banned

Chinese star Zhang Ziyi, as the Japanese geisha
Nitta Sayuri, in *Memoirs of a Geisha* (2005)

'for fear of inciting anti-Japanese sentiments', while the star was blamed for 'selling out', for 'disregarding cultural specificity and ethnic diversity, and thus betraying her national loyalties' (ibid.: 122).

Although branded an 'Orientalist movie icon' in mainland China, Zhang has been recognised as an important (and marketable) symbol of China who conforms closely to western perceptions of Chinese womanhood (ibid.: 124). Despite her commercial and critical success, however, Zhang Ziyi remains problematic as an embodiment of twenty-first-century China. While her performance skills, beauty and charismatic personality have made her indisputably one of the twenty-first century's greatest film stars, as an icon, embodiment or incarnation of China or of Chinese femininity (or even of a transnational and modern or westernised Chinese femininity) her image is complex, contradictory, controversial and contestable. Claims that in the West she is the embodiment of a modern China are undermined by the fact that she is generally known for her historical roles that draw on various motifs of the *femme fatale* (or warrior women) in seventeenth-century fiction and the *sing-song* girls (i.e., tea-serving entertainers/prostitutes) popular in Chinese musicals of the 1950s, making her seem more traditional than modern. Clearly her fascination comes from a range of oblique references to China and the West, both ancient and modern, that she is able to conjure up through her films and publicity, which makes the task of pinning down precisely what her images represent not only challenging but questionable as an exercise. Furthermore, imposing a burden of representation upon her (i.e., as either the incarnation of a modern and westernised China or as a western Orientalist movie icon) will invariably prove hard to sustain as the actress continues to develop her career as a film star in a transnational context, competing for roles alongside other Chinese actresses (e.g., Maggie Cheung, Michelle Yeoh and Gong Li) and other transnational stars (e.g., Penelope Cruz, Keira Knightly or

Aishwarya Rai). As the transnational stars of earlier periods have shown (most notably, Sophia Loren), a film star seldom remains an icon or symbol of anything for very long, for in order to maintain her star status over time she or he must adapt to changing times, indeed being part of the cultural processes of negotiating social change.

Stars are made. Once manufactured and distributed widely, they continue to evolve, their images rarely remaining stable or consistent. For example, although British film star Dirk Bogarde started out in the early 1950s by incarnating an aggressive and sexually charged British working-class masculinity in such films as *The Blue Lamp* (Basil Dearden, 1950), by the time he starred in Luchino Visconti's *Death in Venice* in 1971 his sexuality had matured into something more gentle and ambiguous (i.e., implicitly homosexual) and he had acquired a more bourgeois and European persona. This transformation, moreover, had taken place gradually and incrementally throughout the 1950s and 60s (Medhurst 1986: 348–53).[7] Bogarde's changing persona demonstrates the extent to which film stars occupy different relations with social groups and historical contexts as they age, as the film industry develops and as societies change. It also suggests that the process of identifying a star's cultural significance necessarily involves mapping the shifts that take place over the course of their career rather than fixing upon one moment that may seem more significant than any other, a moment that is singled out as emblematic of a star's relationship to a specific time and place.

Tenuous connections

Studies that seek to establish the various (even contradictory) ways in which a film star embodies or incarnates a particular set of social values or a specific and identifiable period within a culture's history are invariably open to charges of reductionism and over-simplification, as

well as 'reflectionism' (see McDonald 1998: 179). Reflectionism was something that Richard Dyer was concerned to avoid in his own work on stars. In the preface to his book *Heavenly Bodies*, for instance, he stated that his objective with this study was 'to find a way of understanding the social significance of stars which fully respects the way they function as media texts, yet does not fall into a view of a given star as simply reflecting some aspect of social reality that the analyst cared to name' (Dyer 1987: ix). Increasingly, Dyer turned his attention to the role of audiences (and various different types of audience) and the ways in which they interpret and make use of star discourses.

Attempts to identify and understand the socio-cultural contexts in which a star operates, emerges and prospers have often proven instructive.[8] Such an approach can, for instance, provide insights (or, at least, clues) into why certain performers were chosen and groomed for stardom, why they became popular and with what kinds of audience, as well as how their work was evaluated in their own time and thereafter. How stars are used to represent particular social groups or historical moments is vital to understanding not just the cultural meanings but also the cultural practices of stardom: for example, how and why certain star texts come to have specific meanings assigned to them, being accepted or even appropriated by particular social groups. Such questions can provide a useful starting point for investigations into film audiences and film cultures, particularly when it is recognised that the cultural significance of a star results from an active process of selection and manipulation in which certain potential meanings are favoured over others at one time or another. Charting the changing cultural meanings that are assigned to a star can be illuminating, especially when it is recognised that the ideological contradictions that are negotiated by stars throughout their careers are seldom, if ever, resolved or indeed resolvable. If it is true that star images 'set off resonances that have deeper social implications', then the social meanings that are

entangled among the variety of star texts (both films and extra-filmic matter) are likely to reverberate differently over time (Medhurst 1986: 347). Subtle variations are likely to occur as these social resonances rebound off the various constituent forces that distinguish one cultural moment from another, offering scholars an opportunity to map and remap the coordinates of such transformations. However, the words 'resonance' and 'implication' suggest meanings that are fluid and amorphous, drawing attention to the fact that star meanings are largely intangible and virtually ungraspable. Acknowledging this makes the prospect of identifying or fixing a star's cultural significance at best provisional, at worst impossible and, inevitably, challenging.

It would be naive to assume that film stars closely resemble the social groups that they are commonly associated with or held to represent. In the 1970s, Barbra Streisand was not actually like most Jewish women living in Brooklyn, New York, just as Gracie Fields was never really like the vast majority of working-class Lancashire women in the 1930s. As stars, they had qualities that set them apart, distinguishing them and making them stand out as unique. Nevertheless, in the eyes of the world, Streisand became the representative of the post-1960s emancipated Jewish females of Brooklyn just as Fields had been the representative in Britain of liberated working-class women from Rochdale before World War II. A significant part of their stardom was invested in their abilities to personify these groups and their culture (i.e., their values, ideas, ideals, fantasies and aspirations, etc.), giving them a voice and an image. At the same time, however, Streisand and Fields were more than types. Their success depended on being popular with certain social groups and on their acquisition of a professional status as a certain type of entertainer (i.e., comediennes with musical talent and an ability to play tragicomedy, provoking laughter and tears) but their attainment of stardom also rested upon their individuality, extraordinariness and originality. The acquisition of a unique and

exclusive set of skills and characteristics was fundamental to the stardom Barbra Streisand and Gracie Fields, as it has been for the vast majority of film stars. Consequently, they and their counterparts in film industries around the world (and across many decades) have combined typicality with originality. Understanding a star's typicality involves a consideration of their representativeness (i.e., their cultural and historical significance) but it remains essential that this consideration does not overshadow the star's uniqueness, what made them different, even unrepresentative. Moreover, if stars really can offer historians insights into a culture or society at a particular moment of its history, then such insights can never be complete, direct or consistent, particularly during periods of social transformation. What stars offer, if anything, are little more than fleeting and tantalising glimpses of a world in flux, unsteady and unstable, easily misapprehended.

Stars exist primarily in the realm of representation and, as such, are divorced from reality. Their relation to reality is necessarily tenuous, given that most inhabit an exalted position in a higher social sphere. On screen they may play characters that are closer to real life, these characters having been designed by writers to represent and articulate aspects of human experience. However, social disconnection is often the price of fame, the celebrity eliciting unusual responses from most of the ordinary people they encounter in daily life. Film stars, the ultimate celebrities, can easily become detached from the real people and the culture that they are generally believed to represent, so that to read them as representative is to ignore the gap that separates stars from ordinary people. Once raised to the lofty heights of stardom (the upper stratosphere in the case of super- or mega-stars), the culture from which the star emerged becomes insignificant. To ignore the pedestal on which stars are raised is to ignore the gap that separates them from their fans, the gap that generates desire for the star, the desire to be like their favourite star as well as the desire to know more about them. These

gaps are not only fundamental to a star's achievement and to the retention of star status but also to how they function in society and how people relate to them.

Conclusion

Film stars have often been considered in terms of what they have to reveal about being human and even a particular kind of human being: male or female, black or white, American and non-American, etc. The processes of making stars representative and the forging of links between certain stars and specific social groups and eras warrant investigation. How film-makers, studio executives, publicists, audiences, critics and scholars establish these connections and attempt to sustain them, even in the face of contradiction, ambivalence and hybridity, even when star images strain under the heavy burden of representation, can prove insightful. How and why stars acquire symbolic value remains an important area of star studies.

The symbolic value of stars is most clearly represented by the 1950s 'sex bombs', the 80s body-built action stars and transnational stars, particularly Asian stars working in the West. The pneumatic bombshells of the 1950s forcefully incarnated cultural fantasies of femininity, female heterosexuality but also race and ethnicity, class and national identity. These over-inflated, transgressive and contradictory figures proliferated in an era of sexual prurience and repression in which women were increasingly gaining freedom and independence. Consequently, the sex symbol was not only transgressive but also transient, modern by the standards of the 1950s but retrogressive thereafter. Always contradictory and ambivalent, she epitomised the symbolic potential inherent in stardom, over-valued by audiences in one era and devalued in other.[9] Her significance, moreover, is to be not only evaluated but also

contested as part of the negotiations and exchanges that arise from the different values and inequalities of numerous social groups within the cultural arena. Sex symbols also reveal how time-sensitive and fluid stars can be in terms of reputation, although they (like the body-built stars that later superseded them) also demonstrate how varied reactions to them can be at any one time, provoking adoration and repudiation in more or less equal measure.

The sex symbol and the muscle-bound action hero are also representative of the extraordinariness of film stars. In the case of both the sex symbol and the body-built star, their larger-than-life quality is writ large upon every contour of their over-sized body, bodies that conform more closely to fantasy physiques than conventional human anatomy. The fantastic nature of all stars is exposed by these extreme and exaggerated versions of cinematic bodies, the idealised bodies that commonly populate mainstream commercial cinemas (i.e., toned rather than pumped up) of Hollywood, Europe, Bollywood and China. Meanwhile, transnational stars demonstrate the conflicting demands placed upon stars more generally in their construction as recognisable social (i.e., national or ethnic) types, oscillating between stereotypical notions of national or ethnic identities, on the one hand, and more universal subjectivities that ignore the specificities of nationality, regionality, class or ethnicity, on the other. As transnational stars move from one geographical territory to another, their cultural identities either become exaggerated or obscured, being utilised in some instances rather than others. Many transnational stars have therefore been accused of misrepresenting their national or ethnic characteristics abroad through exaggeration or denial. Transnational stars, perhaps more than any other, reveal the instability and mutability of star identities, which are sensitive to changes in context, industrial and cultural. The kinds of changes that often happen incrementally, almost imperceptibly, with stars who consistently work in the same environment can undergo dramatic shifts when they are transplanted

to new pastures. Given the extent to which the ultimate level of stardom (super- or mega-stardom) requires an international profile, stars are exposed to high levels of instability that inevitably render them internationally recognised symbols of hybridity and inauthenticity as much as personifications of national, regional, racial, class, gender and sexual identity.

CONCLUSION

Through close-ups, films provide intimate views of stars, while interviews in magazines offer intimate insights into their personalities and private lives, for which many people will pay a modest sum. Yet despite these repeated incursions into their personal space, stars remain distant and out of reach. Stars, therefore, both invite and evade scrutiny. A considerable part of this book has been about analysing stars and about what analysis of stars can reveal about film, the film industry, about film culture and even, to some extent, about the wider culture in which films, star images and discourses circulate. This raises a multitude of questions. The attempt to find answers to the questions of what stars do, how they do it and how they are used has resulted in a rich and diverse body of academic literature, much of which has been incorporated into the preceding chapters. These chapters have attempted to organise this branch of film studies into discrete areas, compartmentalising it as part of the process of mapping out the field. The overarching objective has been to select key works that represent most clearly the separate strands of star studies in an effort to better understand its themes, conceptual frameworks and methodologies. This mapping exercise has revealed that considerable progress has been made in terms of understanding the nature and operation of film stardom, the practices of star gazing and the meanings attached to certain stars. Nevertheless, it has also suggested that considerable scope remains for this field to further

Poster for *Gong Fu Zhi Wang (The Forbidden Kingdom)* (2008) starring Jackie Chan and Jet Li

expand and diversify. For instance, it is clear that many nations are currently under-represented in terms of English-language studies of stars: most notably, Japan, Iran, Mexico, South America, Australia, South Africa and Nigeria. Studies of the stars, star systems and fan cultures of these countries would complement the extensive work available on North American and European stars, as well as the emerging work on Chinese and Indian stars.

There is also scope for many more detailed studies of individual stars from around the world, particularly those stars that operate within an international arena: most notably, Bollywood and Chinese stars. It is likely that such studies will follow in due course. Book-length academic studies of Nargis, Amitabh Bachchan, Shah Rukh Khan, Madhuri Dixit, Aamir Khan, Jackie Chan, Zhang Ziyi and Jet

Li, to name just a few, seem long overdue. Such books would no doubt incorporate many of the familiar features of star scholarship, such as a consideration of a performer's star qualities and idiolect, their career trajectory (i.e., training, breakthrough roles, accolades, etc.), the significant contributions of collaborators (teachers, coaches, agents, directors, etc.), the emergence of their type and star vehicles, as well as their attempts to depart from typecasting and extend their range across numerous genres, cinematic modes (i.e., commercial, art house and independent) and national cinemas. It seems likely that students, independent researchers and academic writers will continue to explore the ways in which certain stars embody, incarnate or personify social groups or historical moments. Their work will no doubt examine the way stars endorse or oppose prevalent social values (whether established or emergent), negotiating various ideological contradictions that emerge within or between social groups, revealing these through inconsistencies in their image (i.e., film roles, publicity, promotion and gossip). Similarly, much more research is likely to be carried out into how certain types of audience or members of a specific social group (particularly marginalised groups) have engaged with and made use of stars at particular historical moments.

Scholarship on stars within film studies continues to advance along two distinct lines: how stars work (e.g., their working methods, financial and contractual arrangements, degree of agency and professional practices), on the one hand, and how stars act or perform, on the other. While more direct contact (e.g., interviews) with stars, agents, managers and publicists may clarify the nature of working practices of film stars, more detailed analysis of key moments in key movies should also continue to prove instructive, particularly in terms of the detailed analysis and understanding of the contribution made by an actor's breathing, eyes, voice, facial expressions and bodily movements and postures to screen performance. As noted in Chapter 2, script analysis has begun to

enrich such analysis in recent years and this methodology will no doubt continue to provide a valuable means of exploring a star's approach to performance and characterisation, along with the distinctive qualities they bring to a role. Studies of studio-era stars will undoubtedly continue to profit from examination of the extra-cinematic materials (e.g., press books, scrapbooks, newspaper reviews and fanzines, etc.) housed in the world's leading film archives in public or university libraries, particularly as these become increasingly accessible online as collections are digitised.[1] Meanwhile, studies of contemporary stars are likely to benefit from the use of internet sites, official websites, blogs and social networking sites. Increasingly, star scholars are taking advantage of the internet to provide access to a star's fans, enabling them to monitor fan behaviour and interaction but also providing a means for contacting fans directly to solicit participation in a survey or to take part in interviews about their relation to, admiration for and uses of a particular star.

What is clear is that there is no one way to produce a star study, with a variety of alternative methodologies and conceptual frameworks being available to those in pursuit of answers to the questions posed by stars and stardom. Studies involving detailed textual analysis of star acting have as much to contribute to the expanding field of star studies as detailed analysis of a star's reception in fan magazines and newspaper reviews. Studies informed by interviews with stars, their acting coaches, managers, agents and PR staff, have as much to reveal as others that chart career trajectories through popularity polls, box-office receipts, star ratings, awards and accolades. Studies that involve interviews with focus groups and questionnaire surveys completed by representative groups of fans offer just as much as others that explore how stars are used as icons, figureheads for countries and organisations, commercial companies and products. Any one of these approaches to exploring stars and stardom will elicit valuable material that enables

us to glimpse something of the multiple forms and uses of stars and stardom in operation throughout the world's film industries, cinema cultures and mass media, as well as in society more generally. In short, there is no recipe for the perfect star study. Moreover, star studies as a discrete branch of film studies has more to gain from plurality than from a single orthodox approach.

The limitations of time, space and financial resources mean that most star scholars are selective, concentrating on those elements that best reward their efforts. Ultimately, this requires students, researchers and academic writers to isolate the most pertinent and meaningful characteristics of a star's work and image, and to investigate these by the most productive and viable means, leaving other issues and methods to someone else. Given the ineffable and polysemic nature of stardom, the full extent of any star's significance can never be authoritatively defined. Consequently, it seems inappropriate for anyone to set out with the intention of achieving a comprehensive or definitive assessment. This is also why any truly significant film star requires more than one study to be devoted to them, enabling their qualities, personae and work to be mapped and remapped, and then remapped again. This process of sustained remapping is a fundamental part of star studies. Having characterised this sub-disciplinary field for many decades, remapping ensures that star studies is likely to remain a rich and vibrant academic area of film studies for many years to come. And so it goes on.

NOTES

1 Star Studies

1 For evidence of the rifts within film studies scholarship on stardom in the mid-1990s, see the Preface to Danae Clark's *Negotiating Hollywood* (1995: ix–xii).

2 See also Guy Austin's *Stars in Modern French Film* (2005), Alastair Phillips and Ginette Vincendeau's edited collection *Journeys of Desire* (2006) and John Gaffney and Diana Holmes's anthology *Stardom in Postwar France* (2007a).

3 Essays on non-western film stars are included in the following edited collections: Thomas Austin and Martin Barker's *Contemporary Hollywood Stardom* (2003), Lucy Fisher and Marcia Landy's *Stars: The Film Reader* (2004) and Andy Willis's *Film Stars: Hollywood and Beyond* (2004).

4 The *Star Decades* series includes the following: Jennifer M. Bean (ed.), *Flickers of Desire: Movie Stars of the 1910s* (2011a); Patrice Petro (ed.), *Idols of Modernity: Movie Stars of the 1920s* (2010); Adrienne L. McLean (ed.), *Glamour in a Golden Age: Movie Stars of the 1930s* (2011a); Sean Griffin (ed.), *What Dreams Were Made of: Movie Stars of the 1940s* (2010); R. Barton Palmer (ed.), *Larger Than Life: Movie Stars of the 1950s* (2010a); James Morrison (ed.), *Hollywood Reborn: Movie Stars of the 1970s* (2010); and Robert Eberwein (ed.), *Acting for America: Movie Stars of the 1980s* (2010a).

5 Downing and Harris note a number of examples of individual star studies, including Graham McCann's *Marilyn Monroe* (1998), Rachel

Moseley's *Growing Up with Audrey Hepburn: Text, Audience, Resonance* (2003) and Susan Hayward's *Simone Signoret: The Star as Cultural Sign* (2004).

6 Dyer drew heavily upon star studies, such as Francesco Alberoni's article 'L'Elite irresponsible' (1962), Richard Griffith's *The Movie Stars* (1970), Marsha McCreadie's *The American Movie Goddess* (1973), Richard Schickel's *His Picture in the Papers* (1974), David Shipman's *The Great Stars – the Golden Years* (1970) and Charles Affron's *Star Acting* (1977). He was also heavily influenced by a number of studies of gender and sexual difference in cinema, such as Marjorie Rosen's *Popcorn Venus* (1973), Molly Haskell's *From Reverence to Rape* (1973), Joan Mellen's *Big Bad Wolves* (1978) and Laura Mulvey's article 'Visual Pleasure and Narrative Cinema' (1975).

7 Alberoni's essay was originally published in French the journal *Ikon* in 1962. An English translation was included in Denis McQuail's book *Sociology of Mass Communications* in 1972 and this version was subsequently reprinted in P. David Marshall's *The Celebrity Culture Reader* in 2006.

8 See Annette Kuhn, *An Everyday Magic: Cinema and Cultural Memory* (2002).

2 Methods

1 Most notably, James Naremore's *Acting in the Cinema* (1988), Andrew Klevan's *Film Performance* (2005), Karen Hollinger's *The Actress* (2006) and Cynthia Baron and Sharon Marie Carnicke's *Reframing Screen Performance* (2008), as well as the edited collections by Lesley Stern and George Kouvaros (*Falling for You*, 2000) and Pamela Robertson Wojcik (*Movie Acting*, 2004a), all of which offer instructive and alternative approaches to analysing screen performance.

2 Philip Drake, in his essay 'Jim Carrey: The Cultural Politics of Dumbing Down' (2004), employs the term 'idiolect' (which he

borrows from James Naremore's *Acting in the Cinema*, where it is used sparingly) to designate the elements of an actor's performance that recur from one role to another, operating as 'ostensive inter-textual signifiers' that offer 'the return of familiar pleasures' (Drake 2004: 74). Drake further notes that these pleasures are bound up with 'the discourses of celebrity that circulate outside of the filmic text, and therefore are to a great extent resistant to formal analysis' (ibid.). In other words, one must seek confirmation of them through publicity and promotional materials or reviews as much as through close textual analysis of film sequences.

3 Starr A. Marcello also notes that most contemporary vocal performances on film are recorded in an ADR studio: for instance, 75 per cent of the dialogue in James Cameron's *Titanic* (1997) was recorded in post-production (Marcello 2006: 65). In her essay 'Performance Design: An Analysis of Film Acting and Sound Design', she analyses vocal aspects of film performances in terms of accent and intonation, etc., while also providing a detailed description of the 'uniquely filmic components of sound and performance' (ibid.: 59). Her section on ADR is particularly instructive, especially her description of the typical arrangement for an ADR session, involving 'the actor, in headphones, standing in front of a padded music stand on which the script is placed, speaking into a microphone while the scene he or she is recording is projected onto a video monitor in his or her line of sight' (ibid.).

4 It is also worth noting here that Starr A. Marcello, Pamela Robertson Wojcik and Gianluca Sergi are part of a growing number of film scholars who have become increasingly attuned to the voice and its place within the filmic system as a whole, supplementing earlier theoretical work on the cinematic voice carried out in the 1980s (e.g., Michel Chion 1983 and Kaja Silverman 1988). In more recent times, studies of the cinematic voice have proceeded along historical lines, as part of industry-based studies or in terms of close readings of film performance (see Susan Smith 2005 and 2007, and Victoria Lowe 2004).

5 P. David Marshall's principal interest lies in 'how power is articulated through celebrity' and how dominant and subordinate groups use and influence the 'celebrity apparatus' (Marshall 1997: ix). Theories of (charismatic) leadership, of affect and reception are key aspects of Marshall's methodology, providing valuable insights into the power, influence and operation of celebrity. Hence, Max Weber's work on charisma, Raymond Williams's work on 'structures of feeling' and Hans Robert Jauss's work on the reception of literary texts (e.g., his 'horizon of expectations') all play a seminal role in informing Marshall's understanding of this phenomenon (ibid.: 73–4).

6 While Geraghty suggests that Dyer's arguments may need reformulating for scholars of contemporary film culture, Su Holmes argues in her essay '"Starring … Dyer?": Re-Visiting Star Studies and Contemporary Celebrity Culture' that the concepts and approach to film stars set out in *Stars* (1979) is highly relevant for scholars of contemporary celebrity (Holmes 2005).

3 Star Quality

1 See Adrienne L. McLean's essay 'Betty Grable and Rita Hayworth: Pinned Up' (2011b) for an account of Betty Grable's success in 1940s Hollywood musicals despite her much publicised lack of acting, singing and dancing talent.

2 See David M. Lugowski's essay 'Norma Shearer and Joan Crawford: Rivals at the Glamour Factory' (2011), in A. L. McLean (ed.), *Glamour in a Golden Age: Movie Stars of the 1930s*, New Brunswick, New Jersey and London: Rutgers University Press, pp. 129–52.

3 While glamour is particularly associated with studio-era Hollywood, it has long been a feature of stardom in many countries, including India. One of the most glamorous stars of early Indian cinema was Sulochana (originally Ruby Meyers), whose professional name means 'the beautiful-eyed one' (Majumdar 2009: 95). According to Neepa Majumdar, this Anglo-Indian

actress and one-time telephone operator was 'the embodiment of the idea of the star in the earliest years of Indian cinema' (ibid.: 94). Her success between 1925 and 1933 (during which time she made a successful transition from silent to sound cinema) rested largely on her beauty and attractive physique, as well as her fashionable, cosmopolitan and modern image (ibid.: 94–104).

4 One of the most beautiful women to fail in Hollywood in the 1930s was Russian actress Anna Sten, who producer Samuel Goldwyn hired in 1933 as a rival for Garbo. For more details, see Jeanine Basinger's *The Star Machine* (2007: 103–4).

5 One of the most popular and successful female stars of Franco's Spain was Ana Mariscal, who was noted for her androgynous voice. For more details, see Núria Triana-Toribio's essay 'Ana Mariscal: Franco's Disavowed Star' (2000).

6 One of the British stars of the studio era who did not make the transition to Hollywood was Anna Neagle, even though she was one of country's most popular film performers of the mid-twentieth century. Josephine Dolan and Sarah Street, although noting some problematic features of her voice and use of accents, argue that while 'her accent is undoubtedly middle class, its particular inflections are far more inclusive than many others in that it avoids the clipped, strangulated extremes of those voices that dominated British screens (and radio) of the time' (Dolan and Street 2009: 40). Nevertheless, Neagle's clearly defined middle-class English tones obviously played their part in restricting her success to Britain.

7 Alastair Phillips and Ginette Vincendeau do note that Audrey Hepburn was a major exception in that, despite her Belgian nationality and Dutch-English parentage she 'spoke [English] with almost no accent and this helped her blend of sophisticated European femininity to cross over to a wholly American image' (Phillips and Vincendeau 2006: 12).

8 See Roland Barthes's essay 'The Face of Garbo', in *Barthes: Selected Writings* (Sontag 1982: 82–4).

4 Star Systems

1 One of the major omissions of this book (and many film studies texts on stars and stardom prior to 2010) is the child star. For research on this topic, see Karen Lury's *The Child in Film* (2010), as well as Paul McDonald's case study of Shirley Temple in *The Star System* (2000: 57–62). Studies of child stars do feature in many of the *Star Decades* books: most notably, Kathryn Fuller-Seeley's 'Shirley Temple: Making Dreams Come True' (2011). Others include, Sean Griffin's 'Judy Garland and Mickey Rooney: Babes and Beyond' (2010b), Cynthia Erb's 'Jodie Foster and Brooke Shields: "New Ways to Look at the Young"' (2010) and Robert Eberwein's 'Michael J. Fox and the Brat Pack: Contrasting Identities' (2010b).

2 Neepa Majumdar, in *Wanted Cultured Ladies Only!*, notes that a star system did not develop in Indian cinema until the mid-1920s, a decade later than in the USA (Majumdar 2009: 24).

3 For research on female stars turned producers since the 1970s, see William Brown's essay 'Jessica Lange and Sissey Spacek: Country Girls' and Christina Lane's 'Sally Field and Goldie Hawn: Feminism, Post-Feminism, and Cactus Flower Politics', both published in Robert Eberwien (ed.), *Acting for America: Movie Stars of the 1980s* (2010a).

4 Since the 1930s, pay differentials between male and female stars have persisted throughout the world. While many of the highest paid stars of the silent era were female (e.g., Mary Pickford), during the sound era male stars have regularly earned considerably more than their female counterparts of equal stature. This situation endured not only through the studio and post-studio era but right up until present times. Many prominent and powerful female stars have fought against this injustice and made frequent demands for equal pay: most notably, Bette Davis in the 1940s (see Sikov 2007: 82 and 207) and Meryl Streep in the 1980s (see Mizejewski 2010: 221). In terms of Bollywood, Gandhy and Thomas write in their essay 'Three Indian Stars', that 'male stars have by far the highest "value", commanding at least double what comparable female

stars earn, and a female star's value is determined largely by which male stars are prepared to work with her' (Gandhy and Thomas 1991: 109).

5 An American actress who achieved a similar degree of control in the early to mid-1930s was Barbara Stanwyck, signing a series of non-exclusive one- and multi-picture deals with Warner Bros. and Columbia that enabled her to operate as a freelance star during this period. For further details, see Linda Berkvens's essay, 'From Below to Above the Title: The Construction of the Star Image of Barbara Stanwyck, 1930–1935' (2009).

6 Most of these studio drama schools were headed by women, such as Phyllis Loughton (Paramount and, later, MGM), Lillian Albertson (Paramount and, later, RKO), Florence Enright (Universal and, later, 20th Century-Fox), Lillian Burns (Republic and then MGM), Lela Rogers (RKO), Sophie Rosenstein (Warner Bros. and Universal) and Josephine Hutchinson (Columbia), many of whom published influential film acting manuals during the 1930s and 40s. For more details, see Baron and Carnicke's *Reframing Screen Performance* (2008: 18–19).

7 Jeanine Basinger describes how Rita Hayworth (originally Margarita Carmen Cansino) underwent electrolysis to change her hairline and had her hair dyed in order to reduce the ethnicity of her appearance during the 1930s (Basinger 2007: 41–3). Adrienne L. McLean observes that Hayworth's physical transformation remained a key feature of her publicity, being part of an ongoing discourse about the star's struggle to find an identity, so that the Cansino persona was retained alongside the Hayworth persona (McLean 2005: 33).

8 For more details about these stars' types during the silent era, see the following essays: Christine Gledhill, 'Mary Pickford: Icon of Stardom' (2011), Scott Curtis 'Douglas Fairbanks: Icon of Americanism' (2011), Scott Curtis, 'Douglas Fairbanks: Hollywood Royalty' (2010), Kristen Hatch, 'Lillian Gish: Clean, and White, and Pure as the Lily' (2011), Jennifer M. Bean, 'Charles Chaplin: The Object of Mass Culture' (2011b) and Mary Desjardins, 'An Appetite for Living: Gloria Swanson, Colleen Moore and Clara Bow' (2010).

9 See Amy Lawrence's essay 'Rudolph Valentino: Italian American' (2010b).

10 See Chris Cagle's essay 'Robert Redford and Warren Beatty: Consensus Stars for a Post-Consensus Age' (2010).

11 See Thomas Schur's essay 'Faye Dunaway: Stardom and Ambivalence' (2010).

12 British actor Eric Portman turned his back on Hollywood due in large part to its attempts to typecast him. For more details, see Andrew Spicer's essay, 'The Mark of Cain: Eric Portman and British Stardom' (2009).

13 Typecasting was also a feature of Indian cinema, where it reached extreme levels in the 1950s. See Majumdar for more details (Majumdar 2009: 133–4).

14 Andrew Britton has explored the relationship between star vehicles and genre in his essay 'Stars and Genre', in which he notes that star vehicles are often preceded by genres (i.e., growing out of established genres) and also tend to be hybrids of different genres. For more details, see Britton (1991: 202–3).

15 One of the most famous associations between a French actress and director was that of Brigitte Bardot and Roger Vadim. Diana Holmes has discussed this relationship at length, noting that Vadim stage-managed her career from 1951 to 1956 (Holmes 2007: 47). As a reporter on *Paris-Match*, Vadim orchestrated 'her introduction to a wider public' by featuring their romance in the pages of his magazine, including their marriage in December 1952 (ibid.: 48). However, Holmes notes that Vadim's 'moment of triumph' came with Bardot's breakthrough vehicle *Et Dieu … créa la femme* (1956), which he co-wrote and directed (ibid.: 50). However, by the end of 1956 Bardot had slipped out of Vadim's control, embarking upon an affair with her *Et Dieu* co-star Jean-Louis Trintignant, divorcing Vadim, personally and professionally.

16 Michael Lawrence notes the tradition of art-cinema stars who are associated with a particular director, such as Liv Ullman with Ingmar Bergman, Anna Karina with Jean-Luc Godard, Monica Vitti with Michelangelo Antonioni and Hanna Schygulla with Rainer Werner Fassbinder (Lawrence 2010: 152).

17 For further information on female stars who became producers during and after the 1970s, see Maria Pramaggiore's essay 'Jane Fonda: From Graylist to A-List' and Cynthia Erb's 'Jodie Foster and Brooke Shields: "New Ways to Look at the Young"' (both 2010).

5 Star Identities

1 Danae Clark, in *Negotiating Hollywood* (1995), contests many of the claims made about the relationship between star images and real persons, especially the use of the term 'persona' to designate something between the real historical person of the actor and the parts that actor has played on screen. She claims that 'this triple articulation (person, persona, parts) remains inadequate', proposing the notion of the 'actor as worker' as a means of formulating the actor's subject identity (Clark 1995: 11). She regards such things as persona, image and person as 'aris[ing] out of the discursive struggle between labor and management', noting that the Hollywood studios separated notions of image and person in order to construct and retain control over a coherent persona that could be sold, which was achieved 'by detaching the image from the person', enabling the studio to 'reconstruct the relation between the two into a unified subject position called the "persona"' (ibid.: 22). For instance, by changing an actor's name (and biography), they frequently created new images and identities. Clark notes that in such circumstances, an 'agreement of sorts was made: in return for the actor's physical body (as bearer of an image), the studio would attempt to generate for her or him the wealth and social prestige of star ranking' (ibid.: 23). Further discussion of the star as worker/image can also be found in Jane Gaines's *Contested Culture* (1992: 146) and Paul McDonald's *The Star System* (2000: 13).

2 That is, what Barry King refers to as 'image', Gledhill describes as 'character/role'. Gledhill reserves the term 'image' to mean something different from King, using it to describe the ways in which a star's identity

is used and understood socially or culturally: for instance, when s/he is used as a representative of a specific social group or type, either by fans or by critics and commentators. This use of stars is explored in more detail in Chapter 6.

3 This is an aspect of stardom that Richard Dyer had previously sought to explain and understand by using the concept of 'charisma', which he perceives as residing in the ideological contradictions that stars embody and which he argues is one of the main sources of audience fascination with stars (Dyer 1979: 31).

4 Alan Lovell indicates a wariness of using the term 'persona', having noted how a range of authors use this term to mean different things (Lovell 2003: 265). Similarly, Jeanine Basinger notes that what is regularly referred to nowadays as 'persona' was once simply called 'type' within the Hollywood studio system (Basinger 2007: 74).

5 Sabrina Qiong Yu, in 'Jet Li: Star Construction and Fan Discourse on the Internet' (2010), has discussed the way in which the official website of Chinese martial arts star Jet Li (www.jetli.com) is used as a means through which he and his fans communicate with each other, enabling the star to construct his star image, bypassing or, at least, limiting industry intervention (Qiong Yu 2010: 234). After examining the website in detail, she concludes that, while 'film stars were mainly produced by the industry and media texts in the past, nowadays stars themselves and fans are playing increasingly significant roles in star-making', arguing that 'the internet empowers stars by giving them the opportunity to take more control over their own image' (ibid.). She also argues that fans are empowered and granted greater visibility by being able to publish postings on the forum and send emails to the star (ibid.).

6 Official star websites provide valuable sources of information for star scholars and offer the potential to engage directly with fans about their attachment to stars and their films, in order to better understand the appeal of a film star. Nevertheless, much more research is required to understand how these sites are generated, designed and managed and what specific purposes they serve: most notably, how much of the

information that purports to be by the star really is generated by them and how much information from fans is authentic or unedited.

7 During the 1920s there was also a dramatic growth in the publication of film magazines in China. Mary Farquhar and Yingjin Zhang observe that by the mid-1920s, the popular Chinese press fed 'a growing consumer fascination with film celebrities, publishing magazines such as *Star Focus* (Mingxing tekan, 1925–28), *Star Monthly* (Mingxing yuebao, 1933–35), *Star Families* (Mingxing jiating, 1933) and *Stars* (Mingxing, 1935–37, 1938)' (Farquhar and Zhang 2010: 5). They also note that both western and Chinese 'female stars were prominently featured in glossy pictorials like *The Young Companion* (*Liangyou*) from 1927 to 1937 to market the latest fashions, hairdos, lifestyles, domestic products and interior designs' (ibid.).

8 Behroze Gandhy and Rosie Thomas note that there was no developed marketing of Indian stars until the 1940s and 50s (Gandhy and Thomas 1991: 114). Similarly, Neepa Majumdar notes that discourses of Indian stardom until the early 1940s were split between 'official' and 'unofficial' sources: the former comprised of mainstream journalism that confined itself to a star's professional and career details, while the latter was comprised mainly of oral gossip and only ever obliquely hinted at in mainstream publications (Majumdar 2009: 30).

9 See Christine Becker's essay 'Clark Gable: The King of Hollywood' (2011) for details of how Howard Strickling and his publicity team at MGM crafted Gable's image during the 1930s.

10 In Hollywood in the 1930s and 40s, fan clubs and societies were usually set up by a film studio's publicity department, enabling it to disseminate information to a star's fans without the intervention of the press and gossip columnists, thus providing publicists with greater levels of control over a star's image. Many of these clubs produced their own newsletters or 'fanzines', which were mailed exclusively to club members. During the 1930s, such clubs had large memberships. Sennett notes, for instance, that at one time the teenage singing star Deanna Durbin had a fan club made up of fifty separate branches across the USA (Sennett 1998: 41). He

notes, further, that the monthly fan magazines were not only extremely popular but also 'resolutely lowbrow', making them widely despised among Hollywood's star fraternity (ibid.: 50). Danae Clark has observed that by the 1930s many movie actors 'maintained an uneasy relationship' with the star journals, film magazines and fanzines circulating in the USA (Clark 1995: 77). 'Though essential to an actor's rise to stardom,' she writes, 'they often printed erroneous or unauthorized information', which could occasionally prove 'potentially damaging to the actor' (ibid.). Clark notes that the Screen Actors Guild became concerned about the fanzines' policy of fabrication and urged a clean-up campaign in 1934, by which time, as Sennett has noted, 'fans could purchase nearly two dozen monthly fan magazines, most of them poorly edited and wholly unreliable' (Sennett 1998: 51).

11 The work produced by the publicity offices of the various Hollywood studios provides a rich source of information for scholarship on stars and stardom. While the vast majority of this output was ephemeral and has subsequently been lost, much has been preserved and made accessible via major collections, providing film historians with valuable research material. Archives where considerable quantities of such material can be examined include the Margaret Herrick Library (housing the archive of the Academy of Motion Picture Arts and Sciences) in Los Angeles in the USA, the Constance McCormick Collection at the Cinema-Television Library at the University of Southern California, LA, and the Bill Douglas Centre for the History of Cinema and Popular Culture in Exeter, UK.

12 In addition to the Margaret Herrick Library, Hollywood press books can also be obtained from the New York Public Library for Performing Arts (in Manhattan) and the British Film Institute Library (in London).

13 Paul McDonald has observed that since Henry Rogers set up the public relations company, Rogers & Cowan, in 1950, Hollywood PR has grown into a highly lucrative and important business within the film industry (McDonald 2008: 175). In the early years of the twenty-first century, this sector of the film business was dominated by PMK/HBH (Pickwick,

Maslansky-Koenigsberg/Huvane Baum Halls) and by Pat Kingsley. Kingsley, who was originally an agent at Rowan & Cowan, became the co-founder of Pickwick Public Relations in 1971 and went on to become one of the most important agents in Hollywood during the 1980s. Further information about the work of PR companies in post-studio era Hollywood can be found in Joshua Gamson's *Claims to Fame* (1994: 42, 62–3, 66–78, 113–15 and 163–5).

14 Another important force in the Hollywood studio system were the New York film critics that produced newspaper reviews of the latest releases, since these tended to be released in Manhattan, NYC. Frank Nugent and Bosley Crowther of the *New York Times* were among the most popular and influential from the 1930s to 50s. Others included, Kate Cameron (*Daily News*), Archer Winsten (*Post*), Eileen Creelman (*Sun*), Howard Barnes (*Herald Tribune*) and Leo Mishkin (*Morning Telegraph*). Their reviews offer film historians fascinating insights into the critical reception of movies at the time of their release in America and can be found in many archives, such as the New York Library of Performing Arts and the British Film Institute Library.

15 By the 1950s, the magazine *Confidential* had become hugely popular by going far beyond the previous limits of propriety of *Photoplay*, reporting real stories of 'adultery, destructive behaviour, and immoral activities both past and present' (Sennett 1998: 61). Robert Sennett notes that, by 1957, *Confidential*'s circulation had risen to over 5 million, making it one of the most popular magazines in the USA (ibid.).

16 The Hedda Hopper Collection is now housed at the Margaret Herrick Library in Los Angeles, while the Louella Parsons Collection is at the Cinema-Television Library at the University of Southern California in Los Angeles. Sean Griffin is one of several film scholars that have recently made use of papers from the Hedda Hopper Collection for his work on Hollywood stars (see Griffin 2010b).

17 Neepa Majumdar, in *Wanted Cultured Ladies Only!*, offers an insightful account of the unique operation of gossip, rumour and scandal in Indian cinema of the 1930s and 40s (Majumdar 2009: 38–44).

18 For Hollywood studio attempts to scotch rumours of male homosexuality and create a veneer of heterosexual romance, see Tison Pugh and Barry Sandler's essay 'Montgomery Clift: Hollywood Pseudohomosexual' (2010) and Foster Hirsch's 'Doris Day and Rock Hudson: The Girl Next Door and the Brawny He-Man' (2010).

19 See Gaylyn Studlar's essay 'Theda Bara: Orientalism, Sexual Anarchy, and the Jewish Star' (2011) for an account of how, during the earliest years of the star system in the USA, audiences were not deceived by the fictional personae created by studio publicity departments. Here she observes that 'readers' letters to movie magazines 'reveal[ed] the public's awareness of studio publicity departments and press agents in creating outright fictions regarding actors' background, suppressing facts that might conflict with their players' screen image' (Studlar 2011: 125).

6 Unstable Symbols

1 The *Star Decades* series of books, edited by Adrienne L. McLean and Murray Pomerance for Rutgers University Press, sets out to analyse Hollywood movie stars against the background of American cultural history, frequently presenting stars as social icons: most notably, Christine Gledhill's 'Mary Pickford: Icon of Stardom' (2011), Scott Curtis's 'Douglas Fairbanks: Icon of Americanism' (2011), Amy Lawrence's 'Rudulph Valentino: Italian American' (2010), David M. Lugowski's 'Claudette Colbert, Ginger Rogers and Barbara Stanwyck: American Homefront Women' (2010), Sean Griffin's 'Judy Garland and Mickey Rooney: Babes and Beyond' (2010b), Maria Pramaggiore's 'Jane Fonda: From Graylist to A-List' (2010) and Chris Cagle's 'Robert Redford and Warren Beatty: Consensus Stars for a Post-Consensus Age' (2010).

2 See Matthew Solomon's essay ' Reflexivity and Metaperformance: Marilyn Monroe, Jayne Mansfield, and Kim Novak' (2010) for more on the links between the Hollywood blonde bombshells of the 1950s.

3 Diana Dors' three-picture contract with the Hollywood studio RKO resulted in her supporting role in Victor Mature's *The Long Haul* (Ken Hughes, 1957), a starring role opposite Rod Steiger in *The Unholy Wife* (John Farrow, 1957) and the leading female role in the independently produced comedy *I Married a Woman* (Hal Kanter, 1958), with George Gobel and Adolphe Menjou. None of these were particularly successful in either commercial or critical terms, although the second film is now generally regarded as the best of the three, despite its rather hackneyed noir plot.

4 For her role in Fracassi's *Aida*, Sophia Loren's skin was darkened and her singing voice was supplied by the soprano Renata Tebaldi (Gundle 2004: 81).

5 See Rebecca Bell-Metereau's essay 'Sylvester Stallone and Arnold Schwarzenegger: Androgynous Macho Men' (2010).

6 During the 1980s, Hong Kong cinema became the third largest film industry in the world, after the USA and India.

7 In later life, Bogarde also became famous as a writer of novels and memoirs, living in Provence in the south of France. This lent him a more sedate and literary persona (i.e., as a 'man of letters'), as well as confirming his European identity. After his death in 1999, the details of his personal life (especially his homosexuality) became more widely reported.

8 For instance, Sunny Singh has written a fascinating account of Shah Rukh Khan as an 'embodiment of 21st century India, and a one-man industry capable of articulating and representing the *zeitgeist* of the billion people who constitute the nation' (Singh 2008:1). In her essay 'The Road to *Rāmarājya*: Analysing Shah Rukh Khan's Parallel Text in Commercial Hindi Cinema' (2008), Singh argues that 'only SRK has grown into a national icon as well as a formidable international brand' (Singh 2008: 4). Charting the development of his star image from 1995 to 2007, Singh explores the ways in which SRK simultaneously personifies the Indian middle-class aspirant and staunch patriot, who's star text runs parallel to the traditional Hindu myths of Rāma despite his strongly defined and highly publicised Muslim background. The ambivalences and

contradictions of his star persona are foregrounded here and form part of understanding the ways in which his image (in terms of film roles and publicity) corresponds to tensions and negotiations within the emerging national identity of post-nationalist and twenty-first-century India.

9 It is worth noting here, however, that the sex symbol has retained higher value in the West for gay audiences, particularly since the gay liberation movement of the 1960s. The sex symbol has also found greater favour among women since the rise of post-feminism in the 1990s.

Conclusion

1 For instance, see the Media History Digital Library (at http://mediahistoryproject.org/). Dedicated online resources for film stars include the Judy Holliday Resource Center (www.judyhollidayrc.com), which Pamela Robertson Wojcik uses in her essay 'Judy Holliday: The Hungry Star' (2010).

REFERENCES

Aaron, M. (2006), 'Barbra Streisand', in L. R. Williams and M. Hammond (eds), *Conteporary American Cinema*, London and New York: Open University Press and McGraw-Hill, pp. 301–2.

Affron, C. (1977), *Star Acting: Gish, Garbo, Davis*, New York: E. P. Dutton.

Alberoni, F. (1962/1972), 'The Powerless Elite: Theory and Sociological Research on the Phenomenon of Stars', reprinted in D. McQuail (ed.), *Sociology of Mass Communications*, London: Penguin, pp. 75–98.

Alexander, K. (1991) 'Fatal Beauties: Black Women in Hollywood', in C. Gledhill (ed.), *Stardom: Industry of Desire*, London and New York: Routledge, pp. 45–54.

Austin, G. (2005), *Stars in Modern French Film*, London: Arnold.

Austin, T. and Barker, M. (eds) (2003), *Contemporary Hollywood Stardom*, London: Arnold.

Babington, B. (ed.) (2001), *British Stars and Stardom*, Manchester: Manchester University Press.

Bakker, G. (2001), 'Stars and Stories: How Films Became Branded Products', *Enterprise and Society* vol. 2, pp. 461–502.

Baron, C. and Carnicke, S. M. (2008), *Reframing Screen Performance*, Michigan: University of Michigan Press.

Baron, C., Carson, D. and Tomasulo, F. P. (eds) (2004), *More Than a Method: Trends and Traditions in Contemporary Film Performance*, Detriot: Wayne State University Press.

Barr, C. (ed.) (1986), *All Our Yesterdays*, London and New York: BFI.

Barthes, R. (1955/1982), 'The Face of Garbo', reprinted in S. Sontag (ed.), *Barthes: Selected Writings*, Oxford: Fontana/Collins, pp. 82–4.

Barthes, R. (1957/1972), *Mythologies*, trans. A. Lavers and C. Smith, New York: Hill and Wang.

Barton Palmer, R. (ed.) (2010a), *Larger Than Life: Movie Stars of the 1950s*, New Brunswick, New Jersey and London: Rutgers University Press.

Barton Palmer, R. (2010b), 'Charlton Heston and Gregory Peck: Organization Men', in R. Barton Palmer (ed.), *Larger Than Life: Movie Stars of the 1950s*, New Brunswick, New Jersey and London: Rutgers University Press, pp. 37–60.

Basinger, J. (2007), *The Star Machine*, New York: Alfred A. Knopf.

Bean, J. M. (ed.) (2011a), *Flickers of Desire: Movie Stars of the 1910s*, New Brunswick, New Jersey and London: Rutgers University Press.

Bean, J. M. (ed.) (2011b), 'Charles Chaplin: The Object of Mass Culture', in J. M. Bean (ed.), *Flickers of Desire: Movie Stars of the 1910s*, New Brunswick, New Jersey and London: Rutgers University Press, pp. 242–63.

Becker, C. (2011), 'Clark Gable: The King of Hollywood', in A. L. McLean (ed.), *Glamour in a Golden Age: Movie Stars of the 1930s*, New Brunswick, New Jersey and London: Rutgers University Press, pp. 245–66.

Bell, M. (2010), *Femininity in the Frame: Women and 1950s British Popular Cinema*, London and New York: I.B.Tauris.

Bell, M. and Williams, M. (eds) (2009), *British Women's Cinema*, London and New York: Routledge.

Bell-Metereau, R. (2010), 'Sylvester Stallone and Arnold Schwarzenegger: Androgynous Macho Men', in R. Eberwein (ed.), *Acting for America: Movie Stars of the 1980s*, New Brunswick, New Jersey and London: Rutgers University Press, pp. 36–56.

Bergfelder, T., Carter, E. and Göktürk, D. (eds) (2002), *The German Cinema Book*, London: BFI.

Berkvens, L. (2009), 'From Below to Above the Title: The Construction of the Star Image of Barbara Stanwyck, 1930–1935', *Networking Knowledge: Journal of the MeCCSA Postgraduate Network* vol. 2 no. 1, pp. 1–14.

Bessière, I. (2006), 'In Search of Global Stardom: French Actors in 1990s Hollywood', in A. Phillips and G. Vincendeau (eds), *Journeys of Desire: European Actors in Hollywood*, London: BFI, pp. 70–4.

Bingham, D. (2004), 'Kidman, Cruise, and Kubrick: A Brectian Pastiche', in C. Baron, D. Carson and F.P. Tomasulo (eds), *More Than a Method: Trends and Traditions in Contemporary Film Performance*, Detriot: Wayne State University Press, pp. 247–74.

Bode, L. (2010), 'No Longer Themselves? Framing Digitally Enabled Posthumous "Performance"', *Cinema Journal* vol. 49 no. 4, pp. 46–70.

Bogle, D. (2001/2004), 'The 1950s: Black Stars', reprinted in P. R. Wojcik (ed.), *Movie Acting: The Film Reader*, New York and London: Routledge, pp. 191–204.

Bose, D. (2006), *Brand Bollywood: A New Global Entertainment Order*, New Delhi, Thousand Oaks and London: Sage.

Bose, M. (2007), *Bollywood: A History*, Stroud: Tempus.

Britton, A. (1991), 'Stars and Genre', in C. Gledhill (ed.), *Stardom: Industry of Desire*, London and New York: Routledge, pp. 198–206.

Britton, A. (1984/1995), *Katharine Hepburn: Star as Feminist*, London: Studio Vista.

Brown, T. and Walters, J. (eds) (2010), *Film Moments: Criticism, History, Theory*, London: BFI.

Brown, W. (2010) 'Jessica Lange and Sissey Spacek: Country Girls', in R. Eberwien (ed.), *Acting for America: Movie Stars of the 1980s*, New Brunswick, New Jersey and London: Rutgers University Press, pp. 57–76.

Butler, J. (ed.) (1991), *Star Texts: Image and Performance in Film and Television*, Detroit: Wayne State University Press.

Butler, J. (1998), 'The Star System and Hollywood', in J. Hill and P. Church Gibson (eds), *The Oxford Guide to Film Studies*, New York and Oxford: Oxford University Press.

Cagle, C. (2010), 'Robert Redford and Warren Beatty: Consensus Stars for a Post-Consensus Age', in J. Morrison (ed.), *Hollywood Reborn: Movie Stars of the 1970s*, New Brunswick, New Jersey and London: Rutgers University Press, pp. 39–60.

Carnicke, S. M. (2004), 'Screen Performance and Directors' Visions', in
C. Baron, D. Carson and F. P. Tomasulo (eds), *More Than a Method:
Trends and Traditions in Contemporary Film Performance*, Detriot:
Wayne State University Press, pp. 42–67.

Carter, E. (2004), *Dietrich's Ghosts: The Sublime and the Beautiful in Third
Reich Film*, London: BFI.

Chapman, J., Glancy, M. and Harper, S. (eds) (2007), *The New Film History:
Sources, Methods, Approaches*, London: Palgrave.

Chion, M. (1983/1999), *The Voice in the Cinema*, trans. Claudia Gorbman,
New York: Columbia University Press.

Chopra, A. (2007), *King of Bollywood: Shah Rukh Khan and the Seductive World
of Indian Cinema*, New York and Boston: Warner.

Clark, D. (1995), *Negotiating Hollywood: The Cultural Politics of Actors' Labor*,
Minneapolis and London: University of Minnesota Press.

Cook, D. A. (1990), *A History of Narrative Film*, 2nd edn, New York and
London: W. W. Norton & Company.

Cook, P. (2001), 'The Trouble with Sex: Diana Dors and the Blonde
Bombshell Phenomenon', in B. Babington (ed.), *British Stars and Stardom*,
Manchester: Manchester University Press, pp. 167–78.

Cornea, C. (ed.) (2010), *Genre and Performance: Film and Television*,
Manchester: University of Manchester Press.

Countryman, E. (2010), 'John Wayne: Hero, Leading Man, Innocent, and
Troubled Figure', in S. Griffin (ed.), *What Dreams Were Made of: Movie
Stars of the 1940s*, New Brunswick, New Jersey and London: Rutgers
University Press, pp. 217–34.

Curtis, S. (2010), 'Douglas Fairbanks: Hollywood Royalty', in P. Petro (ed.),
Idols of Modernity: Movie Stars of the 1920s, New Brunswick, New Jersey
and London: Rutgers University Press, pp. 21–40.

Curtis, S. (2011), 'Douglas Fairbanks: Icon of Americanism', in J. M. Bean
(ed.), *Flickers of Desire: Movie Stars of the 1910s*, New Brunswick, New
Jersey and London: Rutgers University Press, pp. 281–341.

deCordova, R. (1990), *Picture Personalities: The Emergence of the Star System in
America*, Urbana and Chicago: University of Illinois Press.

deCordova, R. (1985/1991) 'The Emergence of the Star System in America', reprinted in C. Gledhill (ed.), *Stardom: Industry of Desire*, London and New York: Routledge, pp. 17–29.

Denison, R. (2010), 'Bollywood Blends: Genre and Performance in Shahrukh Khan's Post-millennial Films', in C. Cornea (ed.), *Genre and Performance: Film and Television*, Manchester: University of Manchester Press, pp. 184–204.

Desjardins, M. (2010) 'An Appetite for Living: Gloria Swanson, Colleen Moore and Clara Bow', in P. Petro (ed.), *Idols of Modernity: Movie Stars of the 1920s*, New Brunswick, New Jersey and London: Rutgers University Press, pp. 108–36.

De Vany, A. and Walls, W. D. (1996), 'Uncertainty and the Movie Industry: Does Star Power Reduce the Terror of the Box Office?', *Journal of Cultural Economics* vol. 23, pp. 285–318.

Dolan, J. and Street, S. (2009), '"Twenty Million People can't be Wrong": Anna Neagle and Popular British Stardom', in M. Bell and M. Williams (eds), *British Women's Cinema*, London and New York: Routledge, pp. 34–48.

Doty, A. (2011), 'Marlene Dietrich and Greta Garbo: The Sexy Hausfrau versus the Swedish Sphinx', in A. L. McLean (ed.), *Glamour in a Golden Age: Movie Stars of the 1930s*, New Brunswick, New Jersey and London: Rutgers University Press, pp. 108–28.

Downing, L. and Harris, S. (eds) (2007), *From Perversion to Purity: The Stardom of Catherine Deneuve*, Manchester and New York: Manchester University Press.

Drake, P. (2004), 'Jim Carrey: The Cultural Politics of Dumbing Down', in A. Willis (ed.), *Film Stars: Hollywood and Beyond*, Manchester: Manchester University Press, pp. 71–88.

Drake, P. (2006), 'Reconceptualizing Screen Performance', *Journal of Film and Video* vol. 58 no. 1–2, pp. 84–94.

Dyer, R. (1979), *Stars*, London: BFI.

Dyer, R. (1987), *Heavenly Bodies: Film Stars and Society*, London: Macmillan.

Dyer, R. (2002), 'Rock: The Last Guy You'd have Figured', in R. Dyer, *The Culture of Queers*, London and New York: Routledge, pp. 159–74.

Dyer, R. (2003), *The Matter of Images: Essays on Representation*, 2nd edn, London: Routledge.

Eberwein, R. (ed.) (2010a), *Acting for America: Movie Stars of the 1980s*, New Brunswick, New Jersey and London: Rutgers University Press.

Eberwein, R. (2010b) 'Michael J. Fox and the Brat Pack: Contrasting Identities', in R. Eberwein (ed.), *Acting for America: Movie Stars of the 1980s*, New Brunswick, New Jersey and London: Rutgers University Press, pp. 99–119.

Eckert, C. (1978/1991), 'The Carole Lombard in Macy's Window', reprinted in C. Gledhill (ed.), *Stardom: Industry of Desire*, London and New York: Routledge, pp. 30–9.

Elsaesser, T. (2000), *Weimar Cinema and After: Germany's Historical Imaginary*, London and New York: Routledge.

Erb, C. (2010), 'Jodie Foster and Brooke Shields: "New Ways to Look at the Young"', in J. Morrison (ed.), *Hollywood Reborn: Movie Stars of the 1970s*, New Brunswick, New Jersey and London: Rutgers University Press, pp. 82–100.

Farquhar, M. (2010), 'Jackie Chan: Star Work as Pain and Triumph', in M. Farquhar and Y. Zhang (eds), *Chinese Film Stars*, London and New York: Routledge, pp. 180–95.

Farquhar, M. and Zhang, Y. (eds) (2010), *Chinese Film Stars*, London and New York: Routledge.

Fisher, L. and Landy, M. (eds) (2004), *Stars: The Film Reader*, New York: Routledge.

Fuller-Seeley, K. (2011), 'Shirley Temple: Making Dreams Come True', in A. L. McLean (ed.), *Glamour in a Golden Age: Movie Stars of the 1930s*, New Brunswick, New Jersey and London: Rutgers University Press, pp. 44–65.

Gaffney, J. and Holmes, D. (eds) (2007a), *Stardom in Postwar France*, New York and London: Berghahn.

Gaffney, J. and Holmes, D. (2007b), 'Stardom in Theory and Context', in J. Gaffney and D. Holmes (eds), *Stardom in Postwar France*, New York and London: Berghahn, pp. 7–25.

Gaines, J. M. (1986), 'War, Women, and Lipstick: Fan Mags in the Forties', *Heresies* vol. 18, pp. 42–7.

Gaines, J. M. (1992), *Contested Culture: The Image, the Voice and the Law*, London: BFI.

Gallagher, M. (2004), 'Rumble in the USA: Jackie Chan in Translation', in A. Willis (ed.), *Film Stars: Hollywood and Beyond*, Manchester: Manchester University Press, pp. 113–39.

Gamson, J. (1994), *Claims to Fame: Celebrity in Contemporary America*, Berkeley, Los Angeles and London: University of California Press.

Gandhy, B. and Thomas, R. (1985/1991), 'Three Indian Film Stars', reprinted in C. Gledhill (ed.), *Stardom: Industry of Desire*, London and New York: Routledge, pp. 107–31.

Geraghty, C. (1986), 'Diana Dors', in C. Barr (ed.) *All Our Yesterdays*, London and New York: BFI, pp. 341–5.

Geraghty, C. (2000), 'Re-examining Stardom: Questions of Texts, Bodies and Performance', in C. Gledhill and L. Williams (eds), *Reinventing Film Studies*, London: Arnold, pp. 183–201.

Geraghty, C. (2002/2003), 'Performing as a Lady and a Dame: Reflections on Acting and Genre', reprinted in T. Austin and M. Barker (eds), *Contemporary Hollywood Stardom*, London: Arnold, pp. 105–17.

Gibbs, J. and Pye, D. (2005), *Style and Meaning: Studies in the Detailed Analysis of Film*, Manchester: Manchester University Press.

Gibbs, J. and Pye, D. (eds) (2006), *Close-Up 01: Filmmakers' Choices/The Pop Song in Film/Reading Buffy*, London: Wallflower Press.

Gledhill, C. (ed.) (1991a), *Stardom: Industry of Desire*, London and New York: Routledge.

Gledhill, C. (1991b), 'Signs of Melodrama', in C. Gledhill (ed.), *Stardom: Industry of Desire*, London and New York: Routledge, pp. 207–29.

Gledhill, C. (2011), 'Mary Pickford: Icon of Stardom', in J. M. Bean (ed.), *Flickers of Desire: Movie Stars of the 1910s*, New Brunswick, New Jersey and London: Rutgers University Press, pp. 43–68.

Gledhill, C. and Williams, L. (eds) (2000), *Reinventing Film Studies*, London: Arnold.

Goffman, E. (1959/1990), *The Presentation of Self in Everyday Life*, London: Penguin.

Griffin, S. (ed.) (2010a), *What Dreams Were Made of: Movie Stars of the 1940s*, New Brunswick, New Jersey and London: Rutgers University Press.

Griffin, S. (2010b), 'Judy Garland and Mickey Rooney: Babes and Beyond', in S. Griffin (ed.), *What Dreams Were Made of: Movie Stars of the 1940s*, New Brunswick, New Jersey and London: Rutgers University Press, pp. 120–41.

Griffith, R. (1970), *The Movie Stars*, New York: Doubleday.

Gundle, S. (1995/2004), 'Sophia Loren, Italian Icon', reprinted in L. Fisher and M. Landy (eds), *Stars: The Film Reader*, New York: Routledge, pp. 77–96.

Gundle, S. (2008), *Glamour: A History*, Oxford and New York: Oxford University Press.

Hagener, M. (2002), 'German Stars of the 1990s', in T. Bergfelder, E. Carter and D. Göktürk (eds), *The German Cinema Book*, London: BFI, pp. 98–105.

Hansen, M. (1986/1991), 'Pleasure, Ambivalence, Identification: Valentino and Female Spectatorship', reprinted in C. Gledhill (ed.), *Stardom: Industry of Desire*, London and New York: Routledge, pp. 259–82.

Hanson, H. and O'Rawe, C. (eds) (2010), *The Femme Fatale: Images, Histories, Contexts*, London and New York: Palgrave.

Haskell, M. (1973), *From Reverence to Rape: The Treatment of Women in the Movies*, New York: Holt, Rinehardt and Winston.

Hatch, K. (2011), 'Lillian Gish: Clean, and White, and Pure as the Lily', in J. M. Bean (ed.), *Flickers of Desire: Movie Stars of the 1910s*, New Brunswick, New Jersey and London: Rutgers University Press, pp. 69–90.

Hayward, S. (2004), *Simone Signoret: The Star as Cultural Sign*, London: Continuum.

Herzog, C. C. and Gaines, J. M. (1985/1991), '"Puffed Sleeves Before Tea-Time": Joan Crawford, Adrian and Women Audiences', reprinted in C. Gledhill (ed.), *Stardom: Industry of Desire*, London and New York: Routledge, pp. 74–91

Hirsch, F. (2010), 'Doris Day and Rock Hudson: The Girl Next Door and the Brawny He-Man', in R. Barton Palmer (ed.), *Larger Than Life: Movie Stars*

of the 1950s, New Brunswick, New Jersey and London: Rutgers University Press, pp. 147–64.

Hollinger, K. (2006), *The Actress: Hollywood Acting and the Female Star*, New York and London: Routledge.

Hollows, J., Hutchings, P. and Jancovich, M. (eds) (2000), *The Film Studies Reader*, London: Arnold.

Holmes, D. (2007), '"A Girl of Today": Brigitte Bardot', in J. Gaffney and D. Holmes (eds), *Stardom in Postwar France*, New York and London: Berghahn, pp. 40–66.

Holmes, S. (2005), '"Starring ... Dyer?": Re-Visiting Star Studies and Contemporary Celebrity Culture,' *Westminster Papers in Communication and Culture* vol. 2 no. 2, pp. 6–21.

Iversen, G. (2009), 'Charismatic Ordinariness: Ullmann before Bergman', in T. Soila (ed.), *Stellar Encounters: Stardom in Popular European Cinema*, New Barnet, Hertfordshire: John Libbey, pp. 73–80.

Jeffers McDonald, T. (2006), '"Very Little Wrist Movement": Rock Hudson Acts Out Sexual Heterodoxy', *Canadian Journal of Communication* vol. 31, pp. 843–58.

Kindem, G. (1982), 'Hollywood's Movie Star System: An Historical Overview', in G. Kindem (ed.), *The American Movie Industry: The Business of Motion Pictures*, Carbondale: Southern Illinois University Press, pp. 79–93.

King, B. (1986), 'Stardom as an Occupation', in P. Kerr (ed.), *The Hollywood Film Industry*, London and New York, pp. 154–84.

King, B. (1987), 'The Star as the Commodity: Notes Towards a Performance Theory of Stardom', *Cultural Studies* vol. 1 no. 2, pp. 145–61.

King, B. (1985/1991), 'Articulating Stardom', in C. Gledhill (ed.), *Stardom: Industry of Desire*, London and New York: Routledge, pp. 167–82.

King, B. (2003), 'Embodying an Elastic Self: The Parametrics of Contemporary Stardom', in T. Austin and M. Barker (eds), *Contemporary Hollywood Stardom*, London: Arnold, pp. 45–61.

King, G. (2003), 'Stardom in the Willenium', in T. Austin and M. Barker (eds), *Contemporary Hollywood Stardom*, London: Arnold, pp. 62–73.

Klevan, A. (2005), *Film Performance: From Achievement to Appreciation*, London: Wallflower Press.

Kourelou, O. (2010), '"Put the Blame on ... Mei": Zhang Ziyi and the Politics of Global Stardom', in H. Hanson and C. O'Rawe (eds), *The Femme Fatale: Images, Histories, Contexts*, London and New York: Palgrave, pp. 113–26.

Krämer, P. (1999), 'Bibliographical Notes', in A. Lovell and P. Krämer (eds), *Screen Acting*, London and New York: Routledge, pp. 165–70.

Kuhn, A. (2002), *An Everyday Magic: Cinema and Cultural Memory*, London: I.B.Tauris.

Kuhn, A. (2009), 'Film Stars in 1930s Britain: A Case Study in Modernity and Femininity', in T. Soila (ed.), *Stellar Encounters: Stardom in Popular European Cinema*, New Barnet, Hertfordshire: John Libbey, pp. 180–94.

Landy, M. (2001), 'The Extraordinary Ordinariness of Gracie Fields: The Anatomy of a British Film Star', in B. Babington (ed.), *British Stars and Stardom*, Manchester: Manchester University Press, pp. 56–67.

Landy, M. (2009), 'Yesterday, Today, and Tomorrow: Tracking Italian Stardom', in T. Soila (ed.), *Stellar Encounters: Stardom in Popular European Cinema*, New Barnet, Hertfordshire: John Libbey, pp. 230–44.

Lane, C. (2010), 'Sally Field and Goldie Hawn: Feminism, Post-Feminism, and Cactus Flower Politics', in R. Eberwien (ed.), *Acting for America: Movie Stars of the 1980s*, New Brunswick, New Jersey and London: Rutgers University Press, pp. 180–200.

Lawrence, A. (2010a), *The Passion of Montgomery Clift*, Berkeley, Los Angeles and London: University of California Press.

Lawrence, A. (2010b), 'Rudolph Valentino: Italian American', in P. Petro (ed.), *Idols of Modernity: Movie Stars of the 1920s*, New Brunswick, New Jersey and London: Rutgers University Press, pp. 87–107.

Lawrence, M. (2010), 'Lee Kang-sheng: Non-professional Star', in M. Farquhar and Y. Zhang (eds), *Chinese Film Stars*, London and New York: Routledge, pp. 151–62.

Lovell, A. (2003), 'I Went in Search of Deborah Kerr, Jodie Foster and Julianne Moore but Got Waylaid', in T. Austin and M. Barker (eds), *Contemporary Hollywood Stardom*, London: Arnold, pp. 259–70.

Lovell, A. and Krämer, P. (eds) (1999), *Screen Acting*, London and New York: Routledge.

Lowe, V. (2004), '"The Best Speaking Voices in the World": Robert Donat, Stardom and British Cinema', *Journal of British Cinema and Television* vol. 1, pp. 181–96.

Lugowski, D. M. (2010), 'Claudette Colbert, Ginger Rogers and Barbara Stanwyck: American Homefront Women', in S. Griffin (ed.), *What Dreams Were Made Of: Movie Stars of the 1940s*, New Brunswick, New Jersey and London: Rutgers University Press, pp. 96–119.

Lugowski, D. M. (2011), 'Norma Shearer and Joan Crawford: Rivals at the Glamour Factory', in A. L. McLean (ed.), *Glamour in a Golden Age: Movie Stars of the 1930s*, New Brunswick, New Jersey and London: Rutgers University Press, pp. 129–52.

Lury, K. (2010), *The Child in Film: Tears, Fears and Fairy Tales*, London and New York: I.B. Tauris.

Majumdar, N. (2009), *Wanted Cultured Ladies Only! Female Stardom and Cinema in India, 1930s–1950s*, Urbana and Chicago: University of Illinois Press.

Maltby, R. (2003), *Hollywood Cinema*, 2nd edn, Oxford: Blackwell.

Marcello, S. A. (2006), 'Performance Design: An Analysis of Film Acting and Sound Design', *Journal of Film and Video* vol. 58 no. 1–2, pp. 59–70.

Marshall, P. D. (1997), *Celebrity and Power: Fame in Contemporary Culture*, Minneapolis and London: University of Minnesota Press.

Marshall, P. D. (ed.) (2006), *The Celebrity Culture Reader*, New York: Routledge.

Mask, M. (2009), *Divas on Screen: Black Women in American Film*, Urbana and Chicago: University of Illinois Press.

McCann, G. (1998), *Marilyn Monroe*, New Brunswick: Rutgers University Press.

McCreadie, M. (1973), *The American Movie Goddess*, New York: Wiley.

McDonald, P. (1998), 'Reconceptualising Stardom', in R. Dyer, *Stars*, 2nd edn, London: BFI, pp. 175–211.

McDonald, P. (2000), *The Star System: Hollywood's Production of Popular Identities*, London: Wallflower Press.

McDonald, P. (2004), 'Why Study Film Acting?: Some Opening Reflections', in C. Baron, D. Carson and F. P. Tomasulo (eds), *More Than a Method: Trends and Traditions in Contemporary Film Performance*, Detriot: Wayne State University Press, pp. 23–41.

McDonald, P. (2008), 'The Star System: The Production of Hollywood Stardom in the Post-Studio Era', in P. McDonald and J. Wasko (eds), *The Contemporary Hollywood Film Industry*, Malden, MA, Oxford and Victoria: Blackwell, pp. 167–81.

McDonald, P. and Wasko, J. (eds) (2008), *The Contemporary Hollywood Film Industry*, Malden, MA, Oxford and Victoria: Blackwell.

McLean, A. L. (2005), *Being Rita Hayworth: Labor, Identity, and Hollywood Stardom*, New Brunswick, New Jersey and London: Rutgers University Press.

McLean, A. L. (ed.) (2011a), *Glamour in a Golden Age: Movie Stars of the 1930s*, New Brunswick, New Jersey and London: Rutgers University Press.

McLean, A. L. (2011b), 'Betty Grable and Rita Hayworth: Pinned Up', in S. Griffin (ed.), *What Dreams Were Made of: Movie Stars of the 1940s*, New Brunswick, New Jersey and London: Rutgers University Press, pp. 166–91.

Mayne, J. (1993), *Cinema and Spectatorship*, London and New York: Routledge.

Medhurst, A. (1986), 'Dirk Bogarde', in C. Barr (ed.), *All Our Yesterdays*, London and New York: BFI, pp. 346–54.

Mellen, J. (1978), *Big Bad Wolves: Masculinity in the American Film*, London: Elm Tree.

Mishra, V. (2002), *Bollywood Cinema: Temples of Desire*, New York and London: Routledge.

Mizejewski, L. (2010), 'Meryl Streep: Feminism in the Era of the Backlash,' in R. Eberwein (ed.), *Acting for America: Movie Stars of the 1980s*, New Brunswick, New Jersey and London: Rutgers University Press, pp. 201–22.

Morin, E. (1957/2005), *The Stars (Les Stars)*, trans. by Richard Howard, Minneapolis and London: University of Minnesota Press.

Morrison, J. (ed.) (2010), *Hollywood Reborn: Movie Stars of the 1970s*, New Brunswick, New Jersey and London: Rutgers University Press.

Moseley, R. (2003), *Growing Up with Audrey Hepburn: Text, Audience, Resonance*, Manchester: University of Manchester.

Mulvey, L. (1975), 'Visual Pleasure and Narrative Cinema,' *Screen* vol. 16 no. 3, 1975, pp. 6–18.

Munni Kabir, N. (ed.) (2008), *Women in Indian Film*, New Delhi: Zubaan.

Naremore, J. (1988), *Acting in the Cinema*, Berkeley, Los Angeles and London: University of California Press.

Negra, D. (2001), *Off-White Hollywood: American Culture and Ethnic Female Stardom*, London and New York: Routledge.

Nichols, B (ed.) (1985), *Movies and Methods Volume II*, Berkeley, Los Angeles and London: University of California Press.

Papadimitriou, L. (2009), 'Stars of the 1960s Greek Musical: Rena Vlahopoulou and Aliki Vougiouklaki', in T. Soila (ed.), *Stellar Encounters: Stardom in Popular European Cinema*, New Barnet, Hertfordshire: John Libbey, pp. 205–14.

Petro, P. (ed.) (2010), *Idols of Modernity: Movie Stars of the 1920s*, New Brunswick, New Jersey and London: Rutgers University Press.

Phillips, A. (2006), 'Changing Bodies, Changing Voices: French Success and Failure in 1930s Hollywood', in A. Phillips and G. Vincendeau (eds), *Journeys of Desire: European Actors in Hollywood*, London: BFI, pp. 84–93.

Phillips, A. and Vincendeau, G. (eds) (2006), *Journeys of Desire: European Actors in Hollywood*, London: BFI.

Pramaggiore, M. (2010), 'Jane Fonda: From Graylist to A-List', in J. Morrison (ed.), *Hollywood Reborn: Movie Stars of the 1970s*, New Brunswick, New Jersey and London: Rutgers University Press, pp. 16–38.

Pugh, T. and Sandler, B. (2010), 'Montgomery Clift: Hollywood Pseudohomosexual', in R. Barton Palmer (ed.), *Larger Than Life: Movie Stars of the 1950s*, New Brunswick, New Jersey and London: Rutgers University Press, pp. 18–36.

Qiong Yu, S. (2010), 'Jet Li: Star Construction and Fan Discourse on the Internet', in M. Farquhar and Y. Zhang (eds), *Chinese Film Stars*, London and New York: Routledge, pp. 225–36.

Radner, H. (2006), 'Louis Jourdan – the 'Hyper-sexual' Frenchman', in A. Phillips and G. Vincendeau (eds), *Journeys of Desire: European Actors in Hollywood*, London: BFI, pp. 124–32.

Rosen, M. (1973), *Popcorn Venus*, New York: Coward, McCann and Charterhouse.

Sánchez–Biosca, V. (2006), 'The Latin Masquerade: The Spanish in Disguise in Hollywood', in A. Phillips and G. Vincendeau (eds), *Journeys of Desire: European Actors in Hollywood*, London: BFI, pp. 133–9.

Schickel, R. (1974), *His Picture in the Papers*, New York: Charterhouse.

Schur, T. (2010), 'Faye Dunaway: Stardom and Ambivalence', in J. Morrison (ed.), *Hollywood Reborn: Movie Stars of the 1970s*, New Brunswick, New Jersey and London: Rutgers University Press, pp. 138–57.

Sedgwick, J. and Pokorny, M. (eds) (2005), *An Economic History of Film*, London and New York: Routledge.

Sennett, R. S. (1998), *Hollywood Hoopla: Creating Stars and Selling Movies in the Golden Age of Hollywood*, New York: Billboard.

Sergi, G. (1999), 'Actors and the Sound Gang', in A. Lovell and P. Krämer (eds), *Screen Acting*, London and New York: Routledge, pp. 126–37.

Shail, R. (2009), 'The Historical Specificity of Stardom: Terence Stamp in the 1960s', in T. Soila (ed.), *Stellar Encounters: Stardom in Popular European Cinema*, New Barnet, Hertfordshire: John Libbey, pp. 99–107.

Shingler, M. (2006a), 'Breathtaking: Bette Davis' Performance at the End of *Now, Voyager*', *Journal of Film and Video* vol 58 no. 1–2, pp. 46–58.

Shingler, M. (2006b), 'Fasten Your Seatbelts and Prick Up Your Ears: The Dramatic Human Voice in Film', in *Scope* no. 5, University of Nottingham, http://www.scope.nottingham.ac.uk/article.php?issue=5&id=128

Shingler, M. and Gledhill, C. (2008), 'Bette Davis: Actor/Star', *Screen* vol. 49 no. 1, pp. 67–76.

Shipman, D. (1970), *The Great Stars – the Golden Years*, London: Hamlyn.

Sieglohr, U. (ed.) (2000a), *Heroines Without Heroes: Reconstructing Female and National Identities in European Cinema, 1945–51*, London and New York: Cassell.

Sieglohr, U. (2000b), 'Hildegard Knef: From Rubble Woman to Fallen Woman', in U. Sieglohr (ed.), *Heroines Without Heroes: Reconstructing Female and National Identities in European Cinema, 1945–51*, London and New York: Cassell, pp. 113–27.

Sikov, E. (2007), *Dark Victory: The Life of Bette Davis*, New York: Henry Holt and Company.

Silverman, K. (1988), *The Acoustic Mirror: The Female Voice in Psychoanalysis and Cinema*, Bloomington and Indianapolois: Indiana University Press.

Singh, S. (2008), 'The Road to *Rāmarājya*: Analysing Shah Rukh Khan's Parallel Text in Commercial Hindi Cinema', in *BELLS: Barcelona English Language and Literature Studies* vol. 17, pp. 1–15 (http://www.publicacions. ub.edu/revistes/bells17/documentos/591.pdf).

Singhal, R. (ed.) (2004), *Mega Star of Bollywood: Amitabh Bachchan*, Delhi: Pentagon.

Smith, S. (2005), *The Musical: Race, Gender and Performance*, London: Wallflower Press.

Smith, S. (2007), 'Voices in Film', in J. Gibbs and D. Pye (eds), *Close-Up 02*, London: Wallflower Press.

Soila, T. (ed.) (2009), *Stellar Encounters: Stardom in Popular European Cinema*, New Barnet, Hertfordshire: John Libbey.

Solomon, M. (2010), 'Reflexivity and Metaperformance: Marilyn Monroe, Jayne Mansfield, and Kim Novak', in R. Barton Palmer (ed.), *Larger Than Life: Movie Stars of the 1950s*, New Brunswick, New Jersey and London: Rutgers University Press, pp. 107–29.

Spazzini, M. (2009), '"Italy's New Sophia Loren": Sabrina Ferilli', in T. Soila (ed.), *Stellar Encounters: Stardom in Popular European Cinema*, New Barnet, Hertfordshire: John Libbey, pp. 161–7.

Spicer, A. (2006), 'Acting Nasty? British Male Actors in Contemporary Hollywood', in A. Phillips and G. Vincendeau (eds), *Journeys of Desire: European Actors in Hollywood*, London: BFI, pp. 140–8.

Spicer, A. (2009), 'The Mark of Cain: Eric Portman and British Stardom', in T. Soila (ed.), *Stellar Encounters: Stardom in Popular European Cinema*, New Barnet, Hertfordshire: John Libbey, pp. 108–17.

Stacey, J. (1991), 'Feminine Fascinations: Forms of Identification in Star-Audience Relations', in C. Gledhill (ed.), *Stardom: Industry of Desire*, London and New York: Routledge, pp. 74–91.

Stacey, J. (1994), *Star Gazing: Hollywood Cinema and Female Spectatorship*, London and New York: Routledge.

Staiger, J. (1983/1991), 'Seeing Stars', in C. Gledhill (ed.), *Stardom: Industry of Desire*, London and New York: Routledge, pp. 3–16.

Staiger, J. (1992), *Interpreting Films: Studies in the Historical Reception of American Cinema*, Princeton, NJ: Princeton University Press.

Stern, L. and Kouvaros, G. (eds) (2000), *Falling for You: Essays on Cinema and Performance*, Sydney: University of Sydney Press.

Stimpart, L., Laux, J., Marino, C. and Gleason, G. (2008), 'Factors Influencing Motion Picture Success: Empirical Review and Update', *Journal of Business and Economics Research* vol. 6 no. 11, pp. 39–51.

Street, S. (2006), '"Star Trading": The British in the 1930s and 1940s Hollywood', in A. Phillips and G. Vincendeau (eds), *Journeys of Desire: European Actors in Hollywood*, London: BFI, pp. 61–9.

Stringer, J. (2003), 'Scrambling Hollywood: Asian Stars/Asian American Star Cultures', in T. Austin and M. Barker (eds), *Contemporary Hollywood Stardom*, London: Arnold, pp. 229–42.

Stringer, J. (2010), 'Leslie Cheung: Star as Autosexual', in M. Farquhar and Y. Zhang (eds), *Chinese Film Stars*, London and New York: Routledge, pp. 207–24.

Studlar, G. (2011), 'Theda Bara: Orientalism, Sexual Anarchy, and the Jewish Star', in J. M. Bean (ed.), *Flickers of Desire: Movie Stars of the 1910s*, New Brunswick, New Jersey and London: Rutgers University Press, pp. 113–36.

Tasker, Y. (1993), *Spectacular Bodies: Gender and Sexuality in Popular Cinema*, London: Routledge.

Thompson, J. O. (1978/1991), 'Screen Acting and the Commutation Test', reprinted in C. Gledhill (ed.), *Stardom: Industry of Desire*, London and New York: Routledge, 1991), pp. 183–97.

Triana-Toribio, N. (2000), 'Ana Mariscal: Franco's Disavowed Star', in Ulrike Sieglohr (ed.), *Heroines Without Heroes: Reconstructing Female and National*

Identities in European Cinema, 1945–51, London and New York: Cassell, pp. 185–95.

Vincendeau, G. (2000), *Stars and Stardom in French Cinema,* London and New York: Continuum.

Vincendeau, G. (2006), '"Not for Export": Jean Gabin in Hollywood', in A. Phillips and G. Vincendeau (eds), *Journeys of Desire: European Actors in Hollywood,* London: BFI , pp. 114–23.

Viviani, C. (2006), 'The "Foreign Woman" in Classical Hollywood Cinema', in A. Phillips and G. Vincendeau (eds), *Journeys of Desire: European Actors in Hollywood,* London: BFI, pp. 94–101.

Weber, M. (1922/1968), *Economy and Society,* New York: Bedminster Press.

Weiss, A. (1991), '"A Queer Feeling When I Look at You": Hollywood Stars and Lesbian Spectatorship in the 1930s', in C. Gledhill (ed.), *Stardom: Industry of Desire,* London and New York: Routledge, pp. 283–99.

Werner, S. (2007), '1950s Popular Culture: Star-Gazing and Myth-Making with Roland Barthes and Edgar Morin', in J. Gaffney and D. Holmes (eds), *Stardom in Postwar France,* New York and London: Berghahn, pp. 26–39.

White, P. (1999), *Uninvited: Classical Hollywood Cinema and Lesbian Representability,* Bloomington and Indianapolis: Indiana University Press.

Willis, A. (ed.) (2004), *Film Stars: Hollywood and Beyond,* Manchester: Manchester University Press.

Wojcik, P. Robertson (2000), 'A Star is Born Again or, How Barbra Streisand Recycles Garland', in L. Stern and G. Kouvaros (eds), *Falling for You: Essays on Cinema and Performance,* Sydney: University of Sydney Press, pp. 177–207.

Wojcik, P. Robertson (ed.) (2004a), *Movie Acting: The Film Reader,* New York and London: Routledge.

Wojcik, P. Robertson (2004b), 'Typecasting', reprinted in P. Robertson Wojcik (ed.), *Movie Acting: The Film Reader,* New York and London: Routledge, pp. 169–89.

Wojcik, P. Robertson (2006), 'The Sound of Film Acting', *Journal of Film and Video* vol. 58 no. 1–2, pp. 71–83.

Wojcik, P. Robertson (2010), 'Judy Holliday: The Hungry Star', in R. Barton
Palmer (ed.), *Larger Than Life: Movie Stars of the 1950s*, New Brunswick,
New Jersey and London: Rutgers University Press, pp. 205–19.

Zhen, Z. (2010), 'Ling Bo: Orphanhood and Post-war Sinophone Film
History', in M. Farquhar and Y. Zhang (eds), *Chinese Film Stars*, London
and New York: Routledge, pp. 121–38.

Zucker, C. (ed.) (1990), *Making Visible the Invisible: An Anthology of Original
Essays on Film Acting*, Metuchen, NJ, and London: Scarecrow Press.

Zucker, C. (2004), 'Passionate Engagement: Performance in the Films of Neil
Jordan', in C. Baron, D. Carson and F. P. Tomasulo (eds), *More Than a
Method: Trends and Traditions in Contemporary Film Performance*, Detriot:
Wayne State University Press, pp. 192–216.

INDEX

Note: Page numbers in **bold** indicate detailed analysis; those in *italic* denote illustrations. *n* = endnote.

List of Illustrations

While considerable effort has been made to correctly identify the copyright holders, this has not been possible in all cases. We apologise for any apparent negligence and any omissions or corrections brought to our attention will be remedied in any future editions.

Now, Voyager, © Warner Bros. Pictures, Inc.; *Susan and God*, Metro-Goldwyn-Mayer; *North by Northwest*, © Loew's Inc.; *The Godfather*, © Paramount Pictures Corporation; *La Vita é bella*, © Melampo Cinematografica Srl; Gwyneth Paltrow, British *Vogue* cover (February 1998), photograph: Mario Testino, Conde Nast Publications Ltd; *Shakespeare in Love*, © Miramax Films/© Universal Pictures; *Dilwale Dulhania Le Jayenge*, Yash Raj Films International; *Grand Hotel*, © Metro-Goldwyn-Mayer Distributing Corp.; *Andaz*, Mehboob Productions; *Tovarich*, Warner Bros.; *Yentl*, © Ladbroke Entertainments Limited; *Yield to the Night*, Associated British Picture Corporation/Associated British Pathé/Kenwood Films; Amitabh Bachchan, *Masala!* cover (vol. 9, issue 400, August 2011), ITP Publishing Group; Shah Rukh Khan, *Filmfare* cover (8 December 2010), World Wide Media; Doris Day, American *Photoplay* cover (October 1955), Macfadden Publications; *Les Bijoutiers du Clair de Lune*, Iéna/U.C.I.L./C.E.I.A.P.; *Carmen Jones*, © Carlyle Productions; *Rush Hour*, © New Line Productions, Inc.; *Memoirs of a Geisha*, © Columbia Pictures Industries, Inc./© DreamWorks LLC/© Spyglass Entertainment Group, LLC; *The Forbidden Kingdom*, © J&J Project, LLC.

UNIVERSITY OF GLASGOW LIBRARY